Aerial Photography and Videography Using Drones

Eric Cheng

"You couldn't ask for a better field guide to this new frontier."

—From the Foreword by Adam Savage, co-producer and
co-host of *Mythbusters* on Discovery Channel

Peachpit
Press

Aerial Photography and Videography Using Drones
Eric Cheng

Peachpit Press
Find us on the Web at www.peachpit.com

To report errors, please send a note to errata@peachpit.com
Peachpit Press is a division of Pearson Education
Copyright © 2016 by Eric Cheng

Senior Editor: Karyn Johnson
Development Editor: Stephen Nathans-Kelley
Senior Production Editor: Lisa Braziel
Copyeditor: Kim Wimpsett
Proofreader: Liz Welch
Compositor: WolfsonDesign
Indexer: James Minkin
Interior Design: Mimi Heft
Cover Design: Mimi Heft
Cover Photo: Eric Cheng

ISBN-13: 978-0-134-12277-9
ISBN-10: 0-134-12277-1

9 8 7 6 5 4 3 2 1

Printed and bound in the United States of America

Endorsements for *Aerial Photography and Videography Using Drones*

"Essential reading for anyone curious about consumer quads, especially all my family and friends who can't stop asking about my funky flying camera."

—*Norman Chan, editor of Tested.com*

"... the ultimate guide for aerial imaging. From techniques, to demystifying gear, to understanding the regulatory environment, this is essential reading for new and experienced operators alike."

—*Gregory McNeal, JD/Ph.D., co-Founder of AirMap, Professor of Law and Public Policy at Pepperdine University, contributor to Forbes.com*

"Drones dramatically change the way we think about film and photography, allowing for the capture of completely new perspectives. Eric leads you down a path of getting to know this new language; it's thrilling and beautiful."

—*Damian Kulash, Jr., lead singer of OK Go and music video director*

"Aerial photography has been overly complicated ever since cameras were first introduced to DIY drones. Eric delivers a much-needed introduction to give you the best possible start in the craft."

—*Austin Furey, marketing manager, Flite Test*

ERIC CHENG is a technologist and award-winning photographer. Throughout his career, Eric has combined passions for photography, entrepreneurship, technology, and storytelling. His work as an image-maker has been featured at the Smithsonian's Natural History Museum and in many media outlets, including *Wired*, *Outdoor Photographer*, *Popular Photography*, *The Washington Post*, *The Wall Street Journal*, *Make*, ABC, *Good Morning America*, CBS, CNN, Discovery Channel, National Geographic Channel, and numerous news networks across the globe.

Caught between technical and creative pursuits, Eric has bachelor's and master's degrees in computer science from Stanford University, where he also studied classical cello performance. He leads regular photography expeditions and workshops around the world and has given seminars and lectures internationally at events including TEDx, e.g., the Churchill Club, DEFCON, Photoshelter Luminance, Photographers@Google, CES, SXSW, AsiaD, Creative Mornings, NASA UTM, and others.

Eric was formerly Director of Aerial Imaging at DJI, the creators of the popular Phantom camera drone, and is on the advisory board of the U.S. Association of Unmanned Aerial Videographers (UAVUS), Drone World Expo (DWE), and UAViators Humanitarian UAV Network. He is a Field Associate at the California Academy of Sciences, and also serves as a mentor at Startupbootcamp.

Eric's photography can be found at www.echengphoto.com. He publishes Wetpixel. com, the leading underwater photography community on the Web, and writes about his aerial imaging pursuits at skypixel.org.

Eric lives in San Mateo, California, with his wife, Pam, and son, Mako.

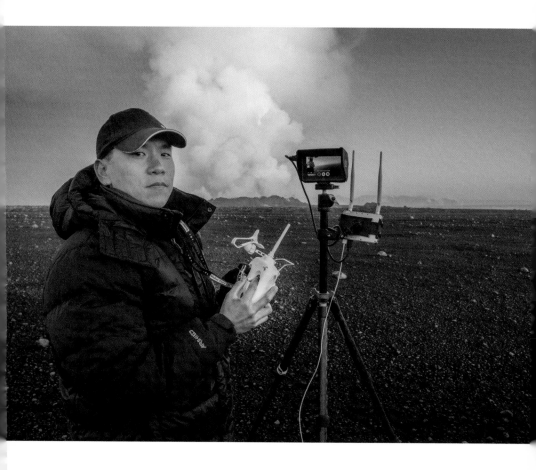

Contents

CHAPTER 2
Learning to Fly 33

CHAPTER 3
Aerial Stills Photography 60

CHAPTER 5
Getting the Shot: Real-World Stories 142

CHAPTER 6
Flight, Policy, and Travel 236

Foreword

For most of my professional life I've told stories of one kind or another for a living. For the last 13 years I've co-hosted and co-executive produced the show *Mythbusters* on Discovery Channel. We're all equipment junkies on our crew; high-speed cameras, helicopters, GoPros and Blackmagic cameras, 3D, VR, underwater photography—you name it, and we've tried it to help tell our stories. The funny thing is, every time I get together with Eric Cheng and we start talking about gear, I begin the conversation under the impression that our little show is on the bleeding edge, and invariably I find that Eric has a vast amount of previous experience with exactly the tech I've only recently discovered.

Our second cameraman, Duncan, got interested in flying platforms for cameras a few years ago. He started with planes, but when he lost one in a river on a shoot in Utah he started investing in custom-built quadcopters and then octocopters. At what seemed like an incredibly opportune moment, Eric took his expertise over to DJI and supplied our crew with a couple of drones. Quite frankly, he's changed my life.

Holy cow, do I love aerial photography! As a producer, it provides me with a scope I could *never* afford with any other tech. Helicopters cost as much to rent for a day as a high-end, off-the-shelf unmanned aircraft system (UAS) costs. Moreover, these incredible pieces of technology can move through spaces a helicopter never could, and capture images that would be impossible to get with anything else. It's not just an aerial photography system. It's a crane. It's a dolly. It's my POV falling off a building into water. It's the most exciting development in storytelling I've come across for the kind of shows I make.

As with any new technology, there are growing pains. People are already over-using UASs. I encounter at least four aerial shots from them in *every* reality show I see. Some of these shots stick out like sore thumbs. They say, "Hey! Look at the cool piece of tech I'm using to show you this house!"

Of course, the goal is to make the tech invisible, to show the audience viewpoints and perspectives that enhance the story and draw viewers in, not remind them that they can buy a flying camera at Target next weekend. We need early adopters who can show people how to properly utilize the new toys, rather than simply show them off. We need aerial photographers who break new ground while remaining properly grounded in the essentials of the art.

That's Eric Cheng. Eric is a friend of mine.

Eric is perhaps the most dedicated envelope-pusher I've ever met when it comes to equipment and technology. He's also impressively humble. He might refer to underwater photography as a hobby of his, and neglect to tell you he created and edited *Wetpixel*, a magazine about underwater photography. Or that he travels for weeks at a time to indulge his "hobby."

He's also a gifted and fantastic teacher. He loves talking about his mistakes, his highs, his lows (if you meet Eric, get him to tell you about filming a time-lapse of the aurora borealis—it's a hair-raising story), and the lessons he's learned. He has ample advice and he's always willing to share it.

But here's my favorite reason that you've bought the right book by the right person at the right time: Eric is a natural-born storyteller. He understands, with each new piece of hardware that he plays with, what he really and truly wants to do with it. Fundamentally, Eric is interested telling a story about how magnificent and lovely the world is from new perspectives, which is what makes his photography so compelling. With whatever medium he uses, Eric intrinsically understands the story in each picture he's taking, and the journey he hopes to take the viewer on.

You couldn't ask for a better field guide to this new frontier.

—*Adam Savage, lifelong maker; co-producer,*
 co-host of Mythbusters *on Discovery Channel*

Introduction

The democratization of photography and videography in the past decade has been incredibly exciting. Stand-alone cameras improve dramatically year after year, users of smartphones with cameras now number in the billions, and those users share more than 2 billion photos to the Internet every day.

In the past few years, another exciting revolution in imaging has taken off from relative obscurity: aerial photography and videography using drones. Consumer drones, which exist now as multirotor and fixed-wing remote-controlled (RC) aircraft, suddenly appeared on the market in 2013 as ready-to-fly (RTF) products capable of carrying small cameras. While RC helicopters carrying larger cameras had been used for years by Hollywood to capture aerial footage for films, normal consumers could rarely take advantage of the technology because of its cost, complexity, and do-it-yourself nature. The consumer drones introduced in 2013 were affordable and relatively easy to fly; suddenly, new aerial perspectives were available to everyone, and the excitement they engendered resulted in an explosion of consumer drone usage, mostly as aerial camera platforms.

Aerial Photography and Videography Using Drones is designed to help you make the most of the opportunities these nimble, affordable, and accessible flying machines created for would-be aerial photographers and videographers. The book takes you through the current state of camera drone equipment (Chapter 1), how to train yourself to become a competent drone operator (Chapter 2), tips for how to get the best aerial still images and videos (Chapters 3 and 4, respectively), images and stories from me and other aerial storytellers that will give you a peek at what awaits you in the world of aerial photography and videography (Chapter 5), and the current regulatory environment for drone usage in the United States (Chapter 6).

Drone technology is changing quickly, and although the book uses mostly camera drones like the DJI Phantom 3 to illustrate details, it was written to address general principles that should stay relevant even if the technology changes (which it surely will, quickly). The book focuses on RTF, integrated camera drones and is not a general drone primer for folks who are looking to build their own, although details about using GoPro cameras in the air are included.

Putting a camera drone in the air is all about storytelling, and the book would not be complete without telling some of my favorite stories (along with some stories from guest contributors). Chapter 5 consists of a portfolio of aerial still images, the equipment used to capture the images, and the story behind each image.

At the time of this writing, I was employed by DJI, which means that most of my experiences in aerial imaging were accomplished using DJI products. DJI does not explicitly support or endorse this book, and I have done my best to write from an objective standpoint as a longtime veteran in the photography, technology, and publishing industries.

I hope that this book will help you to master your skills as an aerial storyteller using camera drones, and I look forward to seeing some of the work you share with the world!

A Note About the Downloadable Videos

With this book, you have access to several short video clips that you can watch to see some of the concepts described in action. These clips are excerpted from the full-length video *Aerial Photography and Video Using Drones: Learn by Video* (Peachpit Press, 2015), which is also available for sale on peachpit.com.

To access the videos that are referenced in this book, download the files to your computer following these steps:

1. Register your book at www.peachpit.com/aerialphoto. If you don't already have a Peachpit account, you will be prompted to create one.

2. Once you are registered at the Peachpit website, click the Account link, select the Registered Products tab, and click the "Access Bonus Content" link.

3. A new page opens with the download files listed. Copy the files to any location you prefer on your system.

Acknowledgments

When I started experimenting with small RC helicopters in 2009 and putting cameras on them in 2011, I never thought that aerial imaging would be so fundamentally disrupted in just a few short years. Democratized aerial imaging was unheard of in 2011, and even when the first RTF quadcopters were released in 2013, aerial imaging required quite a bit of custom DIY work to the nascent quadcopters to make them useful. In 2015, camera drones can be found nearly everywhere, with integrated cameras and an ease of use that have enabled the industry to continue to grow exponentially. In the coming years, continued improvements in user experience promise to catapult camera drones into the consumer imaging mainstream.

I'm excited for the future of consumer drones and the possibilities they bring to so many different industries. Almost every major company seems to be working on a drone strategy, and new drone startups pop up virtually every day with big plans in the space.

Writing this book has been a wonderful way to relive the past few years of total immersion in the aerial imaging industry. The knowledge, tips, and stories I've shared have come from countless hours of research, frustration, epiphanies, and flat-out awe from the experiences I've been so fortunate to have during my efforts to become a better aerial imager.

I'd like to thank Julian Cohen, Romeo Durscher, and Renee Lusano for generously sharing their aerial stories as part of Chapter 5; DJI, for being supportive of my first attempt to author a real book; and my friends in the fledgling aerial imaging community who either went through the early days with me or helped make some of the stories happen: Romeo Durscher, Randy Jay Braun, Pablo Lema, David Merrill, Tom Gruber, Jimmie Fulton, Steve Doll, Jeff Foster, Jerome Miller, Jeff Cable, Carlos "CHARPU" Fernandez Puertolas,

Ferdinand Wolf, Ryan Tong, Lisa Lu, Russell Brown, Barry Blanchard, Steve Mandel, George Krieger, Gerard Mattimoe, Patrick Meier, Jean Tresfon, Maria Stefanopoulos, Ragnar Sigurdsson, Einar Erlendsson , and others I have surely missed.

I'd also like to thank the wonderful folks at Peachpit: Stephen Nathans-Kelly, for his clear head and for making sure everything made sense; Karyn Johnson, for keeping faith in me despite long delays in getting started on the project; and Mimi Heft, for bringing the book to life through design.

Finally, I thank my wife, Pam, whose (nearly) endless patience and support allowed me to work the required late nights even during the early months of our first son, Mako (who won't remember any of this).

The first picture I took using a GoPro mounted on my original DJI Phantom, on February 1, 2015

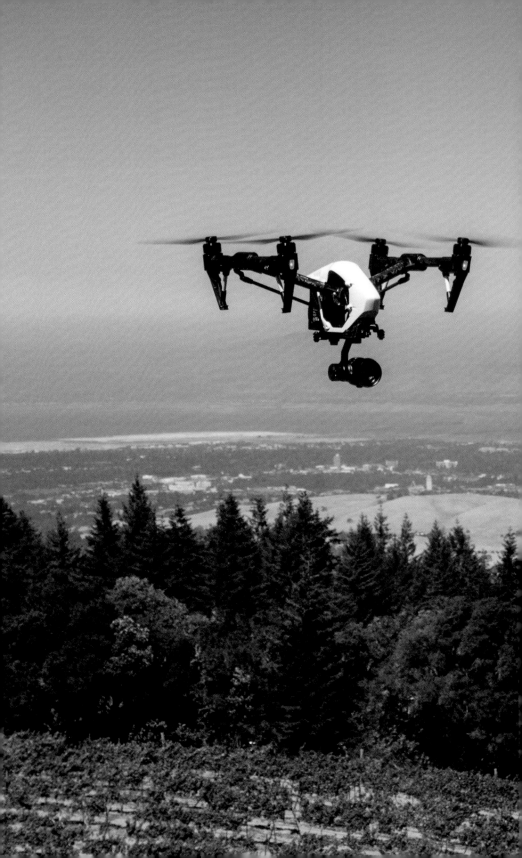

CHAPTER 1

Equipment

What Is a Drone?

Drone is an aeronautical term referring to an unmanned aircraft that navigates via onboard computer or by remote control (RC). It has its origins in the military going back to the mid-1930s and was first used to refer to remote-control aircraft that were used for target practice (paying homage to a drone bee and its queen operator). In more recent times, *drone* became the common term for unmanned aerial vehicle (UAV); the word still conjures military applications for many people but is increasingly becoming a more neutral term as consumer and civil applications become more common.

Within the context of aerial imaging, *drones* is the media word for multirotors, which are simply helicopter-like aircraft that contain more than one rotor. Multirotors are commonly sold in stores as *quadcopters*, which are usually roughly symmetrical in design and use four motors and propellers to fly. Hexacopters and octocopters are also common in the aerial imaging space but are typically reserved for higher-end, custom applications.

Although *drone* is by far the most common term used in media for the unmanned aircraft used to carry cameras, it can be controversial. In the regulatory world, the terms *small unmanned aircraft system* (sUAS) and *small unmanned aerial vehicle* (sUAV) are more commonly used. Diehard RC pilot hobbyists usually hate the term *drone* and will argue that *multirotor* is the correct word to use. They also assert that drones must be autonomous, which means that the term cannot be used to describe the aircraft we fly to take pictures from the sky.

Quadcopters use onboard computers as fundamental control systems and must be computer controlled simply to stay in the air. In addition, most modern quadcopters can actually navigate autonomously in more obvious ways when asked to do so (for example, "fly home and land"). The fact that quadcopters actually do qualify as being included in the dictionary definition of the word *drone*, combined with the unwieldy acronyms used in more official fronts, virtually guarantees that the word *drone* will prevail. Also, the media has already decided what the word will be, which is why this book is called *Aerial Photography and Videography Using Drones*.

Now that I have established that I am, indeed, talking about drones, I can subcategorize them by use. All the drones I discuss in this book are nonmilitary, and I will refer to them as *consumer drones* or *camera drones*.

Drones and Cameras

I still remember seeing a camera drone for the first time. It was 2009, and I had been playing with RC, toy helicopters for about a week, learning to fly them—and crash them—in my living room. During some routine web browsing, I happened to stumble upon a video showing a hexacopter, a multirotor with six propellers, hovering stably in the air before zooming off at high speed, all while carrying a point-and-shoot camera. At that moment, I knew that one day I'd have my own camera drone in the air. As it turned out, hexacopters and other multirotors were still firmly in the realm of experimental hobby. Many months passed before I was able to get a camera attached to an RC helicopter into the air and fly it well enough not to destroy the camera!

Luckily, in the last six years, camera drones have come a long way and are now on the verge of mainstream adoption. Dozens of ready-to-fly models are readily available for purchase, some of them expressly built to help realize the dream of capturing pictures and video from the air.

Before I get into all the equipment necessary to get a camera into the air, let's take a moment to think about your goals. Are you a photographer looking for new perspectives to explore? Are you capturing video for weddings? Do you just want to fly fast while recording your flights? Which drones, cameras, transmitters, and other equipment you choose will depend on what you want to do with your camera once it's in the air.

Quadcopters

As of September 2015, almost all camera drones are quadcopters. In fact, almost all consumer drones are quadcopters, from the tiniest flying toys on the market, which are barely an inch in diameter, to larger quadcopters that are well suited to capturing aerial imagery (**FIGURE 1.1**).

A quick search on Amazon.com for *quadcopters with cameras*—an actual, organized category found at the online retailer's website—yields hundreds of results, with products ranging in price from around $20 to many thousands of dollars. Given the incredible variety of quadcopters on the market, how do you choose which one to get?

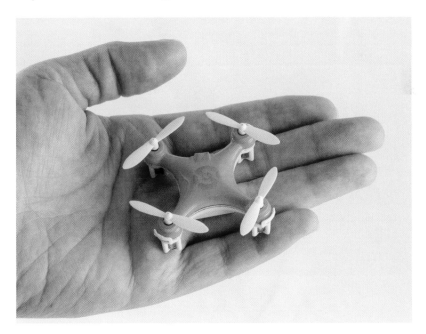

FIGURE 1.1 A Cheerson CX-10 Mini, one of the smallest quadcopters on the market

Although there are many brands on the market, there are actually only a few products that enable a pilot to capture usable pictures and videos. Instead of discussing all the options, which would be impossible, I'll focus on the ones I think will actually be worth using. Luckily, my opinions have been validated by the marketplace, and these models also happen to be the best-selling.

Doing research into aerial imaging naturally leads to the DJI Phantom series, which are by far the most popular camera drones on the market. A YouTube search for *DJI Phantom* currently returns more than a million aerial videos shot with the Phantom (**FIGURE 1.2**). Its iconic, white-plastic form has become the standard design used in knock-off clones.

The DJI Phantom almost single-handedly created the consumer aerial imaging market. Before the Phantom was released in January 2013, almost all creative aerial imaging was done by helicopter. Quadcopters and other RC multicopters certainly existed before then, but the industry was still really in a pre-birth stage. By the end of 2012, it hadn't progressed significantly from where I found it when I first started looking into the possibilities in late 2009.

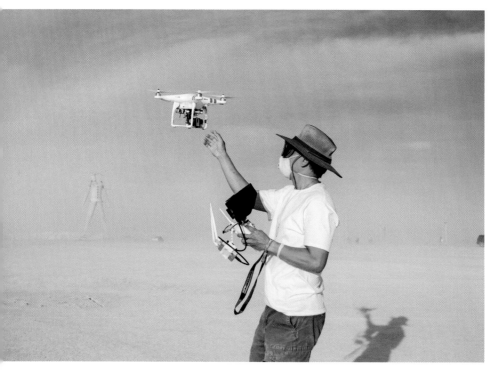

FIGURE 1.2 Me flying a DJI Phantom 2 at Burning Man.
Photo courtesy Gerard Mattimoe.

HISTORY OF QUADCOPTERS

Quadcopters have been around for more than 100 years. In 1907, a French aircraft designer named Louis Breguet built the Breguet-Richet Gyroplane (**FIGURE 1.3**), a four-propeller gyroplane that became the first rotary-wing aircraft to lift a pilot off the ground (albeit only 2–5 feet!). It took another 50 years before a quadrotor helicopter would be designed that could achieve forward flight.

In the 1940s, traditional helicopters entered mass production, rendering manned quadcopters a thing of the past. Quadrotor copters have been revived only recently by the boom in the small unmanned aircraft system (UAS) industry.

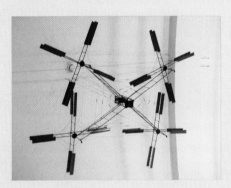

FIGURE 1.3 Breguet-Richet Gyroplane 1907 by PHGCOM—Own work.

Licensed under CC BY-SA 3.0 via Wikimedia Commons. http://commons.wikimedia.org/wiki/File:Breguet_Gyroplane_1907.jpg#/media/File:Breguet_Gyroplane_1907.jpg. | Source: http://en.wikipedia.org/wiki/Louis_Charles_Breguet#/media/File:Breguet_Gyroplane_1907.jpg.

The Phantom's key contribution was removing the technical complexity from aerial imagery. Equipped with a GoPro action camera, the original Phantom (which came with a GoPro mount) was the first consumer camera drone that was ready to fly out of the box. Since then, the Phantom has been revved a few times, and the current model, the Phantom 3, features an integrated camera and feels more like a remote, uncannily stable camera than it does a drone that carries a camera.

Camera drones sold by 3D Robotics (3DR) and Parrot also feature out-of-the-box aerial imaging, using either GoPro cameras (3DR Iris+ and Solo) or integrated cameras (Parrot Bebop), but they are far less popular than the Phantoms, both in terms of unit sales and videos that have been shared online.

Consumer drones exist, essentially, in three categories.

- **Integrated, ready-to-fly (RTF) drones:** This category includes the vast majority of the toy market and popular consumer quadcopters used for aerial imaging. Drones in this category either have integrated cameras or are designed to be used with specific, popular action cameras like GoPros. Some prominent companies in this space include DJI, Parrot, 3DR, Blade, Yuneec, and Walkera. RTF drones sell for as little as $20. High-end, prosumer, and professional camera drones can cost thousands of dollars.

- **Hobby drones:** These drones are most commonly sold in kit form and can be customized for specific applications or desires. Hobby drones typically lag behind integrated drones in terms of convenience and support but can be configured to support features not yet common in integrated drones. Most hobby drones are sold to hobbyists who focus on building and do-it-yourself (DIY) as the main purpose of flying drones.

- **Packaged hobby drones:** These drones usually appear to be integrated drones on the surface but are usually pre-assembled hobby drones packaged in a glossy shell, with marketing resources thrown into the mix to make them seem like integrated products. The companies that make packaged hobby drones usually do not add any real technology to their drones and are essentially service integrators. This is a dangerous category of drone to purchase because it is likely that most companies in this space will not exist for long or will, by necessity, shift focus to niche, specialized markets to survive. In specialized markets, packaged hobby drones can thrive because specific needs can be met by customization and market-tailored customer support.

Drone users who have specialized needs in aerial imagery (for example, specific camera requirements such as near-infrared or thermal imaging) need to pursue customized solutions that involve attaching a dedicated (land) camera to a quadcopter or other multicopter (in the "hobby drone" or "packaged hobby drone" categories). The vast majority of people interested in aerial imaging will want to purchase products in the "integrated, RTF" category. This book will mostly focus on this category of consumer drones, although I'll touch on other options in less detail.

WATCH THE VIDEO OVERVIEW OF CONSUMER DRONES

Download Chapter01_Overview.mov to watch a video of classifications and descriptions of various consumer drones. Please see this book's Introduction for information on how you can access and download the video files designed to accompany this book.

Batteries and Chargers

A battery is one of the main components in a viable camera drone; the energy density of a battery and its ability to deliver energy quickly are major factors in a drone's capability to fly well in the air and stay aloft for a long time. It is well known that improvements in battery technology move slower than do improvements in chip speeds and other components. Luckily, the smartphone revolution put a lot of pressure on battery companies to improve energy density. These days, rechargeable lithium-ion polymer (LiPo) batteries, which are energy dense and can discharge huge amounts of current upon demand, are the standard batteries used in smartphones, tablets, computers, and drones.

Consumer drone batteries exist in two forms. Almost all recent drones that are not toys use so-called smart batteries, which integrate charging, monitoring, and discharging electronics into each battery. Smart batteries (**FIGURE 1.4**) can report their state (and any detected problems), charge their multiple cells efficiently and safely, and discharge safely (slowly) if they are left alone for long periods of time. Smart batteries usually exist in cartridge form, and installing one is as easy as pushing it into a drone's battery bay.

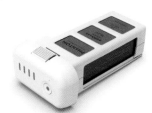

FIGURE 1.4 A smart battery for the DJI Phantom 3

Almost by definition, the other class of batteries can be called *dumb*, or normal, batteries. These batteries exist as just a bunch of connected battery cells. Many toy quadcopters and older consumer drones use dumb batteries, which require complex chargers to balance cells and are typically installed in drones by manually connecting wires (**FIGURE 1.5**).

FIGURE 1.5 A Turnigy Nano-tech LiPo battery made for the RC hobby

Normal batteries need to be treated carefully during charging and storage. These batteries do not have integrated charging electronics, and third-party chargers (**FIGURE 1.6**) must be used to charge and balance battery cells. Because LiPo batteries used in the RC hobby tend to have more than one cell, chargers need to carefully balance all the cells in a battery to prevent any one cell from being overcharged or overdischarged. Typically, chargers need to be configured to match battery specifications, and charging batteries using the wrong settings can be dangerous.

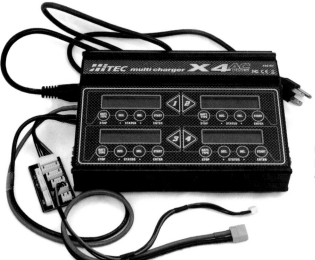

FIGURE 1.6 A Hitec battery charger made for the RC hobby

LiPo batteries also need to be stored carefully, typically at what is called *storage voltage*. A battery at storage voltage is partially charged and is in the battery's most stable state (batteries don't like to be at either end of their storage states). At storage voltage, a typical LiPo battery loses less than 1 percent of its capacity per month, which means that it can be stored for long periods of time without becoming damaged. Advanced battery chargers have a mode that can either charge or discharge batteries to storage voltage.

Advanced hobbyists often snicker at folks using higher-priced, smart batteries, and both DIY and high-end drones that are used in film and television production typically use normal batteries. But I have never seen someone go back to normal batteries after they have started using smart batteries. The convenience, safety, and state reporting ability of smart batteries are well worth the additional cost, especially if you are not willing to actively manage batteries as they cycle between use, transport, and storage.

Lithium batteries have high energy density, which makes them particularly well suited for use in consumer drones, but the energy density comes at a price. When something bad happens to a lithium battery, it can catch on fire or explode. Lithium fires burn really hot and don't react well to water, so they are difficult to extinguish.

A YouTube search for *phone battery fire* yields more than 2 million videos that show the lithium batteries in cell phones exploding or burning. In the United States, the Transportation Security Administration (TSA) regulates what kind of batteries, and how many of them, you can bring on an airplane.

The potential danger of a lithium-battery fire is one of the main reasons all serious drone manufacturers are moving to smart batteries. Smart batteries remove human error from the charging equation and can automatically put batteries in the safest state for long-term storage.

Despite increased safety from smart batteries, it is still a good idea to charge and store your batteries either in a "LiPo bag" (**FIGURE 1.7**), which can help to prevent fires from spreading, or in another suitable container. Cinder blocks are common building materials for battery storage and charging, as are old ammo cans. Note that if you use ammo cans for storage and charging, they should never be closed tightly unless you drill holes in them first. An ammo can that is closed tightly and doesn't have holes drilled in it can explode if a battery inside catches on fire.

FIGURE 1.7 A LiPo bag made for charging and storing lithium batteries

▶ 1S, 2S, 3S, WATT?

Determining battery capacity, maximum discharge rate, and maximum charge rate can be confusing, especially if you aren't using a smart battery and are trying to figure out charge settings to use.

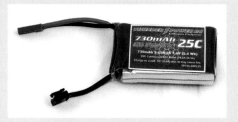

All batteries in the consumer drone space will typically have between two and six numbers written on them: V (volts), mAh (milliampere, or milliamp hours), Wh (watt hours), an S rating, and a C rating or two (**FIGURE 1.8**). A common misconception is that the milliamp-hour rating is a measure of energy, and I've heard people say things like, "Battery A is 5700 mAh, bat-

FIGURE 1.8 A LiPo battery made by Thunder Power RC shows ratings of 730 mAh (2S), 7.4 V, 25C continuous discharge, 50C burst discharge, and 5C max charging rate.

tery B is 4500 mAh, so battery A holds more energy." But energy is actually measured in watt hours, which is the amount of time (hours) the battery can expend power (watts). More watt hours equals more capacity. Luckily, adding voltage to the equation gives you all the information you need:

W (energy, watts) = V (voltage, volts) * A (current, amps)

At the same voltage, a given battery with a higher mAh (current-time) rating does hold more energy, but if the voltage changes, you have to use the previous equation to figure out which battery is bigger.

Batteries may also have an S rating or a C rating. For example, you might see a 3S battery rated at 30C. And some batteries might even have two or three C ratings.

The S number indicates the number of 3.7 V battery cells in series, so 2S is two 3.7 V cells in series and is a 7.4 V battery.

A C number indicates the maximum current output or input as a multiple of the current rating of the battery. So, a 25C battery rated at 0.73 Ah (730 mAh) can discharge at rate of 25 x 0.73 A = 18.25 amps of current. Discharge C rates are specified for continuous capability and/or burst capability, which is why you sometimes see two C rates specified for discharge. A C number can also be specified as a battery's maximum charge rate and is specified in the same units. This battery can be charged at 5C, which means that it can be charged at up to 5/0.73 A = 3.65 amps. All of the C calculations assume output and input at the battery's rated voltage.

If this discussion doesn't convince you that smart batteries are the future, I don't know what will!

Treated with respect, most LiPo batteries can be charged and used safely hundreds of times (depending on manufacturer). If your battery starts to puff up or act strangely, it's time to replace it. Be sure to recycle your old batteries responsibly!

Aerial Cameras and Gimbals

For the first time in history, anyone can put a camera into the air to take pictures from new and exciting perspectives. We have unlocked the vertical dimension for camera placement and movement. Land photography is currently dominated by camera phones and larger-sensor cameras such as digital single-lens reflex (DSLR) cameras and mirrorless cameras. In the air, however, we are still very limited in terms of cameras that are suitable for use on consumer drones (**FIGURE 1.9**).

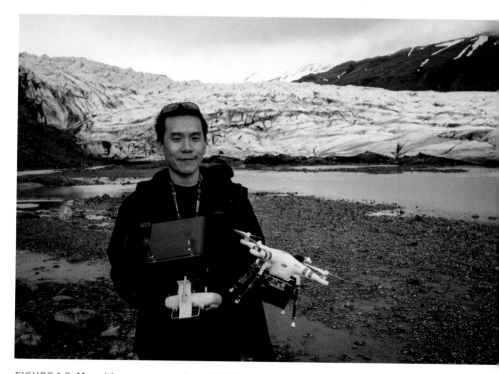

FIGURE 1.9 Me, with a camera-equipped DJI Phantom, in Iceland

Any camera can be strapped onto a drone and put into the air, but it's much better when a camera has the following three characteristics:

- Low weight
- Live video output
- Remote shutter control

Obviously, the heavier a consumer drone is, the shorter the flying time and less maneuverable it is. The lighter the camera, the better. A live video output (*live view*) allows an operator to see what the camera sees, in real time. Without live view, framing pleasing shots from a drone is almost impossible. Finally, a remote shutter release interface is desirable so an operator can decide when to take pictures instead of having a camera shoot all the time (video) or in intervalometer mode (stills), which yields a lot of extra media to go through at the end of every flight.

Professional cameras such as RED cameras and high-end SLRs are used in the air carried by heavy-lift octocopters, but the vast majority of aerial images and video are captured using either GoPros (and other action cameras) or drones that include integrated cameras.

What Is a Gimbal?

Almost all camera drones these days use gimbals to stabilize onboard cameras. The word *gimbal* is a generic term for a pivoted support that allows for object rotation around an axis, but in the drone world, gimbals are mounts that stabilize cameras in two or three axes using brushless motors—the same kind of motors that drones use to fly.

In fact, gimbals work similarly to the way drones work. On the camera mount is an inertial measurement unit (IMU) that tells a gimbal controller its orientation. The gimbal controller controls the gimbal motors and asks them to make the camera platform level again. This happens many hundreds of times per second, resulting in a camera platform that is incredibly stable, even when the drone itself is being tossed around by gusts of wind. A two-axis gimbal stabilizes roll (banking left and right) and pitch (panning up and down), and three-axis gimbals add yaw (turning left and right) stabilization. Trying to create unstable video from a good, three-axis gimbal (**FIGURE 1.10**) is almost impossible.

FIGURE 1.10 A DJI Zenmuse Z15 gimbal for Sony's a7s full-frame camera

Gimbals are made for cameras of all sizes, from GoPros to the largest professional cameras on the market. They are almost always required to capture beautiful video, which usually must be stable in order to be usable, but you might be able to get away with not using a gimbal if you are interested only in capturing aerial still images. Photographers can attach almost any camera to a quadcopter or other consumer drone and get decent still images, and all of the payload capacity a gimbal would have used can be shifted to the camera instead.

Big Sensors on Small Drones

When not using a gimbal, weight savings make it possible to fly something like a Ricoh GR camera on a consumer drone that fits into a backpack. The Ricoh GR (**FIGURE 1.11**) is the lightest camera that uses an APS-C-sized sensor (the same sensor size in most DSLRs) and is particularly suitable for aerial use because it features a port that allows for both live video out and remote shutter release (you can use a custom cable called the gentWIRE-videoUSB).

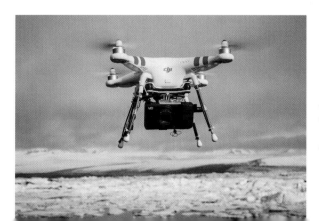

FIGURE 1.11
A Ricoh GR camera on a modified DJI Phantom 2 quadcopter

However, such an endeavor requires a DIY spirit. Aerial mounts for the Ricoh GR are not available for purchase, and video and shutter interfaces must be manually connected to suitable transmitters and receivers. If you are interested in how a Ricoh GR can be used in the air, go to http://skypixel.org/tagged/ricoh for more information.

Flying GoPros

GoPros and other action cameras are well suited for aerial imaging because they are small and lightweight. In 2013, the perfectly timed intersection of ready-to-fly quadcopters, GoPro cameras, and brushless gimbals gave birth to the consumer aerial imaging industry, and GoPros are still the stand-alone cameras most commonly used on consumer drones.

Aside from in niche, quadcopter racing circles, most GoPro cameras are flown in gimbals. Inexpensive, two-axis brushless gimbals for GoPro HERO-series cameras can be purchased for as little as $50, which is amazing, considering that the first polished, ready-to-fly GoPro gimbal, the DJI Zenmuse H3-2D, was $699 in mid-2013 when it was released.

Most aerial imagers who fly GoPros use DJI Phantom 2 quadcopters with Zenmuse H3-3D and H4-3D 3-axis gimbals (for the GoPro HERO3/3+ and HERO4 Black cameras, respectively), which are typically sold ready to fly for about $900, including both quadcopter and gimbal (**FIGURE 1.12**).

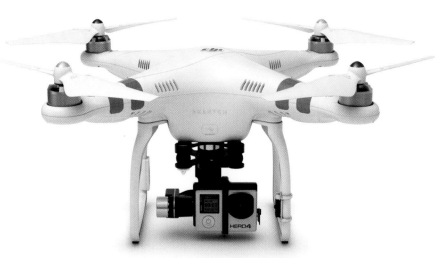

FIGURE 1.12 A DJI Phantom 2 with Zenmuse H4-3D gimbal and GoPro HERO4 Black

For the DIY crowd, three-axis gimbals for GoPros and larger cameras can be purchased from a variety of manufacturers starting from about $150 (**FIGURE 1.13**). Note that DIY gimbals need to be carefully calibrated and are designed for folks familiar with building quadcopters from scratch.

In my experience, the time required to tune DIY gimbals can be extremely frustrating, and I don't see them ever finding success with a mainstream audience. However, some image-makers have had great success with DIY gimbals, and some applications require customized or flexible gimbal solutions. If you do decide to go with a DIY gimbal, be prepared to spend a lot of time to make it work well.

FIGURE 1.13 An RCTimer ASP DIY brushless gimbal

Another complication with using GoPros and other stand-alone cameras is that users must come up with their own first-person view (FPV) video solutions. The RC hobby makes this fairly simple, selling kits that include an analog video transmitter, receiver, monitor, antennas, and mounting equipment, but installation still requires soldering and a bit of technical knowledge. This is usually enough to scare a lot of people away.

Integrated Aerial Cameras

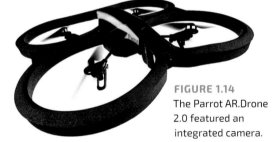

FIGURE 1.14
The Parrot AR.Drone 2.0 featured an integrated camera.

GoPros and action cams work well on consumer drones, but their main benefits are their small size and low weight, not their functionality, when mounted on drones. Most people who use GoPro cameras in the air use the "set-and-forget" method of camera control, starting recording at the beginning of the flight and letting the camera run until landing. This is because GoPro has only recently started to open its HERO bus interface to third-party integrators.

In 2010, Parrot released the AR.Drone (**FIGURE 1.14**), which was the first popular consumer drone with an integrated camera and both iOS and Android support.

The AR.Drone and its successors were marvels of ingenuity and technology, but it wasn't until 2014 that a consumer drone would be sold with a truly useful, integrated camera.

The DJI Phantom 2 Vision+ (**FIGURE 1.15**), announced in April 2014, was the first consumer drone to feature an integrated, gimbal-stabilized camera. The camera and gimbal module were considered to be small for a camera that was capable of shooting 12-megapixel (MP) stills (optionally saved as Adobe DNG raw files) and three-axis, stabilized 1080p HD video.

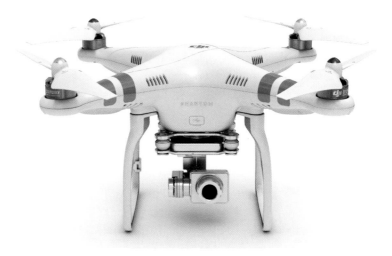

FIGURE 1.15 The DJI Phantom 2 Vision+, with integrated, gimbal-stabilized camera

The reason the Phantom 2 Vision+'s stabilized camera was so small was that it had been divided into two parts: stabilized and unstabilized. In an aerial camera, only the lens and sensor need to be mechanically stabilized by a gimbal; the rest of the camera can be somewhere else in the drone. This design leads to a smaller gimbal, which means less overall weight.

The Phantom 2 Vision+ also featured iOS and Android integration via Wi-Fi connectivity and a range extender, with a mobile app that included FPV video, full control over the camera, an integrated map, waypoint-driven ground station features, and more.

Suddenly, the capture of stabilized aerial video and 12 MP stills shot in raw were possible in a ready-to-fly solution. Many hobby photographers who wanted to get in the air chose the Phantom 2 Vision+ over quadcopters designed to be used with action cams simply because integration provided a better user experience.

The DJI Phantom 3, announced a year later in April 2015, improved on the Phantom 2 with an upgraded camera capable of recording video at 4K, and a rectilinear 94° lens. It also integrates Lightbridge, which means that it transmits a clean, HD 720p video signal to smartphones and tablets (**FIGURE 1.16**). Other new features include an indoor positioning system and a redesigned remote control with buttons and dials for camera control.

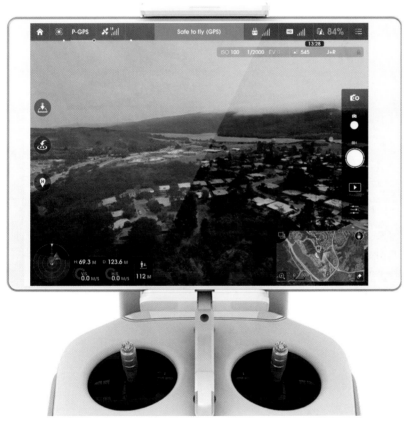

FIGURE 1.16 The DJI GO smartphone and tablet app functions as a remote piloting and camera interface for the Phantom 3.

The Phantom 3 and its prosumer predecessor, the DJI Inspire 1, were the first camera drones that truly felt like remote cameras. As someone who worked in the field as a professional photographer for more than ten years, I think of the Phantom 3 as being the first real flying camera. We are no longer flying drones that *carry* cameras. These drones actually *are* cameras, in terms of functionality.

DJI's push for integrated cameras has paid off, and DJI's drones account for an estimated 70 percent of the market. However, new breeds of camera drones like the 3DR Solo (**FIGURE 1.17**) tap into GoPro's HERO bus and can control GoPros remotely, pulling the popular action cams partially into the world of integrated aerial imaging solutions.

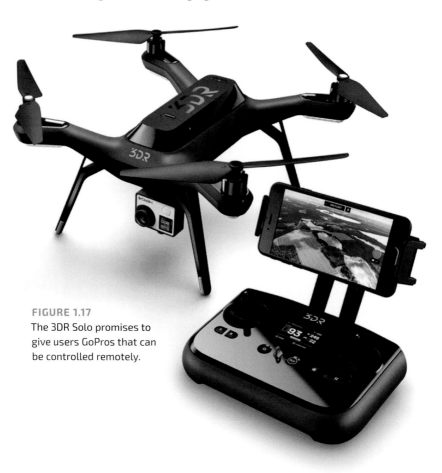

FIGURE 1.17
The 3DR Solo promises to give users GoPros that can be controlled remotely.

Dozens of Kickstarter campaigns advertise shiny new drones, many of which feature integrated cameras. In the first half of 2015, it became clear that integrated cameras are the future; the advantages offered through integration are simply too compelling to ignore.

Vibration Isolation

Once you get over the novelty of being able to place a camera anywhere in space, you will start to pay attention to image quality. In addition to encountering environmental factors that can cause a consumer drone to move and shake as it automatically stabilizes itself in the air, drones have propellers that spin at high speeds. Any imbalance in motors or propellers will introduce high-frequency vibrations, which can ruin both still photos and videos. High-frequency vibrations can be difficult to remove because they are usually not visible to the naked eye during flight. It is only upon closer inspection of captured media that the effects become obvious.

Jello

Never did I think that I would be able to title a section of a book "Jello," but here we are. *Jello* is a common term for the effect that vibrations have on videos produced by digital cameras that use rolling shutters (also known as *rolling shutter artifacts*). Cameras that use rolling shutters (found in almost all small cameras) capture pictures by scanning across the scene, usually vertically (as opposed to global shutters, which capture the entire scene at the same moment). This means that one horizontal line in your picture will have been captured at a different time than the line above it even if you are shooting at high shutter speeds. If you have ever pointed your camera phone out of the window of a moving car and noticed that vertical elements such as telephone poles become slanted, you have seen the effects of rolling shutter.

Jello refers to a visible artifact in video that happens when high-frequency vibrations and rolling shutters collide. The camera sensor is shaking because of the vibrations, and the end effect is that lines in the videos look like they are dancing back and forth quickly, like jello might behave if you were to grab the plate and shake it. Still images affected by jello have horizontal "shearing" and can be unusable.

Balancing Propellers

Before gimbals became common, balancing propellers was a standard part of getting a camera into the air. Because motors and props—a drone's propulsion system—are typically the only moving part of a consumer drone (aside from gimbal motors), removing vibrations from propulsion effectively removes vibrations from the entire drone. Balancing propellers is typically done by suspending a propeller from its center and allowing it to spin freely (**FIGURE 1.18**). If one side is heavier, the prop will rotate to expose the imbalance, and users either sand material off the heavy side or apply tape to the light side to balance the propeller. Balance on the other axis, the narrow dimension across each prop blade, can also be achieved using this method.

Brand-name propellers usually come fairly well balanced, and newer consumer drones use all-in-one propellers that include integrated screw threads. As a result, I rarely see anyone balance props anymore. In practice, if a prop becomes damaged and off-balance, most people simply swap it out with a new one.

Vibration Dampeners

In the world of active gimbal stabilization, the use of vibration dampeners (**FIGURE 1.19**) has become the primary form of vibration isolation. Virtually every gimbal on the market includes vibration dampeners, usually in the form of soft, rubber balls that serve as the primary supports for hanging a gimbal off a drone. Even if gimbals are not used (for example, in aerial vehicles that are designed for still photography only), vibration dampeners are necessary to filter vibrations out of the system.

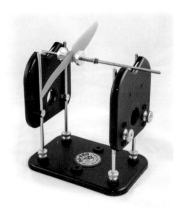

FIGURE 1.18 The DuBro Tru-Spin Propeller Balancer

FIGURE 1.19 Rubber vibration dampers in a custom mount for a compact camera

Custom vibration dampeners are commonly sold as RC hobby parts and can be found by searching for *anti-vibration mount* or *camera damping plate*.

Most consumer drones, however, will use gimbals that include vibration isolation in the gimbal's mount (**FIGURE 1.20**). In some of these camera systems, vibration isolation is something that most users never need to think about. Video, out of the box, is artifact-free.

Even though many consumer drones ship with vibration isolation systems preconfigured, it's still important to understand why the little rubber dampers are there. If you damage a propeller or upset a drone's balance some other way, you may be introducing vibrations in the system that are too strong for the vibration dampers to handle. If this happens, it may be necessary to replace propellers or tune dampening systems until video becomes stable again.

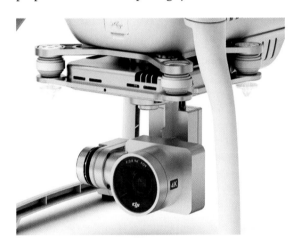

FIGURE 1.20 Rubber vibration dampers used in the stock DJI Phantom 3 camera and gimbal mount

First-Person View

First-person view is a remote video signal that allows a pilot to see what a drone's camera sees, in real time. FPV is considered to be absolutely necessary for aerial photography and videography. Without good FPV, photographers are shooting blindly, and deliberate composition is nearly impossible.

An FPV video signal is typically viewed using a field monitor or FPV goggles (**FIGURE 1.21**), which are designed specifically for use by RC hobbyists. Goggles are typically considered to give a more immersive experience but at the cost of situational awareness.

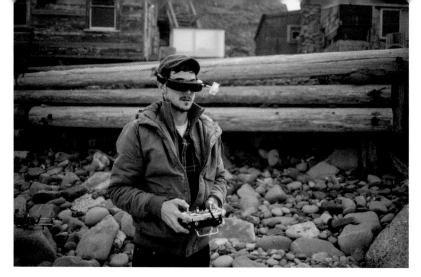

FIGURE 1.21 The well-known drone racing pilot CHARPU flies using FPV goggles.

Analog FPV

In the early days of consumer drones, FPV was accomplished by using a camera's video output in conjunction with dedicated analog video transmitters and receivers (**FIGURE 1.22**). A typical analog FPV system includes a transmitter, receiver, antennas, field monitor, batteries, and cables suitable for use with a chosen camera.

Dedicated FPV systems are changing slowly and are still cemented in the analog world (**FIGURE 1.23**). Some field monitors marketed specifically to RC hobbyists include integrated receivers compatible with the standard FPV radio channels, which are in the unregulated 5.8 GHz band.

"Diversity" receivers include two receivers and two antennas and use the better of the two signals. This allows for two antennas optimized for different purposes to be used at the same time (for example, an omnidirectional antenna and directional antenna).

Analog FPV transmitters also need to be incorporated into your consumer drone and will work only if your drone or camera outputs an analog video signal and power. In typical hobby quadcopters, users are responsible for sourcing and connecting cables that support both their chosen camera and transmitter. If power isn't readily available from the main drone, a dedicated LiPo battery can be used just to power the FPV transmitter. For mounting, users often attach transmitters and dedicated batteries to the consumer drone via Velcro.

In anticipation of third-party FPV modifications, DJI Phantom 2 included a four-wire cable that carried power and analog video routed from the GoPro gimbal.

Common brands in the analog FPV space are ImmersionRC, Fatshark, and Boscam.

FIGURE 1.22 Me flying using an analog FPV system in Tonga
Photo courtesy Julian Cohen.

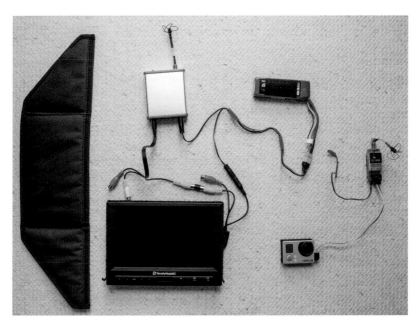

FIGURE 1.23 An analog FPV system, including camera, transmitter, receiver, and monitor

Digital/High-Definition FPV

Strangely, the global shift of nearly every analog system to digital has not yet hit stand-alone consumer FPV systems. The vast majority of stand-alone FPV transmitters and receivers sold today are analog systems. Exceptions to the rule are DJI's Lightbridge 2 wireless HD transmission system (**FIGURE 1.24**), which retails for $1,400, and zero-latency wireless HD systems from Paralinx and Connex, which retail for $870 and $1,600, respectively. All three work using a camera's digital HDMI output. The zero-latency systems provide lossless HD video transmission but at the cost of requiring bulky, directional antennas.

Stand-alone, high-definition video transmission is still expensive, and only a few solutions are currently available. But as you'll see in the next section, integrated high-quality HD FPV has dropped in price so aggressively over the past year that it is sure to replace analog FPV very quickly.

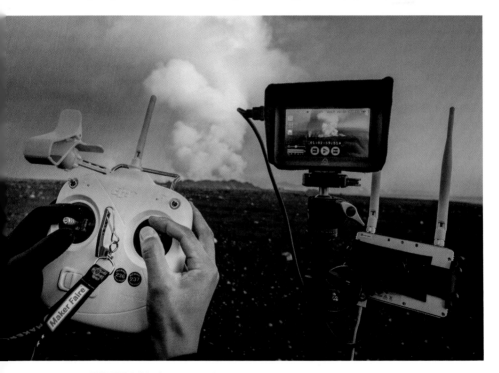

FIGURE 1.24 I'm using DJI's Lightbridge HD wireless video transmission system during a flight over a volcano in Iceland. Photo courtesy Ragnar Sigurdsson.

Integrated FPV

In previous sections, I discussed RTF consumer drones and integrated, aerial cameras. Not surprisingly, integrated solutions also include FPV support. Inexpensive toys that feature FPV usually have only rudimentary FPV that is fun but not useful for actual composition (their cameras also aren't capable of capturing high-quality footage). But higher-quality consumer drones like the DJI Phantom 3, Parrot Bebop, and 3DR Solo feature higher-quality FPV signals good enough to be useful for photographic composition (**FIGURE 1.25**).

I mentioned earlier that aggressive price drops in HD FPV will cause all FPV systems to go digital and HD. The DJI Phantom 3 Advanced, which integrates Lightbridge, retails at $999 and is a great example; stand-alone Lightbridge costs $1,400.

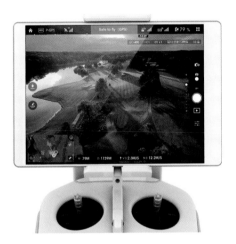
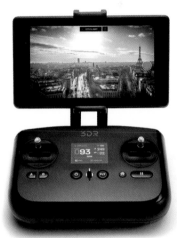

FIGURE 1.25 Remote controllers from DJI, 3DR, and Parrot show integrated FPV solutions.

Integrated FPV "just works" and is designed to be a feature that users don't have to think about. Implemented properly, integrated FPV becomes one of the main features that make users think of camera drones as cameras that just happen to be out of reach, instead of complicated flying devices with cameras attached to them. The only downside to integrated FPV is that there tends to be a bit more latency than in both analog FPV systems and (obviously) so-called zero-latency digital systems. Typically, the latency isn't bad enough to make FPV-based flight difficult, but if you're primarily using FPV for racing or for capturing stills of events that include fast action, an analog or zero-latency system will likely work better.

Ground Station/ Mission Planning

Most $1,000+ consumer drones can be flown autonomously using collections of waypoints known as *missions*. Mission planning is typically done using ground station software on tablets or computers (**FIGURE 1.26**). At the moment, ground station software for consumers is fairly simple. Users tap or click desired waypoints one after another to create a flight plan or, in some cases, draw a desired flight path on a map, with waypoints being automatically generated. All autopilots from 3DR and some, from DJI, support flying using waypoint-driven autonomous missions.

Ground station apps were the first to indicate that drones might eventually simply become hardware infrastructure, with powerful software apps providing the majority of the functionality and added value. Thinking this way, it's easy to imagine that the mobile apps that come with your integrated quadcopter are simply navigation and camera apps. Ground station apps were originally used for autonomous mapping using drones, but now we're seeing expansion to more varied use cases. For example, the 3DR Solo's bundled mobile app includes ground station features specifically designed for cinematographers (for example, orbit and cable cam). Ground station and other apps will continue to become more and more fully featured, which will add considerable value to any consumer drone that supports such software.

Ground station apps can be powerful, but it's important to note that current consumer drones do not include sense-and-avoid technology. I know a lot of people who have lost their quadcopters to stationary objects because they

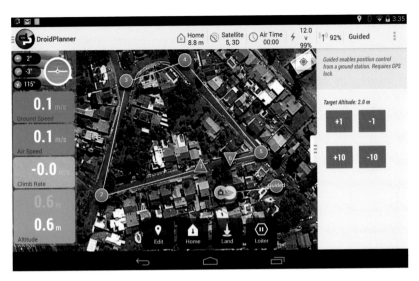

FIGURE 1.26 DroidPlanner is a free ground station app for Android that supports autopilots from 3DR.

were playing around with the ground station app and didn't pay attention to obstacles. Your quadcopter will just as happily fly into a mountain as it will over it, so take special care when planning your missions. Rudimentary sense-and-avoid capability will likely make its way into consumer drones sometime in 2015, and later, drones will start to be able to generate and use real-time maps of their immediate surroundings. When sense-and-avoid becomes mature, real—and safe—autonomous flights can begin.

Stills vs. Video

The same consumer drones are typically used for taking aerial stills and video. Both require robust and high-quality FPV for composition, and both require vibration isolation to prevent rolling-shutter artifacts from compromising captured imagery.

By default, you should consider getting a consumer drone that can successfully capture both stills and video, which pretty much means that you will want either a drone that comes with a three-axis gimbal or one that uses advanced digital image stabilization. Digital image stabilization is suitable for flights in calm conditions, but as soon as wind becomes gusty, the more robust mechanical stabilization afforded by gimbals becomes vastly superior.

Gimbal-based camera drones have also proven their stability through millions of shared videos and still photos, whereas drones with digital image stabilization are, as of this writing, still producing imagery poor in quality.

If you're going to shoot only stills from your camera drone and absolutely need the best in image quality, you can elect to forgo a gimbal and put all that saved weight into a better camera to lift. In the "Big Sensors on Small Drones" section, I mentioned that a camera like the Ricoh GR can be lifted by a drone like the DJI Phantom if a gimbal is not used. The goal is to find the lightest, highest-quality cameras that can be fired remotely and have video out.

Removing a gimbal can result in an aerial Micro Four Thirds or APS-C sensor on a consumer drone that can fit in a backpack, but vibration isolation is something that cannot be left out. Simply bolting a camera to a consumer drone via its tripod socket is tempting, but high-frequency vibrations will force shutter speeds of faster than 1/1000 of a second to capture usable images. Shutter speeds of 1/1000 of a second are easy to accomplish during the day, but it's harder to shoot that fast under cloud cover and when the sun starts to get low in the sky. Using a vibration dampener (with rubber balls or wire isolation), you can achieve usable shutter speeds of around 1/200 of a second, which will let you shoot in more varied lighting conditions.

Fighting to get shutter speeds slower than 1/200 of a second seems silly when you start considering what is possible using gimbal-stabilized cameras. Using the DJI Inspire 1 or Phantom 3, which have what are considered to be best-in-class, integrated (and gimbal-stabilized) cameras, it's common to see pictures exposed for *many seconds* that are still sharp. I have seen eight-second exposures that are sharp, which puts these quadcopters firmly in tripod territory, in terms of stability. Only, these sharp, long exposures are taken *while flying*.

At the moment, getting a camera with an APS-C-sized sensor on a gimbal still requires a heavy-lift hexacopter or octocopter. But it's only a matter of time before we see more large-sensor cameras integrated into consumer drones. The Inspire 1 features a modular, hot-swappable camera interface and has options for both small-sensor and Micro Four Thirds-sensor cameras.

Recommendations: What to Buy

The best consumer drone for aerial imaging is always going to be one you can keep in the air comfortably, reliably, and safely. If you can't fly with confidence, it doesn't matter what kind of camera is up in the air. In this section, please keep in mind that I am a former DJI employee, which may bias my opinions.

If your goal is to capture both stills and video from the air and you don't need to do complex camera movements that require a dedicated camera operator, I recommend buying the DJI Phantom 3 Professional. The Phantom 3 Professional features an integrated, three-axis gimbal-stabilized camera with a 94°, rectilinear lens (similar to a 20mm lens on a full-frame camera). It shoots 4K video and 12 MP stills (supporting the Adobe DNG raw format). It features integrated, high-definition, 720p FPV; has sensors for positioning without a GPS signal (at low altitudes); and supports the DJI GO camera app for both iOS and Android. It flies for up to 23 minutes at a time and fits in a backpack. Best of all, at the time of this writing, the Phantom 3 Professional retails for $1,259. A Phantom 3 Advanced is also available, which has an HD 1080/60p camera instead of a 4K camera and costs $999, arguably the best feature/price combination on the market.

Hobbyists used to complain about the DJI Phantom, claiming that they could build something better for a fraction of the price, but I don't hear anyone saying that about the Phantom 3. It's simply not currently possible to build a quadcopter that matches the Phantom 3 in size and features, for any price.

The 3DR Solo is another option. It is a "smart" drone that can carry a GoPro camera on an optional gimbal. It features integration with smart devices and is the first drone that can control a GoPro through its HERO Bus. It can tell the GoPro to start and stop recording, shoot still images, and change its settings. 3DR has also been focusing on "smart" moves, and the Solo comes bundled with software-driven features that assist cinematographers and photographers by removing them from the flight equation. Moves like "orbit," during which the Solo flies around a subject while always facing it, make it possible to automatically capture videos and stills that would have required advanced piloting skills to manually accomplish. The Solo is priced higher than the Phantom 3 Professional and costs $1,000 without camera or gimbal.

Serious aerial imagers will want to look at the $2,899 DJI Inspire 1, a mid-size quadcopter that features a modular camera mount on a gimbal that can rotate a full 360°. The gimbal can operate independently of drone movement, which means that you can lock the camera facing a specific direction, and no amount of drone movement will be visible in the frame. The stability of gimbals that can rotate 360° is uncanny and can seem like sorcery! The DJI Inspire 1 ships with a camera whose specifications match the camera found on the DJI Phantom 3 (4K video, 12 MP stills). However, the camera mount is modular and the Inspire 1 is overpowered for the weight of its stock camera, the small-sensor Zenmuse X3. In September 2015, DJI announced the Zenmuse X5, a Micro Four Thirds aerial camera that can be flown by the Inspire 1.

Photographers looking to build a drone that can carry even higher-quality cameras will need to look at customized solutions. This means either calling one of the many drone integrators out there that build and support hexacopters and octocopters made to hold high-end cameras or building one from scratch (and thereby becoming an RC hobbyist). DJI products are also popular with RC hobbyists, and its popular Spreading Wings series (S900 and S1000+) are frequently found on TV and film sets.

Building your own drone can be a lot of fun, and if you are technically oriented, it might not even be that difficult to do. However, customized rigs definitely take more time to master and maintain than do products like the DJI Phantom and the 3DR Solo, and you can't just order a replacement for next-day delivery if it stops working during a shoot.

FIGURE 1.27 The flagship DJI Inspire 1 PRO includes the Zenmuse X5 aerial Micro Four Thirds camera with interchangeable lenses.

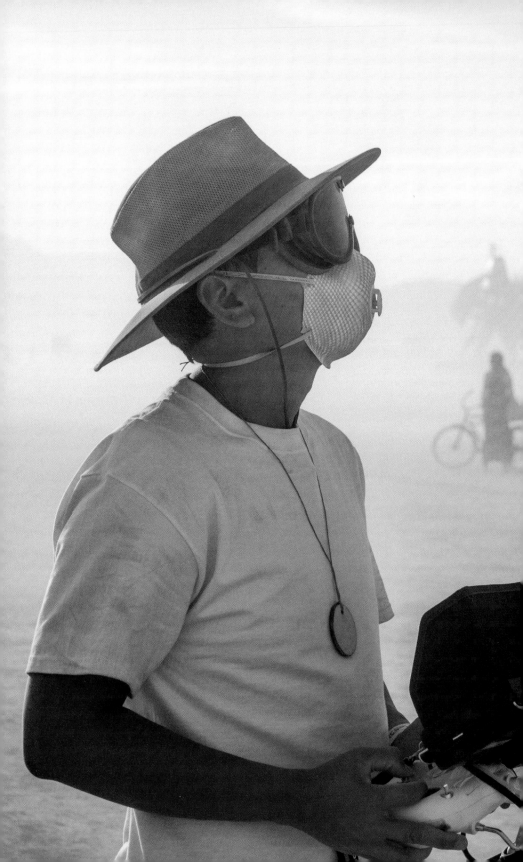

CHAPTER 2

Learning to Fly

During your journey to becoming an aerial photographer, you will quickly discover that piloting skill is by far the most important factor in success. Quadcopters, gimbals, and cameras will change over time, but the ability to operate a camera drone safely and skillfully will always be important, and it will stay with you as you upgrade your equipment, even as flight controllers improve and start to incorporate automatic flight features, even as flight controllers improve and start to incorporate automatic flight features.

Advertisements for many new drones claim that they are so easy to use that anyone can fly them, and while this is essentially true, there is a big difference between nudging a drone into place for a shot and executing a skillful capture that will leave a viewer gasping in awe. Your goal should be to train yourself so that the technical piloting skills required to fly and capture stunning aerial imagery fade away into the background, allowing you to be creative without the limitations imposed by lack of skill. Executing a particular shot should feel like instinct. If you find yourself struggling to move around a drone in the air, you need more practice.

Even if you don't have the time to become a skilled pilot, putting a camera drone into the air can still be both fun and productive. However, the skills developed during hours of practice will not only increase the range and quality of the images you can capture but also enable you to get out of challenging or unanticipated situations that might result in a crash. Learning to fly is important for safety. The same skills that allow you to manually pilot an advanced maneuver could also be used to manually pilot your drone home in the case of malfunction. Also, drones that can fly autonomously can still crash into things, and knowing how to take control can help you to avoid those situations.

Luckily, learning to fly is often indistinguishable from having fun, so go for it!

Choosing a Trainer Drone

A camera drone with a decent camera costs hundreds or thousands of dollars, and the last thing you want is to put one up in the air for the first time and lose it because of inexperienced piloting. Fortunately, most quadcopters and other small multicopters fly the same way, and even a $20 toy can be used as a trainer drone for practicing piloting skills. Most inexpensive, toy quadcopters are autostabilizing and use the same style of two-stick remote controllers that larger camera drones use. Toy quadcopters are great for learning to fly not only because they are inexpensive but also because you can fly them in the comfort of your own home, where there is no wind. Small quadcopters are also generally difficult to damage because there isn't enough mass for crashes to actually break anything (or hurt anyone).

Strangely, small quadcopters can be more difficult to fly than larger drones because most small quads do not use GPS to hold position. Small quads typically autostabilize, meaning that they try to remain level during flight, but they will not hold position automatically and are easily blown around by winds and drafts, including air that is moving because of the spinning of their own propellers! However, because they are inexpensive and durable, you can take more risks with them during flights. If you aren't crashing a toy drone, you aren't pushing yourself enough!

There are many manufacturers of toy quadcopters, and trying to figure out which ones to purchase can be overwhelming. I tend to gravitate toward small quadcopters that fly the most like their larger siblings. All quadcopters are tuned differently, which affects flight characteristics. You may think that

aggressive autostabilizing might be a good thing, but I find that most toy quads stabilize themselves too quickly, which can result in a feeling of less control. Larger drones are usually tuned to move and stabilize smoothly, which is ideal for smooth video capture. Luckily, some small quadcopters fly very well and are perfect for practicing.

My favorite trainer quad is the $90 Blade Nano QX (**FIGURE 2.1**), which flies more like larger camera drones than any other small quadcopter I've tested.

The Nano QX weighs just over half an ounce; it's only a few inches in diameter, and it features a frame with integrated prop guards, which makes this quad very crash-resistant. Although $90 is a bit expensive for a quadcopter that is ostensibly in the "toy" category, the Nano QX is a great learning quad because it can grow with you as you improve your skills.

This quadcopter features two different modes: Stability and Agility. In Stability mode, the Nano QX autostabilizes and returns to a hover when you center the sticks, just like the DJI Phantom and other camera drones do. In Agility mode, the Nano QX no longer returns to a hover. Instead, when sticks are centered, the quad maintains its current orientation in the air, so if it is banked to the left, for example, it will continue to move in that direction. This mode is also called Manual mode and Rate mode by advanced hobbyists and is the mode that most mini-quad racers prefer to use because pilots can fly aggressively and aerobatically, doing flips in the air. Flying in Agility mode is notoriously difficult and is not required to become successful in aerial imaging; most camera drones fly in modes similar to Stability mode.

Another popular trainer quad is the Hubsan X4. The version shown in **FIGURE 2.2** sells for $40, but the X4 is also available with an integrated camera for $45.

FIGURE 2.1 The Blade Nano QX mini quadcopter

FIGURE 2.2 The Hubsan X4 mini quadcopter

The Hubsan X4 is one of the most popular toy quadcopters on the market because it flies well and is inexpensive.

When deciding which trainer drone to get, you might want to take into account the cost of spare parts. All of these inexpensive quadcopters use brushed motors, which are less durable than the brushless motors used in higher-end quads. Brushed motors do not last long and need to be replaced regularly. In general, spare parts for Hubsans are affordable, whereas spare parts for Blades tend to be more expensive.

The cheapest trainer quad to consider is the $20 Cheerson CX-10 (**FIGURE 2.3**). At 1.14" in diameter, the CX-10 is tiny; it's so small that it can be flown even in the smallest of environments.

FIGURE 2.3
The Cheerson CX-10 flies well despite its low cost and small size.

Inexpensive toy quadcopters like the ones I've mentioned here are suitable for learning the basics of drone flight, and mastering any one of them will prepare you well for flying larger camera drones. In fact, because toy drones do not typically have GPS receivers, practicing with them can prepare you better than learning to fly using drones that support GPS; the lack of position hold makes you actively pilot all the time and prepares you for situations in which you cannot for some reason use a GPS signal.

However, once you upgrade to a larger camera drone, it will still be important to get plenty of time in the air using your chosen drone. Small trainers work well only inside at short range, and practicing outside in less than ideal conditions or at long range is also important for successful aerial imaging. While there are large toy drones that are also inexpensive, I usually recommend that people buy a proper camera drone when they are ready (when they are no longer crashing while doing basic maneuvers using a trainer drone).

The transition from indoor to outdoor flight usually means that there is suddenly something interesting to capture from the air, and most people I know

have discarded larger trainers quickly after realizing that they actually want to start taking pictures. Some toy drones have cameras on them; they might fly perfectly well, but it is pretty much a guarantee that images from their integrated cameras will be useful only for novelty purposes.

Finding Good Flying Locations

Good flying locations (**FIGURE 2.4**) are necessary for successful aerial photography and videography. If you don't go to good places to fly, you will have nowhere to practice and nothing to photograph.

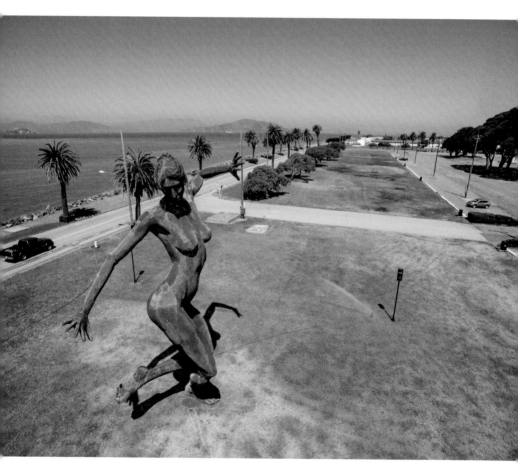

FIGURE 2.4 Bliss Dance statue at Treasure Island, San Francisco

When using small trainer drones, flying inside is perfectly fine; obviously, a large room with plenty of vertical space for flying is ideal, but if you can master flying a toy quadcopter in a small house, you'll be ready for almost anything. If you are totally new to the hobby and have pets, you might want to do an interaction test between your pets and a quadcopter before you commit to spending money. One of my friends has a dog that makes flying a quadcopter around her impossible—the dog absolutely hates electronics and goes crazy when he hears the beeps of a quadcopter powering on!

Before you go out into the field to try to be productive in the air photographically, you'll want to identify a regular flying location that you can use for practice and testing. The location should be large and open and should not be crowded with people. If your backyard is large enough, you're in luck, but if it isn't, you'll have to venture out to look for suitable locations. If you're looking to fly where other people fly, here are some good online resources where you can look for flying fields in your area:

- **Academy of Model Aeronautics (AMA):** www.modelaircraft.org
- **RCGroups.com's Flying Field Directory:** www.rcgroups.com/places/3-rc-flying-fields
- **Google:** Search for *RC flying fields*

Many organized flying fields (**FIGURE 2.5**) are bound by organization rules and might require membership for access. Some explicitly do not allow helicopters or multirotors, and it can be hard to find information unless you show up for a visit. Most people I know who are into multirotors and camera drones find local flying fields that are informal or not sponsored by an official organization. Both formal and informal flying fields are easy to find if you ask around in online community forums or at your local hobby store.

Personally, I prefer informal flying locations that are relatively undiscovered, like obscure parks that are not frequented by many people. To find these locations, use Google or Apple Maps in Satellite view to find large, open areas near you. Often, you'll find a suitable location that isn't very far away, but you will need to get out to do location scouting because it isn't always obvious whether a place is good for flying until you see it in person.

If the open areas are on private land, you might consider (politely and graciously) contacting the owners and asking whether they would be interested in aerial images in exchange for permission to fly. These kinds of relationships can be great, especially once trust is established, because you can secure a regular place to fly that isn't crowded (and give back to the owner by showing them how drones work and giving them aerial images of their property).

FIGURE 2.5 RC hobbyists meet up for a Flite Test "fly-in" event at a park in the San Francisco Bay Area.

At the moment, there is somewhat of a divide between longtime model aeronautics hobbyists and aerial imagers. Model aeronautics hobbyists tend to have building and modeling as a goal, whereas aerial imagers tend to view camera drones as cameras that can be positioned arbitrarily in space. If you happen to intersect with hobbyists, especially in their territory, be friendly, ask for permission to fly, and play by their rules (or go somewhere else).

The regulatory environment for flying model aircraft is changing quickly, especially here in the United States, where policy lags behind Europe and other places. It is your responsibility to be sure that you are flying both safely and legally. Information on what is and isn't allowed around the world can be difficult to find, and at the moment, web and community forum searches are still the best way to find detailed information about regulations. At a minimum, you should check AirMap (http://airmap.io), or download its iOS app, to make sure you aren't planning to fly in a no-fly zone. See Chapter 6 for more about consumer drone policy and regulation.

Once you start flying regularly, you'll start to meet other people who are interested in taking pictures from the air. Everyone has a few favorite locations,

and it's often more fun to fly in pairs or small groups. Before you know it, you'll have a great list of regular places to fly.

Practice fields are a must for beginners, but once you're comfortable flying, you can go capture beauty from the air. The vast majority of pictures and video I see shared on the Web have no subjects. I guarantee you that no one is going to want to see pictures of your local park or your backyard, unless your backyard is really special!

Creating a Flight Checklist

In manned aviation, going through a comprehensive checklist (**FIGURE 2.6**) is required before taking off and upon landing. Flying small drones doesn't yet require a checklist, but it's a good idea to get into the habit of going through one before and after each flight. You can see a larger version of the sample checklist in Appendix A.

PREFLIGHT

Environment Safety Check:
- ☐ Area clear of buildings and people; no airports or sensitive areas nearby

Physical Inspection
- ☐ No cracks
- ☐ No loose or damaged screws or fasteners
- ☐ No loose connections or damaged wiring
- ☐ Propellers tight and/or secured, and not damaged

Control Inspection and Calibration
- ☐ All batteries charged and securely attached
- ☐ Remote controller switches and controls in correct positions
- ☐ Power on remote controller
- ☐ Power on drone and camera/all components
- ☐ Calibrate compass, if necessary
- ☐ Wait for GPS lock
- ☐ Check LEDs and/or integrated apps for warning indicators

Takeoff
- ☐ Put drone on a level, safe platform away from people
- ☐ Start recording, if you are using a stand-alone camera

Landing
- ☐ Clear the landing area of people
- ☐ Trigger auto-land or land manually

Post-Flight
- ☐ Stop recording video before powering drone off
- ☐ Power off drone, then turn off remote controller
- ☐ Log your flight

FIGURE 2.6

Your preflight checklist for aerial photography and video. For a closer look, see Appendix A.

ENVIRONMENT SAFETY CHECK

The first thing to do before a flight is to make sure you are in a suitable location. There should be no airports or sensitive areas nearby, and the takeoff area should be clear of buildings and people. If you don't know whether there are airports or sensitive areas nearby, use an app like AirMap to check.

PHYSICAL INSPECTION

Drones are complicated pieces of machinery, and the physical and electrical stresses imposed upon the airframe and other components during flight are significant. A visual inspection establishes that there aren't any obvious compromises to the structure or electrical system. At a minimum, you should check for the following:

- No cracks
- No loose or damaged screws or fasteners
- No loose connections or damaged wiring
- Propellers tight and/or secured, and not damaged
- All batteries charged and securely attached

Note that most multirotor drones will fly even when propellers are damaged. Some of them might even fly so well that you can't tell that something is wrong. However, a damaged propeller is unbalanced and creates vibrations that travel through the airframe, which might show up in your videos and also cause undue stress to other components in the system. Propellers are inexpensive, and flying with damaged props is not worth the risk.

Nonintegrated camera drones tend to need more than one charged battery to operate properly—a battery for the drone itself, one for the camera, and possibly one for the FPV transmitter. Integrated drones usually just require one.

Ideally, your camera drone uses a smart battery; smart batteries typically have battery capacity indicators on them, so it's easy to check to see whether they are charged. Normal batteries require the use of a LiPo battery voltage checker, which can be purchased for just a few dollars (and up). LiPo voltage checkers read voltage from all the cells in a LiPo battery using a battery's balance connector. Typically, each cell will be around 4.2 volts when the battery is full. If any of the cells do not match the others, remove the battery from use until you can condition it using a battery charger that supports battery conditioning.

CONTROL INSPECTION AND CALIBRATION

Inspecting and calibrating the control systems of a camera drone are the most complicated steps in completing your preflight checklist because some of the systems you need to check are not necessarily visible to the eye. Luckily, most camera drones now incorporate smart device apps that report the status of such systems, and many will proactively warn you if something is off.

When inspecting and calibrating your drone's control systems, always do the following:

- Ensure that remote controller switches and controls are in correct positions.
- Power on the remote controller.
- Power on the drone and camera, as well as all components.
- Calibrate the compass, if necessary.
- Wait for GPS lock.
- Check the LEDs and integrated apps for warning indicators.

Integrated remote controllers from companies such as DJI and 3DR have default switch settings that need to be verified in user manuals. Traditionally, remote controllers are configured by their owners, so correct positions for a flight can vary wildly. However, most experienced hobbyists configure their remote controllers so the startup/default position of all switches is up or back (toward the top/rear of the controller). Configured this way, you can see in a glance that everything is set correctly.

Powering on a drone isn't always straightforward. In the traditional RC hobby, radio transmitters and receivers are designed to require that the transmitter (part of the remote controller) is powered on before the receiver (part of the drone). Doing this ensures that a drone or other moving device is never powered on before a control signal is in place. However, DJI drones don't care which of the two are powered on first, and some toy quadcopters like the Cheerson CX-10 mentioned earlier in this chapter require that the quadcopter is powered on first. Always check the user manual to see what your system requires, if anything, and be sure that all parts of your drone are powered on. In some systems, the drone and remote controller are the only components. But some systems come with other components that also need to be powered on (and charged) such as long-range Wi-Fi routers, FPV transmitters, receivers and monitors, and cameras. Integrated drones tend to have fewer parts to power on.

Drones that include GPS also include a magnetometer (commonly known as a *compass*). Compass calibration (**FIGURE 2.7**) is necessary to ensure that your drone's flight controller knows where true north is. If the compass is not calibrated, it's more difficult for the flight controller to navigate properly when in GPS mode. Most compass calibrations involve a sort of "dance" in which the drone must be rotated a full 360° in various axes. For example, DJI products require a full horizontal rotation, followed by flipping the drone nose down and rotating 360° again. The 3DR Solo requires that a user rotate the drone in all axes, with an onscreen interface indicating when calibration is finished.

FIGURE 2.7 Compass calibration instructions in the DJI Phantom 3 manual show a required 360° turn in two axes.

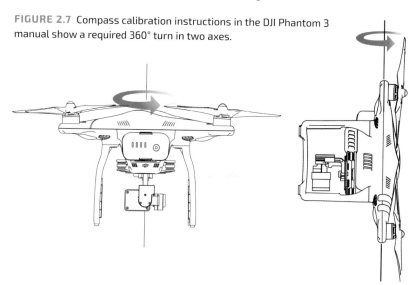

When flying drones outside, most users prefer to fly in a mode that uses GPS for position hold. The name of the mode varies by manufacturer (such as P-GPS for DJI Phantom 3 and FLY for 3DR Solo). GPS lock requires that the GPS receiver lock onto a certain number of satellites before its position becomes accurate enough for use. The more satellites locked, the more robust the information. Each manufacturer has a different specification for the number of satellites required for a good GPS lock, and both DJI and 3DR products feature modes in which takeoff is not allowed until a good lock has been achieved (**FIGURE 2.8**).

FIGURE 2.8 GPS mode and status indicators show how many satellites are locked and whether it is safe to fly (DJI GO app).

Flying without a GPS lock is certainly possible, and competent pilots sometimes prefer flying with GPS disabled. Without GPS, position hold is usually not possible (or desirable), and the drone will drift with wind and momentum. If you are a beginner, always try to fly in GPS mode.

TAKE OFF

After environmental, physical, and control inspections, you're ready to take off and verify that your drone is responding well during its first moments in the air.

To take off, do the following:

- Put the drone on a level, safe platform away from people.

- Start recording, if you are using a stand-alone camera.

- Take off and hover for 20–30 seconds at 6–10 feet.

- Verify that the drone is stable and responsive.

If you aren't using an integrated drone, you're probably using a stand-alone camera like a GoPro. Not many camera drones that carry GoPros have the ability to actually control a GoPro, so starting video capture or intervalometer-based stills shooting is often necessary before you take off. If you don't make this part of your standard routine, you might be surprised by how many times you forget this step! Integrated drones typically have full control over the camera, allowing you to take pictures and start/stop video recording at will.

Making sure your drone "feels right" at the beginning of each flight is a good way to catch problems before your drone flies to a location that might make retrieval difficult if something goes wrong.

LANDING

To land, navigate your drone back to your landing area (either manually or autonomously). Clear the landing area of people and then land manually or use your drone's auto-land feature, if it has one.

If you use a drone's auto-land or return-to-home feature, be sure you know how to override autonomous flight. GPS-based drones typically find their way home successfully (assuming there aren't obstacles in the way) but can potentially try to land as far as 10 feet away from the original launch location. If you see your drone coming down in a way that might be dangerous, you will need to know how to override the automatic landing and bring it in manually. I recommend practicing manual landings as much as possible so they become second nature.

Your drone is now on the ground, but you aren't quite done yet! Cameras like GoPros and the integrated cameras on DJI drones do not like to be powered off while they are recording video. This usually causes the video file to become corrupted. Cameras are designed to repair the last file when they are turned on again, but the repair doesn't always work, and trying to repair the file using a computer is a complicated process. It's much easier to just make sure you stop recording video before powering off a drone.

After you make sure you aren't still recording video, you can power off the drone and, then, the remote controller.

Finally, log your flight so you can keep a history of where you flew. Logging is also important if you eventually would like to become certified as a drone pilot for commercial operations.

A good checklist helps to ensure that your flights are successful and productive in the long term. This checklist might seem long and complicated, but most of the items on the list will become second nature as you fly more and more. Again, see Appendix A for a sample checklist you can use in the field.

Telemetry

You're almost ready to head outside with a camera drone, but before you do so, you need to familiarize yourself with telemetry (**FIGURE 2.9**), which is the process by which remote monitoring data is sent back from a drone.

FIGURE 2.9 A picture of the DJI GO app during a flight over a volcano in Iceland. Telemetry is key to DJI's mobile flight interface.

Integrated drones on the market today give you all the telemetry data you need to be successful in aerial imaging, including (but not limited to) the following:

- FPV video
- Flight mode
- GPS lock status
- Radio signal strength
- Remaining battery capacity and/or flight time
- Height above ground level (AGL)
- Distance from launch point or pilot location
- Vertical and horizontal velocity
- Drone orientation
- Pilot orientation
- Map overlay
- Camera settings and status
- Technical flight data, for logging

It is important to become familiar with all the data presented to you on the screen and to pay particular attention to battery level and FPV video. When you are flying, you should know your battery level at all times and how far away you are from a good landing location. When you first start flying, paying attention to all this data can be taxing from a task-loading perspective. Don't worry—as you spend more time flying, you'll start to be able to monitor this data when you are in the air while giving most of your attention to line-of-sight and FPV video monitoring.

Also, modern drones are smart, so even if you forget to monitor something like battery life, drones like the DJI Phantom 3 and 3DR Solo can automatically "return to home" (launch point or pilot location) when the battery runs low or there is a loss of control signal. Even though many automatic safeguards are in place to help maximize your chances of executing a successful flight, it is still a good idea to actively monitor telemetry data.

Practice Makes Perfect

So far in this chapter, you have learned that flying a trainer drone inside is a great way to get stick time without risking crashing expensive equipment outside. You have identified a suitable location for flying outside and learned what to include in your preflight checklist. You understand telemetry and how it can help you fly safely. Finally, you are ready to start developing the piloting skills necessary to really have fun!

Becoming a good pilot is something that is developed over time, and there is no way to replace time spent in the air or spent practicing in a simulator. Both DJI and 3DR include simulators in their respective mobile apps so you can fly around virtually if you can't get outside for some reason.

You can certainly practice by flying around randomly, but practicing based on a plan will make you a better pilot faster. The next section details a practice plan that, if followed, will help you move from beginner to competent pilot. Each exercise increases in complexity and should be mastered before moving to the next one.

If you plan on practicing with a camera drone, you might want to consider removing the camera and gimbal during your initial flights. Most drones are durable because there aren't a lot of moving parts that can break, but gimbals are fragile. A crash that has contact with the gimbal has a good chance of breaking it, and replacing a gimbal can be expensive. Many of these exercises can also be practiced indoors using a trainer drone.

▶ EXERCISE 1 Takeoff and Landing

You will obviously need to take off and land during each flight, but since takeoff and landing both place a drone close to the ground (and to objects on the ground into which you can fly), it's important to practice both until you are comfortable. Your drone manual will detail steps for how to "arm" (spin propellers up, in many drones) and "disarm" (spin down propellers and disable throttle stick). Also, look for instructions on how to stop your motors in an emergency. Emergencies shouldn't happen often, but if you end up in an undesirable situation, knowing how to stop motors instantly is key to minimizing damage.

The secret to minimizing the chance of a crash upon takeoff is to commit. Some drones have an "auto takeoff" feature that will spin up motors and automatically ascend to a predetermined altitude. If it's not windy and you have at least 10 feet of clearance in each horizontal direction, auto takeoff is a great way to get in the air. If you prefer to take off manually, give your drone plenty of throttle to get it a few feet off the ground in one motion. In general, you want to avoid hovering close to the ground because some drones do not handle ground effects well and can bounce up and down or even move laterally by themselves.

Hover until you feel like you're in complete control and then bring it back down to the ground for a landing. Some drones feature automatic landing modes, which you can try, but I prefer to land manually. Land gently, but again, commit to the landing so you don't have to deal with the turbulence of ground effects for long. Sometimes a small burst of throttle just before you touch down can soften a landing, and if you practice enough, you will be able to land softly enough that your drone doesn't bounce. Note that if your drone does have an automatic landing mode, you should know how to take control during the landing. I've seen too many friends running frantically to try to catch drones that are about to land on their car or other obstacle, and while that can certainly be humorous, it's easier to just take control, fly to an open area, and land manually.

▶ EXERCISE 2 Box

A box (**FIGURE 2.10**) is one of the easiest maneuvers to fly, and its purpose is to help you to understand what the right stick does. The right stick is responsible for pushing your drone around laterally: forward, back, left, and right. If you use only the right stick, your drone will stay at its current altitude and orientation but will move along a horizontal plane staying pointed in the same direction the whole time.

Beginners should start flying with the drone facing away from them. Stand straight and point directly in front of you with a straight arm. This is the direction your drone should be facing; I recommend flying like this because in this orientation your right stick's movements will match your drone's movements. Pushing the stick up makes the drone move forward, pushing right makes the drone move to the right, and so on.

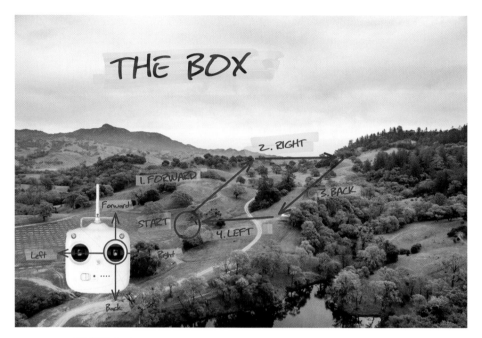

FIGURE 2.10 Exercise 2: box

To fly a box maneuver with your drone, follow these steps:

1. Take off and throttle up until your drone is higher than all obstacles in the area, such as trees.

2. Fly forward a bit so you can see your drone in front of you.

3. Yaw (turn) your drone until it is facing away from you (move the left stick left or right). In this orientation, your right stick movements will match your drone's movements.

4. Now, using only the right stick, fly forward, right, back, and left so you're flying along the four sides of a box (the right stick goes up, right, down, and left). You can fly a box in two directions: clockwise and counterclockwise.

Fly the box maneuver repeatedly to get a feel for how your drone moves laterally through space. Experiment with speed, acceleration and deceleration, and stopping at corners. Try to imagine that you are flying a perfect square. If you have an integrated drone with an app that draws a real-time flight path when you are in the air, you will be able to see the square that you are flying and tune it until it is perfect.

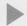 **REMOTE CONTROLLER MODES**

All the discussions about how to fly using a remote controller assume that you are in what is commonly referred to as Mode 2, which is the most common RC mode in the United States. Mode 2 uses the left stick for throttle or elevation (up/down) and yaw (left/right) and uses the right stick for pitch forward and back (up/down) and roll left and right (left/right).

Some remote-controlled toy drones are fixed in one mode or another. If you purchase one of these and want to fly in the way that most of us fly, choose Mode 2 over Mode 1.

▶ EXERCISE 3 In and Out

An in and out maneuver (**FIGURE 2.11**) is the first exercise in spatial orientation. A drone's orientation is the direction it is facing; this is controlled by moving the left stick left and right, which yaws (turns) the drone left and right.

FIGURE 2.11 Exercise 3: in and out

Before you attempt an in and out maneuver, you should be comfortable piloting a drone that is facing away from you. As soon as your drone turns so it is facing another direction, you need to start imagining movements from the drone's position; sometimes, stick movements will be the reverse of what you'll see the drone do in the sky. For example, if the drone is facing you, moving the right stick to the right will cause the drone to move to its right—only the drone's right is now your left! I've found this spatial mapping disconnect to be the main cause of pilot-error crashes.

To fly an in and out maneuver, follow these steps:

1. Take off and throttle up until your drone is higher than all obstacles in the area, such as trees.

2. Yaw (turn) your drone until it is facing away from you. In this orientation, your right stick movements will match your drone's movements.

3. Push the right stick forward to fly forward in a straight line.

4. Push the left stick right or left to turn the drone a full 180°. It should now be facing directly at you. Don't be afraid to use markings and LED lights on your drone to identify the direction it is facing. You can also use the FPV video feed in your app.

5. Push the right stick forward to fly back toward you in a straight line.

6. When you drone is close, stop. Repeat starting from step 2!

WATCH THE VIDEO IN AND OUT DEMONSTRATION

Download Chapter02_Exercises.mov for a demonstration of in and out maneuvers (at timecode 0:28-1:14), along with other exercises. Please see this book's Introduction for information on how you can access and download the video files designed to accompany this book.

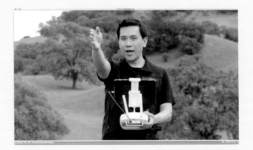

The in and out maneuver seems like a simple exercise, but it is a great starting point for learning—and for starting to internalize—the spatial orientation skills required to fly drones without having to think about piloting. If you want step it up a bit, you can start to roll your drone left and right (right stick left/right) as you fly along the line in and out. This will cause your drone to translate left and right along the line as it moves. Remember that rolling left while your drone is facing you will cause it to move to your right!

▶ EXERCISE 4 Box with Yaw

A box with yaw (**FIGURE 2.12**) is a variation on the box maneuver that includes yawing your drone at each corner so it is always flying in the direction of movement. Instead of relying only on the right stick to move your drone along the four lines of the box, you also use the left stick for yaw. You can fly a box with yaw maneuver either clockwise or counterclockwise.

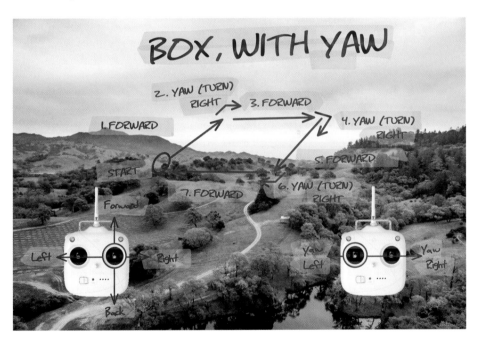

FIGURE 2.12 Exercise 4: box with yaw

To fly a box with yaw maneuver (clockwise), follow these steps:

1. Take off and throttle up until your drone is higher than all obstacles in the area, such as trees.

2. Fly forward a bit so you can see your drone in front of you.

3. Yaw (turn) your drone until it is facing away from you. In this orientation, your right stick movements will match your drone's movements.

4. Using the right stick, fly forward. Stop when you have flown far enough to cover the distance of one side of a horizontal box (you decide).

5. Push the left stick to the right to turn (yaw) the drone 90° to its right. Your drone is now facing your right.

6. Use the right stick to fly forward again. Because your drone is facing your right, it will fly in that direction. Stop when you have covered the distance of the second side of your target box.

7. Again, push the left stick to the right to turn the drone 90° to its right. Your drone is now facing you.

8. Use the right stick to fly forward again. Your drone is facing you, so it flies back toward you.

9. Push the left stick to the right to turn the drone 90° to its right. Your drone is now facing to your left.

10. Use the right stick to fly forward one last time. It will fly to the left, and if you planned the box well, you'll end up where you started in step 3.

At each corner, you can turn left instead of turning right, which will result in flying a counterclockwise box.

When you first start turning your drone left and right, you'll find that you have to think about flying a lot more. Your brain is struggling to map drone orientation and movement to stick direction. As you practice the box with yaw maneuver more and more, you'll find yourself thinking less about flying; ideally, you'll start to feel moments in which the drone feels like an extension of your will.

If you're feeling brave, fly the box with an object in the middle (such as a tree), but don't do this until you are ready. The box with yaw maneuver is a great one to practice because you can see where the drone is going at all times using your camera's live video feed. Obstacles can certainly be avoided by using line of sight to track your drone, but having a camera feed for verification will help you to feel confident that you are not going to fly into something.

▶ EXERCISE 5 Circle

Flying a circle (**FIGURE 2.13**) is the first of the advanced flight exercises because it requires continuous adjustments to both sticks. In this particular circle, your drone will always be facing the direction of movement (turning constantly).

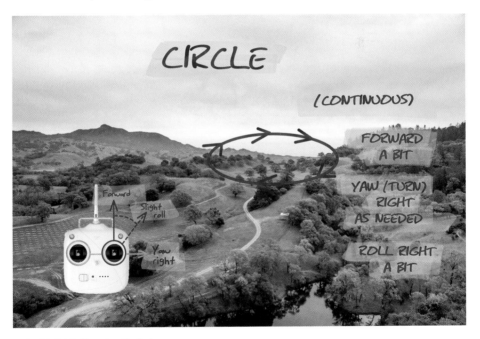

FIGURE 2.13 Exercise 5: circle

To fly a circle (clockwise), follow these steps:

1. Take off and fly to an open area in front of you.

2. Using small movements, fly your drone slowly forward (right stick forward) while yawing slowly to the right (left stick right). The amount of forward speed and yaw rate will determine how large your circle is and how fast you complete it.

3. Optionally, roll the drone to the right at the same time (right stick right).

 This will make the drone behave more like a fixed-wing would when turning (it will roll into the turn). When you roll the drone, your circles will become tighter because you are asking the quad to move orthogonally toward the center of the circle in addition to changing the forward direction by yawing.

Flying "like a fixed-wing" is hard to explain, but here is a good way to visualize it. Hold your hand out in front of you with your fingers straight and touching each other. Now, pretend your hand is an airplane and make it fly around. You'll notice that you intuitively bank your hand when it is turning, which is exactly what airplanes do. Now continue to "fly" your hand around, but prevent your hand from banking. Now, your hand is still turning, but it will feel pretty strange.

When I turn a drone during forward flight, I always think about how an airplane might turn, which means that I almost always apply a bit of roll into each turn. For me, this makes captured footage look more natural, and it is hard to fly without doing it.

▶ EXERCISE 6 Figure Eight

Flying a figure eight (**FIGURE 2.14**) is the holy grail of drone piloting practice. If you can fly a figure eight consistently in both directions, you are a competent pilot and can basically fly any plan you can think of. A figure eight is basically one clockwise circle and one counterclockwise circle with a transition in the middle.

To fly a figure eight, follow these steps:

1. Fly a circle clockwise (see "Exercise 5: Circle" for directions).

2. When you finish the circle, immediately switch directions to fly a circle counterclockwise.

Flying a figure eight is hard, so don't be frustrated if it takes a while to learn. A figure eight includes all the elements you've practiced so far. It requires advanced spatial orientation skills and the ability to use the control sticks to fly without thinking about what each one does.

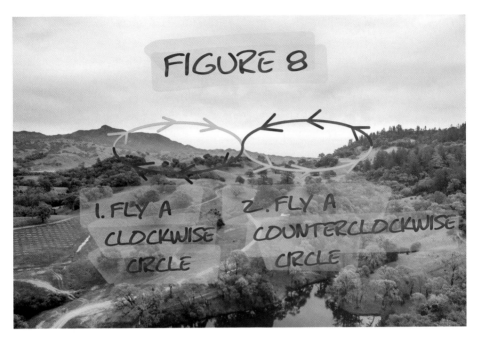

FIGURE 2.14 Exercise 6: figure eight

Also, I find that flying a figure eight is an exercise that never gets old. When I fly a new drone for the first time, I usually fly a figure eight to see how well I can control it. A responsive drone will be able to fly figure eights really easily while making me feel a sense of control the whole time.

WATCH THE VIDEO FIGURE EIGHT DEMONSTRATION

Download Chapter02_Exercises.mov for a demonstration of how to fly figure eight maneuvers (at timecode 04:30 to 06:00), along with other exercises. Please see this book's Introduction for information on how you can access and download the video files designed to accompany this book.

▶ EXERCISE 7 Orbit

Orbit (**FIGURE 2.15**) is a maneuver in which a pilot flies a drone in a circle while keeping the drone facing center the whole time. Normally, there is a subject at the center of the circle that a pilot wants to keep in frame, which is also referred to as the *point of interest*. Those of you who are first-person-shooter fans will know this move as a *circle strafe*.

Orbit is the first exercise that relies solely on the drone flying in a direction it is not facing. In a clockwise orbit, the drone is flying to its left while yawing right. This will cause the drone to fly in a circle while facing in. Orbit is best done with a live video feed because you will need to modulate yaw carefully to keep your subject in the center of the frame or wherever you want it to be in the frame. You can also fly faster to elongate the orbit—it doesn't have to be completely circular.

Orbit is a standard move in aerial video and should be practiced often.

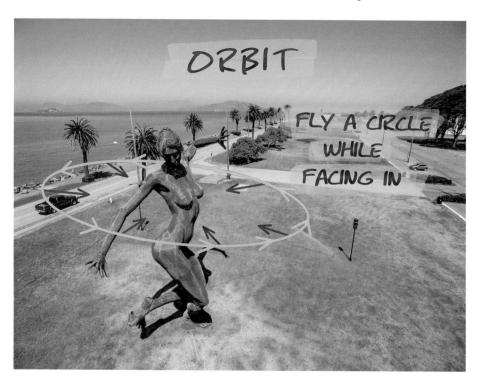

FIGURE 2.15 Exercise 6: orbit

▶ **EXERCISE 8** Assisted Flight Modes

Drones eventually will simply be flying platforms that software can use to accomplish goals. In aerial imaging, we are already starting to see this happen, and new camera drones are starting to come with assisted flight modes for cinematography. For example, the 3DR Solo can execute autonomous moves called Cable Cam, Orbit, and Selfie. In Cable Cam, you set two points in the air by flying to them one after another and marking them. When you run Cable Cam, the drone automatically flies between the two points. Navigation is autonomous—you control only camera and speed of flight. The Solo can also fly an autonomous orbit. You fly in and out to set the radius, and it does the rest.

DJI's GO app has similar features as part of its Intelligent Flight Modes, although they are also relying on the DJI software development kit (SDK) to unlock assisted flight modes through third-party apps.

Assisted flight modes will become more and more popular as drone technology improves, but fully autonomous flight might never really be able to replace a skilled pilot, especially when capturing stills or video of dynamic, unpredictable situations.

Conclusion

In this chapter, I covered trainer drones, flying locations, preflight checklists, telemetry, and how to practice flying. I can't emphasize enough how important it is for you to spend as much time as you can in the air. Modern consumer drones are easy to fly, but they still crash if you fly them into something. Practicing often to build up piloting skills allows you to eventually fly your drone as an extension of will instead of requiring active thought. You'll free your mental resources so they can be used for creativity and fun!

Also, practicing doesn't have to be boring; use interesting locations for inspiration and capture video and stills as you practice. Inspiration will come to you while your drone is in the air, and you'll build an impressive repertoire of aerial camera moves.

CHAPTER 3

Aerial Stills Photography

Virtually every camera drone is capable of capturing both video and still images, and some can even shoot both stills and video at the same time. The drone industry changes quickly, but most camera drones can be reliably placed into one of two categories: drones that use integrated cameras and drones that use third-party, stand-alone cameras.

GoPro HERO action cameras are by far the most popular stand-alone cameras used in aerial imaging; their performance-to-weight ratio is excellent, and they can be carried by quadcopters that fit into backpacks and small cases. Larger cameras, including point-and-shoot models, mirrorless cameras, and SLRs, are also used in the air, but they are usually paired with much larger multirotors that aren't typically purchased ready to fly.

FIGURE 3.1 In this image, I'm preparing for an aerial imaging flight near Cape Town, South Africa, using a DJI Phantom 2 and gimbal-stabilized GoPro HERO3+ Black Edition. Photo courtesy Phil Sokol.

In this chapter, I will focus on ready-to-fly quadcopters that use integrated cameras (such as the DJI Phantom 2, shown in **FIGURE 3.1**) and quadcopters designed to be used with GoPros. I chose to feature GoPro because the vast majority of small gimbals sold for third-party cameras are made for GoPros, and these gimbals can be put on virtually any drone, whether they are distributed ready-to-fly or in kit form.

Integrated cameras can offer the pilot full remote control of a camera, which gives power to aerial imagers to change camera settings on the fly and to even play back captured imagery while a drone is still in the air. Third-party cameras tend not to communicate well with remote pilots, and most third-party cameras are used by starting the capture of video or time-lapse stills before a flight starts. However, things might be starting to change.

The first drone that talks directly to a GoPro for remote access to the camera is the 3DR Solo. 3DR made a deal with GoPro, which opened up camera control via its cameras' HERO bus port. This precedent suggests that stand-alone

camera manufacturers might be willing to work with drone manufacturers to allow direct access to camera functions. However, it is likely that integrated cameras will always feature tighter integration and better user interfaces. As a result, most aerial imagers currently prefer working with camera drones that feature fully integrated cameras.

The most important thing for you to remember as an aerial photographer is that what you are doing, first and foremost, is still photography. No matter what camera drone you use, basic photographic techniques all still apply. Camera drones simply allow you to extend your reach from a composition standpoint and to capture scenes that you might only have been able to imagine before.

Camera Settings

During my many years of experience as a professional photographer, I have been asked hundreds of times for camera settings. Camera settings are obviously important for the success of a given shoot, but the correct answer really is, "Whatever the shot requires." One shooting scenario might require vastly different camera settings from another, especially if a photographer has a specific creative look in mind.

In the air, photographers have traditionally been limited in available camera settings, and even the latest integrated camera drones offer settings comparable only to what a typical point-and-shoot camera might feature. However, as integrated cameras improve, you can expect to start to see parity in camera settings support and even new advanced settings focused around camera movements.

General Settings

Most aerial cameras, whether they are integrated or stand-alone, allow photographers to change exposure, white balance, resolution, and more. The latest GoPro HERO cameras support quite a few settings, but only exposure compensation, ISO, resolution, and interval shooting (time-lapse) are really of interest to most aerial photographers using a GoPro. The new 3DR Solo expands the usable settings palette by enabling shutter control; suddenly, being able to access a GoPro's Continuous Photo Mode (for example) becomes useful.

The latest integrated camera drones from DJI allow photographers to treat a flying camera almost like a land camera. Settings for full manual exposure control are accessible, as well as settings for burst mode, bracketing, time-lapse, and more. The DJI Phantom 3 and Inspire 1 also feature shooting to Adobe's DNG raw format, which is desirable for photographers looking to capture the most information possible.

RAW CAPTURE

Consider shooting in raw if your integrated camera drone offers raw capture. All of DJI's integrated drones support Adobe's DNG raw format, which means that pictures are saved with the most information possible (**FIGURE 3.2**). When pictures are saved in raw, the file includes unprocessed sensor data that must be "converted" by software before a viewer can see the captured picture. Luckily, pretty much all viewing software on computers (such as Photos.app for OS X, Picasa, and Lightroom) will handle DNG raw conversion without any problems, so it isn't much of a burden to capture to DNG.

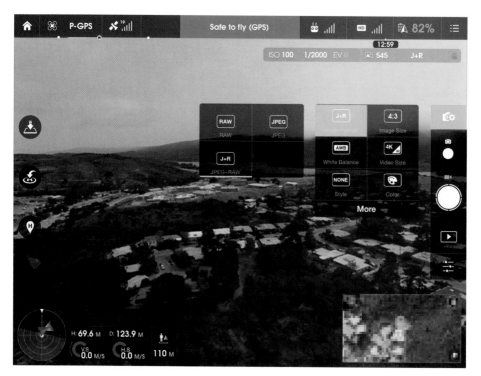

FIGURE 3.2 Choosing to save in JPEG+RAW using the DJI GO app while flying a DJI Phantom 3

The advantages of shooting in raw over JPEG are the same whether you're shooting in the air or on land. JPEGs are designed to save disk space and use lossy compression, which means that data is thrown away when a picture is saved to a drone's microSD card.

Advantages of raw capture include the following:

- Best image quality possible
- Ability to change white balance in post
- Ability to recover lost highlights in post
- Ability to take advantage of better raw converters as they improve over time (images become "upgradeable")

Disadvantages for raw capture vs. JPEG capture include the following:

- Larger file sizes (about five times larger, in the case of images shot by a DJI Phantom 3).
- Raw files are not natively supported everywhere (mobile devices and web services may not recognize the files as being images).

The main reason a photographer might want to shoot in JPEG instead of raw is that JPEGs are natively supported everywhere. In a situation in which a photographer's workflow requires rapid delivery of imagery, JPEGs usually are preferred. A JPEG can be pulled off a card or transferred over Wi-Fi for delivery without requiring raw conversion in post.

Luckily, DJI's camera drones feature simultaneous capture of DNG and JPEG, giving you the best of both worlds at the cost of a using a bit more disk space. DNG+JPEG is what most photographers I know tend to shoot because it gives them capture in the best possible quality while retaining flexibility for instant sharing. Those of you who are worried about using too much disk space should consider that a 16GB microSD card costs less than $10 and holds more than 500 Phantom 3 pictures saved as DNG+JPEG.

EXPOSURE

In the (brief) times of aerial drone photography during which gimbals were not standard, it was often difficult to take sharp pictures from multirotors because of the aircraft's potentially extreme movements during flight. Gimbals keep the camera level and stable and make a huge difference not only for video capture but also for still photography. They stabilize at many hundreds of times per second, which effectively cancels out the effects of airframe movements

that are caused by navigation and/or stabilization. Well-balanced camera drones that are flying without a gimbal can typically shoot sharp pictures at shutter speeds of 1/250 second or so, as long as proper vibration damping is used (discussed later in this chapter). However, when I am taking stills using a camera drone without a gimbal, I tend to target 1/500 second or faster, if possible, to ensure that my resulting images are sharp.

Camera drones with gimbals are altogether a different story when it comes to minimum shutter speed: A camera drone with a good three-axis gimbal can often shoot sharp pictures with a shutter speed of *a few seconds or more*. The first time I put a DJI Inspire 1 in the air at night, I took a sharp picture with an exposure time of eight seconds. The fact that long exposures like this are possible without a tripod can make a seasoned photographer's head explode and are a good example of the powerful enabling effects of new technology applied to an old art form.

Gimbals are great for large airframe movements, but it's the spinning motors and propellers that can cause real damage to images. If you look at a typical camera drone's gimbal, you'll notice that it is attached rather loosely to the drone's frame via a vibration damping system—usually, four rubber balls of varying rigidity, depending on the weight of the camera and gimbal. The damping balls serve to prevent high-frequency vibrations caused by unbalanced motors and propellers from reaching the imaging system.

Normally, one might assume that a fast shutter speed could solve the problem, but most cameras currently being flown in the air use CMOS sensors and rolling shutters. A rolling shutter results in images being captured by scanning across the sensor, and the time required to make the scan can be much slower than typical shutter speeds used in aerial photography. For example, you might be shooting with a shutter speed of 1/1000 second for the purposes of achieving the right exposure, but your camera will be scanning across the frame much more slowly when capturing the frame (1/60 to 1/30 second is typical).

The end result is that vibrations enter an aerial imaging system, creating horizontal shearing artifacts that wreak havoc on images. In video, this effect is called *jello* for the wiggling look of the artifacts—like shaking jello on a plate (**FIGURE 3.3**). In still imagery, you'll see this as horizontal blurs that occur in stripes across the image.

FIGURE 3.3 An example of CMOS rolling shutter artifacts, more commonly known as jello.

A good integrated camera drone has been designed and tested with a solid gimbal and effective vibration damping. If you're building your own camera drone, make sure you're using proper vibration damping and a well-balanced gimbal. Once camera stabilization is ensured, determine your aerial exposures the same way you'd consider exposures when shooting on the ground. Here are some general guidelines to use when choosing exposures in aerial stills imaging:

- Use the lowest ISO possible. Most aerial cameras currently use small sensors, which make them susceptible to noise when higher ISOs are used.

- Choose a fast shutter speed, especially if your drone is moving.

- Watch out for overexposure. Many aerial cameras use fixed apertures (often, at f/2.8). If this is the case, your shutter speeds might be extremely short. Sometimes, images might even be overexposed because the camera can't shoot fast enough. Consider adding a neutral density (ND) filter, if necessary, but make sure you use a filter that many other people use for the same purpose. Most gimbals are not designed to support the extra weight of a filter, and some may burn out because of the extra load on the motors. Gimbal manufacturers might not honor warranties if a filter is used.

- Pay attention to the general composition of your scene and adjust exposure compensation accordingly. For example, if you're taking pictures over snow, you might need to overexpose to compensate for the camera trying to make the snow gray. If you're taking pictures over the ocean, you might need to underexpose because the camera might try to brighten the water automatically.

Note that cameras like GoPros offer only limited control of exposure. See the "GoPro" section later in this chapter for details.

FOCUS

Unless you're using a professional camera drone, it's unlikely that you will ever have to focus your aerial camera. Most aerial cameras have small sensors and fixed apertures. They're prefocused at the hyperfocal distance, which means that very close objects might not be in sharp focus.

Some integrated camera drones are now shipping with larger sensors and variable-aperture lenses that do need to be focused. If you have one of these drones, treat focus as you would when using a land camera: Think about it before you shoot. Many people who have been shooting using current camera drones have stopped thinking about focus in the air, and it will take some time to remember that most photography does actually require thinking about focus (or having an intelligent camera do it for you).

FRAME GRABS FROM 4K VIDEO

Many current camera drones are capable of capturing 4K video (including high-end consumer drones from DJI, and all drones that use the latest GoPro HERO cameras). We'll talk specifically about shooting aerial video in the next chapter, but it's also important to note that 4K video can be useful for capturing stills, as well. The resolution of 4K video is typically either 4096x2160 pixels ("4K") or 3840x2160 ("4K UHD"), both of which are over 8 megapixels. This means you can extract reasonable still images from 4K video by exporting screen grabs from the original video.

You'll achieve the best results by shooting video at fast shutter speeds when your drone is moving slowly. Fast shutter speeds will freeze any motion in your scene, and a slow-moving drone will prevent rolling-shutter artifacts from making vertical lines slant during movement.

One of my most popular aerial still images is on the cover of this book and was actually created by exporting a frame grab from a 4K video (**FIGURE 3.4**)!

You can export a frame grab using various methods, depending on whether you're viewing the video on a computer or smart device. If you don't know how to do this, do a Google search for *screen shot video [platform]*, replacing *[platform]* with the kind of computer or smart device you are using.

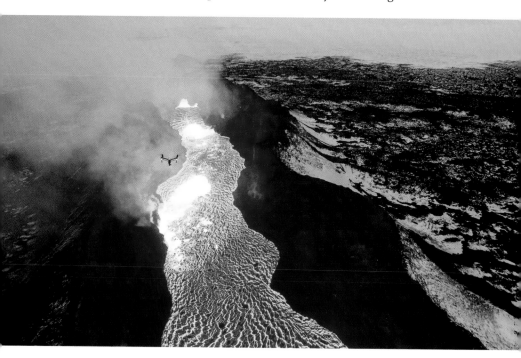

FIGURE 3.4 This image of a DJI Inspire 1 flying over the Holuhraun volcanic erup-
tion in Iceland in January 2015 is actually a frame grab from an aerial 4K video taken
with a second Inspire 1. Shared photo credit: Eric Cheng / DJI & Ferdinand Wolf / Skynamic.

Integrated Cameras

At the moment, DJI's Phantom 3 series and Inspire 1 are the most popular camera drones on the market. Their integrated cameras are comparable in image quality to the GoPro HERO4 (they use the same sensor and internal processor) but feature the integration advantages listed previously. Because DJI's integrated cameras are so popular, I'll use the DJI GO mobile app to illustrate all the camera settings in this section.

Integrated camera drones offer many benefits to users, especially in feature set and user interface, but many models are not upgradable, meaning that you cannot swap out the camera for a better one later. The DJI Inspire 1, however, does feature a modular drone camera mount—the first of its kind.

REMOTE CONTROL

Integrated drones have cameras that can be controlled remotely by physical interfaces on the remote controller and/or via a mobile app. First-generation integrated drones like the DJI Phantom 2 Vision and Vision+ had cameras that could be controlled only by mobile app (aside from gimbal pitch, which could be controlled by a lever or dial on later revisions of the drones). These were great first steps in how integrated drones might work, but mobile app-controlled cameras proved cumbersome because photographers had to remove their hands from the sticks in order to take a picture.

Modern integrated drones like the DJI Phantom 3 and Inspire 1 feature custom remote controllers with buttons and dials that allow for full camera control. These newer drones are starting to feel like remote cameras rather than drones that happen to carry cameras. The Phantom 3's and Inspire 1's controllers have buttons for taking a picture and starting/stopping video recording, as well as dials you can use to change all exposure variables (supporting full-manual exposure) and pitch the gimbal up and down (**FIGURE 3.5**).

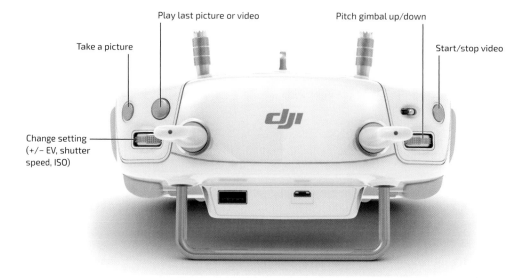

Play last picture or video

Pitch gimbal up/down

Take a picture

Start/stop video

Change setting
(+/– EV, shutter
speed, ISO)

FIGURE 3.5 The DJI Phantom 3 remote controller includes physical buttons and dials for all camera controls.

Integrated, physical camera controls are among the main benefits of integrated camera drones. Photographers can plan compositions, take only the pictures they want to take, and change settings between shots, just like they do when using a land camera. Nonintegrated cameras tend to be used in interval shooting mode (also sometimes called *time-lapse* mode) and left to continue shooting during the entire flight. Changing settings is difficult or impossible because you can't get physical access to the camera without landing the drone.

When I use an integrated camera drone, I feel like I'm operating a camera that happens to be in the air, instead of a drone that happens to be carrying a camera. Approaching aerial imagery this way once you've mastered drone operation will greatly improve the quality of the images you capture during flight.

EXPOSURE CONTROL

Integrated camera drones typically offer exposure control that can be set during flight. In earlier DJI models like the Phantom 2 Vision and Vision+, exposure control was a single slider in the DJI Vision mobile app. This interface was one of the first in a consumer product to allow for live exposure control during a camera drone flight; earlier and competing products required physical access to a third-party camera, requiring pilots to land to change exposure. Although being able to change exposure while in the air was convenient, pilots still had to access the controls via a smartphone, which meant that they had to take their hands off the control sticks, leaving the drone in a hover or allowing only for awkward piloting with the use of only one hand.

Newer drones have moved nearly all camera controls to the remote controller itself (**FIGURE 3.6**). Full manual exposure control (ISO and shutter speed; aperture is fixed), gimbal tilt (and roll, on the Inspire 1), shutter control, and playback can all be done without removing one's hands from the sticks.

FIGURE 3.6 The DJI GO app for DJI Phantom 3 and Inspire 1 features all the camera settings you'd expect to find in a land camera.

In addition, the DJI GO app features a rich set of touchscreen exposure control actions, including the following:

- Tap to auto-expose
- Tap and hold to lock exposure
- Tap and drag to move gimbal

BURST MODE

Some integrated camera drones can shoot in small bursts. The DJI Phantom 3 series and Inspire 1 can shoot in rapid bursts of up to seven pictures in a row. You can select burst mode by tapping and holding down the virtual shutter button in the DJI GO's app's camera screen and trigger bursts by tapping the virtual shutter button (**FIGURE 3.7**).

FIGURE 3.7 Burst mode controls in the DJI GO app for Phantom 3 and Inspire 1, with Seven Shot selected

EXPOSURE BRACKETING

The DJI Phantom 3 series and Inspire 1 also feature automatic exposure bracketing in three- or five-shot bursts with 0.7 stops between each pair of pictures (**FIGURE 3.8**). You can select exposure bracketing mode by tapping and holding down the virtual shutter button in the DJI GO app's camera screen.

FIGURE 3.8 Automatic exposure bracketing in the DJI GO app for Phantom 3 and Inspire 1, with three- or five-shot brackets available

INTERVAL SHOOTING

Just because an integrated camera drone has an explicit shutter release control doesn't mean that it can't be flown while automatically taking pictures.

Interval shooting (**FIGURE 3.9**) is useful when a pilot doesn't want to think about taking pictures during flight or for creative shooting such as time-lapse photography (see "Advanced Techniques" later in this chapter).

FIGURE 3.9 Interval shooting ("Timed Shot") in the DJI GO app for Phantom 3 and Inspire 1

NEXT-GENERATION INTEGRATED CAMERAS

When DJI announced the Inspire 1 in November 2014, it was a sign of things to come. The Inspire 1 shipped with a relatively small camera nearly identical in specs to the camera on the Phantom 3 Professional, which shipped just half a year later, but what was important is that the Inspire 1's camera mount is modular, promising flexibility in camera payloads that will likely become common in the future.

In September 2015, DJI released the Zenmuse X5, a modular camera with a Micro Four Thirds sensor and interchangeable lens support, featuring unprecedented image quality and lens flexibility for a relatively small camera drone. These kinds of constant improvements in technology are likely to continue to change aerial imagery at an unprecedented pace in the coming years.

GoPro

GoPro HERO action cameras are the most popular nonintegrated cameras used in aerial imaging on drones. GoPros are lightweight and offer high-quality video, acceptable stills capture, and a mounting system that has become a standard in action sports and behind-the-scenes shooting.

The vast majority of camera drones that use GoPros have no remote control of the camera while it is in the air, and still images, by necessity, are typically captured using GoPro's excellent Time Lapse photos mode. However, 3DR's new Solo features GoPro integration, which means that for the first time a GoPro can be controlled remotely while attached to a drone. Solo pilots can turn the GoPro on and off, trigger the shutter, and change shooting modes and settings.

Obviously, one benefit to using a GoPro or other third-party camera on your camera drone is that it is removable: You can leverage the camera for multiple purposes. One might expect price to be another factor, but integrated camera drones currently are less expensive than drones that use third-party cameras when you factor in the camera and gimbal cost.

> NOTE For convenience, all settings screenshots in this section were taken using the GoPro app for iPhone. However, I strongly recommend turning Wi-Fi off when using GoPro cameras on drones because of potential radio interference. See the sidebar "Warning: Wi-Fi and Drones" for more information.

▶ WARNING: WI-FI AND DRONES

All of GoPro's current cameras feature Wi-Fi and Bluetooth connectivity to smart devices. It may be tempting to use Wi-Fi to control a GoPro using your smartphone or tablet, but I highly recommend against it. A GoPro's Wi-Fi signal operates at 2.4 GHz, which is the same frequency range that your drone is likely using for command and control and, potentially, for video and telemetry transmission. These competing radio transmissions could interfere with each other and lead to unanticipated results such as loss of drone control. Furthermore, a GoPro's Wi-Fi range is relatively limited, and you are likely to fly out of communication range quickly.

Before you fly using a GoPro, be sure that the GoPro's wireless is turned off.

RESOLUTION AND FIELD OF VIEW

GoPros max out at 12 megapixels when shooting still images (HERO4 Black and Silver), and the camera supports saving only to JPEG format. File sizes are not very large, so I recommend always shooting at a GoPro's maximum resolution. The HERO4 Session and HERO+ shoot at up to 8 megapixels, and the HERO shoots at 5 megapixels.

TIME LAPSE MODE

For most aerial photography applications using GoPros, pilots will be using Time Lapse mode, which takes a picture at regular intervals until shooting is stopped by a second press of the shutter button. GoPro's Time Lapse mode is versatile and supports shooting intervals as fast as one shot every 0.5 seconds (**FIGURE 3.10**). Note that GoPros are capable of shooting stills as quickly as 30 shots a second, but they can do that only in Burst mode, which requires that the shutter is triggered explicitly, and only for 1 second.

During all of my flights using GoPro cameras, I've found that a two-second interval works best. Taking a picture every two seconds is a good compromise: It ensures that you won't miss any moments during your flight and also won't end up with too many pictures to sift through.

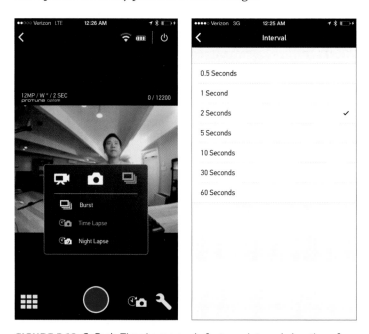

FIGURE 3.10 GoPro's Time Lapse mode features interval shooting of 0.5 to 60 seconds between shots.

At a 2-second interval, you'll capture 300 pictures during a 10-minute flight. Each picture is about 2 MB, so each 10-minute flight would take up about 600 MB of microSD card space.

NIGHT LAPSE MODE

GoPro's Night Lapse mode is similar to its Time Lapse mode but is designed for low-light and nighttime shooting, which might involve shutter speeds as long as 30 seconds. It features an extra interval option called "continuous," which takes another picture as soon as the previous picture is taken. Long shutter speeds and continuous shooting could lead to some interesting low-light imaging experiments from camera drones.

SIMULTANEOUS VIDEO + PHOTO

GoPro HERO4 Black and Silver cameras feature Simultaneous Video + Photo mode (**FIGURE 3.11**), which, as the name suggests, enables automatic photo capture while shooting video. Resolution and frame rates are reduced for both photo and video, maxing out at 1440p (1920x1440) at 24p, and five-second interval shooting.

This is a popular shooting mode for GoPro cameras, especially when the versatility of capturing both video and stills is more important than capturing video with the best possible video quality.

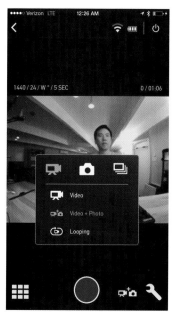

FIGURE 3.11 GoPro's Video + Photo mode features simultaneous capture of video and photos.

PROTUNE

ProTune is GoPro's advanced image quality feature, and photographers who are interested in getting the best possible image quality should absolutely turn it on. Most photographers will recognize the various settings that become accessible once ProTune is toggled on, including White Balance, Color, ISO Limit, Sharpness, and EV Comp (**FIGURE 3.12**).

The most important setting in the ProTune area is EV Comp, which is the only way you can change exposure when using GoPros. It wasn't until late 2014 that GoPro enabled ProTune for still images, but photographers are happy that it's now available. Previously, ProTune worked only in GoPro's video modes, which drove still photographers to do things such as capture 4K video to export frame grabs as still images when they needed exposure compensation.

I also tend to set Sharpness to Low because GoPro photos look more natural when captured using this setting. Finally, I usually leave Color on GoPro Color because I also like the standard GoPro color and contrast (versus the other option, Flat).

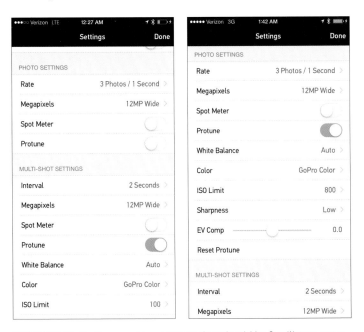

FIGURE 3.12 ProTune enables settings that should be familiar to most photographers.

Other Cameras

Obviously, other cameras (and camera drones) can be used for aerial imaging, and much of what I have discussed in the "Camera Settings" section of this chapter can be applied when appropriate. I rarely see cameras other than GoPros and integrated cameras being used in aerial imaging these days. The ubiquity of GoPro in nonintegrated drones has to do with the popularity of the form factor and availability of gimbals made specifically for GoPros, although the use of a GoPro clone that has the same form factor could be an option for folks on a budget.

Personally, I've been shooting stills with a DJI Phantom 3 and a modified DJI Phantom 2 that holds a Ricoh GR camera (a point-and-shoot camera with an APS-C sized sensor). The Phantom 3 feels like a camera that I can position arbitrarily in space. The modified Phantom 2 is much harder to fly because of the additional weight of the camera and older technology used in the Phantom, but the quality of the Ricoh GR camera makes the combination the highest-quality aerial-stills setup that fits into a backpack.

Accessories

A vibrant OEM and third-party accessories ecosystem is forming around consumer drones, including everything from custom retractable landing gear to typical photography accessories such as filters and lens hoods. Accessories aren't always necessary for taking pictures from the air, but sometimes a filter can help you to create an image that works better to tell the story you are after.

FILTERS

In aerial imaging, ND filters and circular polarizers are sometimes used to slow down shutter speeds and cut glare from reflections. ND filters are more useful for video than they are for stills, but polarizers are useful

FIGURE 3.13 PolarPro filters for DJI Phantom 3

for both, especially on nonfisheye cameras like the integrated cameras on DJI products (which have the FOV of a 20mm lens on a full-frame camera).

The integrated cameras on DJI Phantom 3 and Inspire 1 support threaded filters that use nonstandard thread sizes (**FIGURE 3.13**). DJI-branded filters and third-party filters from PolarPro are easy to find online.

Filters for GoPro cameras also exist, although there are a couple of factors to consider before using them.

First, polarizers are only as effective as light is streaming orthogonally from the lens direction (a 90° angle). Wide-angle lenses like those found on GoPros can capture light that is streaming straight into the lens (a 0° angle) and light that is nearly at a 90° angle in the same frame. This means that a polarizer will have a very different effect in different parts of the frame. To see this effect using a normal camera, put on a wide lens and a polarizer filter and take a picture of the sky when the sun is out.

Second, gimbals need to be balanced carefully, and the addition of a filter to the front of a GoPro's lens (or any stabilized camera's lens) will throw the system off-balance. If the gimbal is powerful enough, it will still be able to stabilize the camera. If it isn't, the gimbal might perform poorly or even burn a motor out as it tries to adjust for the new imbalance.

LENS HOODS

Lens hoods in land photography are useful for helping to prevent flare from lights that aren't actually being captured in frame. In the aerial imaging world, you'll be more concerned with sunlight that happens to be passing through propellers. Because most of the cameras I am discussing use rolling shutters, light that passes through spinning props can cause strange horizontal striping in the resulting images. It's obvious in video but can also be seen in still photos. Lens hoods can prevent this stray light from hitting the lens.

The issues with accessories and gimbals in the earlier "Filters" section also apply to lens hoods.

Aerial Photography Techniques

Aerial photography using camera drones is in its infancy. The first really usable camera drone was the original DJI Phantom (**FIGURE 3.14**), which came ready to fly with a GoPro mount on the bottom of it in January 2013. In just a couple of years, camera drones have evolved from decoupled systems, with drones and cameras operating completely independently, to totally integrated systems that are starting to feel like remote cameras.

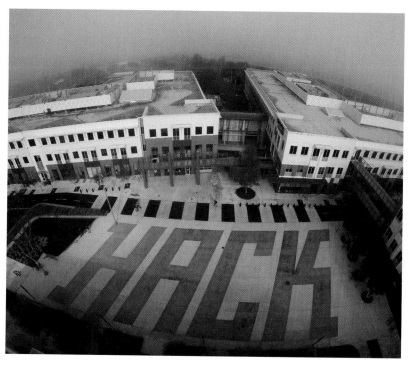

FIGURE 3.14 Facebook's global headquarters at 1 Hacker Way in Menlo Park, California. I shot this picture just a couple of months after DJI's original Phantom quadcopter hit the market.

The most important thing to remember about using a camera drone is that the end goal is still storytelling through captured images. All of the tenets of traditional, land-based photography apply to aerial photography, and it's through properly executed storytelling that the best aerial images are created. Composition, lighting, subject matter, and timing are the main elements that determine the effectiveness of a photograph, whether it was taken on the ground or in the air. Deep knowledge and constant practice with camera drones will help free you up to think about storytelling without becoming lost in the technical weeds. To be most effective as an aerial photographer, you need the piloting and operation of a camera drone to feel like instinct, just like what works best on the ground when using a land camera.

There are, however, some aerial-specific techniques and ideas to consider. Most of us aren't used to thinking about the vertical dimension when we frame photographs.

THE FIRST AERIAL PHOTOGRAPHER

Gaspard-Félix Tournachon, known as Nadar, took the first aerial photograph from a balloon in 1858 (**Figure 3.15**). However, the first surviving aerial photograph was a picture of Boston, also taken from a balloon, shot on October 13, 1860, by James Wallace Black.

In 1882, E.D. Archibald, a British meteorologist, took photos from a kite. It wasn't until 1909 that a picture was taken from an airplane.

FIGURE 3.15 "NADAR élevant la Photographie à la hauteur de l'Art" (Nadar elevating Photography to Art), a lithograph by Honoré Daumier that appeared in Le Boulevard on May 25, 1863

Thinking in 3D

I have spent more than ten years as a professional underwater photographer. Navigating underwater while hauling around scuba diving equipment and large camera rigs with big optics and lighting doesn't seem like it would be connected to aerial photography, but it very much feels the same to me. When we move underwater, we move freely in three dimensions. Moving up is as easy as starting to breathe a bit more deeply, and a deep exhalation from the lungs results in sinking.

Eventually, moving in the vertical dimension becomes automatic, and that freedom has had a profound effect on how one thinks about movement and photographic composition. On land, such freedom had historically been impossible; it wasn't until camera drones were created that I felt similar freedom above water.

With enough time spent flying a drone while watching high-quality FPV video, you'll find yourself beginning to visualize the world from all sorts of

angles, even when you aren't flying. This constant previsualization of potential stories from the air is a rewarding skill to develop. Personally, it presents me with regular ideas for aerial projects and also enriches my daily life as I wander the globe capturing stories.

Just Out of Reach

One of the first questions most consumer drone pilots are asked is, "How high can it fly?"

Aerial photographers hate that question because most interesting shots are taken at low altitude, and there is almost no reason to fly very high. Also, for regulatory reasons, many consumer drones are limited in how high they can fly by default (see Chapter 6).

The strength of a camera drone is that it can fly just out of reach in that unique altitude band between where large aircraft fly and the misguided reach of selfie sticks. When a camera is too high, the images it captures start to look like pictures taken from an airplane or satellite. These sorts of pictures can certainly be useful and beautiful, but they don't create unique images that only camera drones could have taken (**FIGURE 3.16**).

Exploring low-altitude imagery also usually results in images that have a lot of depth to them. High-altitude imagery is flat and is essentially 2D in nature. At low latitudes, subjects that are closer look a lot bigger and can be used as more interesting parts of a composition.

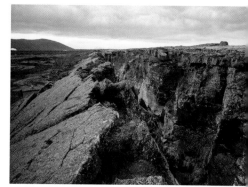

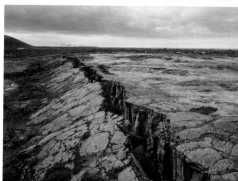

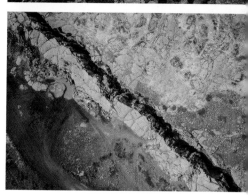

FIGURE 3.16 Grjótagjá is a dramatic tear across the land near Lake Mývatn, but it's almost impossible to see from the ground. I took these three shots from different perspectives. The top shot was taken from where I was standing on top of the broken earth. The middle was taken from about 20 feet up, using a DJI Phantom 2 and Ricoh GR camera. The bottom was taken from much higher. Both of the aerial images are interesting, but I prefer the one taken from low altitude.

Straight Down

Looking straight down from the air isn't something humans get to do often. Usually, we are standing or sitting on something opaque when we are at altitude (and likely, looking out of a window), which is why such views are so rare. Luckily, camera drones are good at looking straight down (**FIGURE 3.17**), and it's one of my favorite camera orientations while flying.

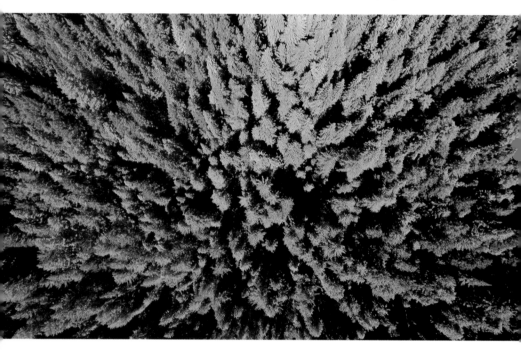

FIGURE 3.17 Hanging just above a forest of redwood trees, looking straight down. Phantom 2 with Zenmuse H3-2D gimbal and GoPro HERO 3+ Black (frame grab from video).

▶ SHORTCUT: CUSTOM BUTTONS

Some camera drones offer customizable buttons on their remote controllers that can be used as a shortcut to point the camera straight down. The DJI Phantom 3's remote controller comes with two customizable buttons on the back of the remote called C1 and C2. One, or both, can be programmed to automatically position the gimbal straight ahead and straight down on alternate button presses. Use shortcuts like these if you shoot straight down or forward often and need to toggle quickly between the two.

One of my favorite ways to shoot straight down is to combine the camera orientation with staying at low altitude (see "Just Out of Reach" earlier in this chapter). Views straight down from too high up start to look like satellite maps, and flying a bit lower can yield perspectives that would be nearly impossible to capture by any other method.

Abstracts

Aerial photography is well suited to the capture of abstract images. Land is, because of the nature of its ownership and use by humans, divided into distinct geometric shapes that are clearly visible as soon as one's perspective lifts off the ground a bit. On land, abstract imagery is often in the macro or micro scale or confined to visualizing just a small part of a larger object that might not be obvious out of context. From the air, abstracts tend to be collections of many whole objects, and often, scale is hard to determine.

Most aerial abstracts I've seen tend to be taken while shooting straight down, which serves to create the sort of regular, geometric patterns that lend themselves to the abstract (**FIGURE 3.18**).

FIGURE 3.18 A low-altitude, straight-down shot at a farm in Northern California

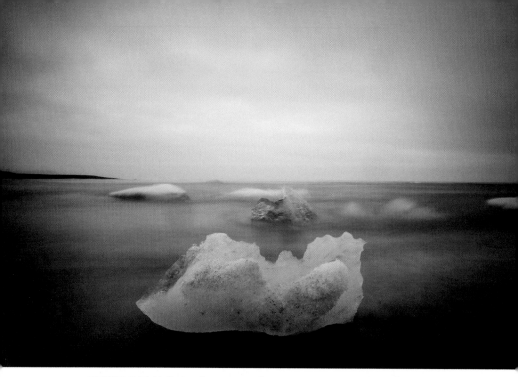

FIGURE 3.19 I left the shutter open for 30 seconds to record this (land-based) shot of icebergs in the surf at Jökulsárlón Glacier Lagoon in Iceland. Water movement has been averaged out into moody texture, allowing the iceberg in the center to present itself more effectively.

Slow Shutter Speeds

Most current camera drones use cameras with fixed apertures of around f/2.8, and since most people fly drones during the day when there is plenty of sunlight, it is rare to see blurry aerial images. Shutter speeds are typically fast, and the ubiquity of camera gimbals further reduces the chances that a picture is blurry. But blurry elements in pictures have always been a staple in creative photography—think of moody shots of running water or a long nighttime exposure that makes car headlights into rivers of light.

Some of the most recent camera drones make slow shutter speeds fairly easy to accomplish. As I mentioned in the "Camera Settings" section earlier in this chapter, DJI cameras can be remotely controlled with full manual exposure. Shutter speeds can be as slow as eight seconds, which is plenty slow enough to achieve interesting creative effects. GoPro HERO4 cameras can be set to Night Mode or Multi-Shot Night Lapse Mode with shutter speeds as long as 30 seconds (**FIGURE 3.19**).

Modern gimbals are able to stabilize exposures from the air in ways that are surprising for photographers who are used to shooting on land. On land,

most photographers expect to be able to handhold a wide-angle exposure for around 1/15 to 1/30 second (longer, if the camera or lens features image stabilization). Longer handheld exposures typically exhibit full-frame blur, in which no elements in the picture remain sharp. Most people look at such pictures and think, "That is a blurry picture." On land, long exposures require the use of a tripod, if the goal is to have stationary objects rendered sharply in the photograph.

When a drone and gimbal are involved, the possibilities change for setting up long exposures (**FIGURE 3.20**). I have seen sharp exposures from a DJI Inspire 1 as long as eight seconds, but three to four seconds is typically more achievable, especially if there isn't much wind and if multiple pictures are taken. Remember, these are for exposures without a tripod!

FIGURE 3.20 A 2-second exposure above the ruins of a pier in California turns the surf into streaks of texture. Photo courtesy Romeo Durscher, taken using a DJI Inspire 1 using a homemade ND64 filter.

From a technical perspective, you can maximize the chance of a sharp frame that still allows moving subjects to blur by doing the following:

- Use shutter speeds between 1/30 and 4 seconds.

- Move your drone far away from the stationary subjects you want to remain sharp in the frame. The farther away they are, the sharper they will be if there is any movement.

- Take as many pictures as you can. Not all the pictures will be successful, and the more you take, the higher the probability of having at least one succeed.

- Manually bracket your exposures, experimenting with how much movement you are blurring in the frame. Different subjects will require different exposure lengths.

- Shoot when the weather is calm. Gimbals do wonders to stabilize cameras, but long exposures are sensitive to even the smallest of movements.

- Use an ND filter to slow down shutter speeds. ND filters for drone cameras are available from camera manufacturers, PolarPro, Snake River Prototyping, and others.

Using a slow shutter speed can be challenging from the air and might not be the first thing that pops into your mind when you go for a flight, but if you manage to use this technique successfully, you'll produce imagery that sets you apart from other aerial photographers.

Shallow Depth of Field

Blurred backgrounds and beautiful bokeh (the shape and quality of the background blur) are two factors that nonphotographers use implicitly to determine whether a picture "looks professional." Blurred backgrounds are a result of focusing accurately and achieving a shallow depth of field, which is accomplished by using a large physical aperture in photography.

Although it might seem great, at first, that camera drones often use f/2.8 lenses, the physical size of the apertures are actually fairly small because focal lengths are quite short (a result of using small sensors). Compounding this, camera drone lenses are also usually wide angle, and shooting distances tend to be long because of safety requirements and the current state of drone

technology (in other words, drones are still allowed to fly into things). Because of these reasons, it's difficult to achieve shallow depths of field when using current consumer camera drones. Note that smartphones also have small-sensor challenges when it comes to achieving shallow depths of field, which is why you typically see blurred backgrounds captured with smartphones only when subjects are close to the lens.

It is, however, possible to shoot with a shallow depth of field from a drone. If you put a camera with a large sensor into the air, outfit it with a medium or long lens, and have the ability to focus while you are in flight, you can achieve a shallow depth of field. A heavy-lift hexacopter or octocopter can definitely lift a mirrorless camera or SLR, complete with a longish lens, wireless follow focus (or autofocus), and a good FPV system. Rigs like these have been used in aerial cinematography for much longer than normal consumers have been putting little drones into the air; obviously, they require more effort to fly and are most often flown with a dedicated pilot, a camera operator, and at least one spotter—a full crew.

Most recently, the Zenmuse X5, a gimbal-stabilized Micro Four Thirds camera, has been released for the DJI Inspire 1 which brings, for the first time, a relatively large sensor and interchangeable lenses to a medium-sized camera drone. A medium-length lens attached to such a camera drone could achieve a shallow depth of field at the closest range you'd want a drone to get to a subject. What's more, unlike custom, heavy-lift systems, an Inspire 1 can easily be operated by one person, with aperture control, autofocus, and manual focus available as part of the DJI GO app and as shortcut options for the remote control's customizable rear buttons.

As drones continue to become more and more integrated, custom, medium-sized camera drones will most likely disappear in favor of integrated models, which will be much smaller and lighter for the same sensor size in payloads.

Advanced Techniques

Virtually every advanced technique that land photographers use can be applied in some way to aerial photography using camera drones. In this section, I'll discuss four advanced techniques that are particularly popular among aerial imagers.

Panoramas

Panoramas are popular in aerial photography because camera drones usually have unobstructed, panoramic views from wherever they happen to be hovering (**FIGURE 3.21**).

Shooting aerial panoramas is easy. To create one, just rotate your drone slowly, taking successive overlapping pictures, and drop them into a program that stitches them together automatically. You'll find numerous online tutorials demonstrating stitching methods using various editing programs and cloud services. I'll talk through a couple of them here, but if you need more information about stitching, spending five minutes doing web searches will get you far.

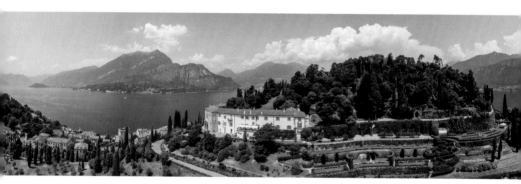

FIGURE 3.21 A six-shot panorama taken near Bellagio on Lake Como, Italy, with a Phantom 3 Professional, and stitched using Adobe Photoshop Lightroom

SHOOTING AN AERIAL PANORAMA

To take an aerial panorama, do the following:

1. If you're shooting with a GoPro or other camera that you cannot control in flight, set an appropriate manual exposure (if possible) and start shooting using interval mode set to two to three seconds per shot.

2. Fly to wherever you'd like to take the aerial panorama from and make sure you're in a stable hover using GPS position hold.

3. Pitch the gimbal to the angle you'd like to use for your panorama. If you're shooting with a fisheye lens, like the lenses found on GoPro cameras, shoot close to horizontal to avoid having fisheye distortion cause stitching problems.

4. Set your exposure mode to manual and choose an appropriate exposure that is good enough to capture pictures along the entire planned panorama composition. I do this by pointing the drone at the brightest area and setting exposure there.

5. Start shooting, rotating the drone to the right or left between shots (or pitching the camera up or down for vertical panoramas), ensuring that you have 30 to 50 percent overlap between each image.

As an alternative to capturing stills, you can also shoot high-resolution video (preferably 4K) and rotate slowly in one direction. Later, in post, screenshots can be taken at the appropriate locations to create source imagery for stitching. But keep in mind that, in most instances, this approach will not yield a panorama that is as high in quality as one created from still images.

PROCESSING A PANORAMA IN ADOBE LIGHTROOM

I highly recommend using Adobe Photoshop Lightroom for image processing and library organization. As of mid-2015, Lightroom includes built-in panorama stitching.

To process a panorama using Adobe Lightroom, do the following:

1. Import the panorama picture fragments into Lightroom.

2. Make sure you have enabled profile corrections to account for lens distortion and vignetting by selecting the Enable Profile Corrections check box in the Develop dialog box (**FIGURE 3.22**). This is especially important if you are using a camera with a fisheye lens (like a GoPro).

3. Multiselect the frames.

FIGURE 3.22 Enabling Profile Corrections in the Adobe Photoshop Lightroom Develop dialog box

4. Choose Photo > Photo Merge > Panorama from the menu (**FIGURE 3.23**).

5. Select Cylindrical as the projection, wait for the preview, and then click Merge in the Panorama Merge Preview dialog box (**FIGURE 3.24**).

6. (optional) Crop out the irregular borders.

FIGURE 3.23 Choosing Panorama from the Photo Merge menu

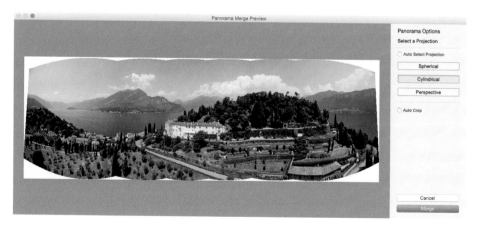

FIGURE 3.24 When you see your panorama preview, merge the images to create the panorama.

PROCESS A PANORAMA IN GOOGLE PHOTOS

Google Photos' Auto Awesome feature will detect panorama frames in uploaded pictures and automatically create panoramas for you. Simply upload all the panorama frames to your account at http://photos.google.com and wait. When Google decides that you should see your new panorama, it will appear in the Assistant feature.

Time-Lapse

Time-lapses are sequences of still images that are played back as a video, which effectively plays time back in fast motion. To make effective time-lapse movies, a chosen composition or subject must change over time. Common time-lapse sequences might involve the movement of celestial objects (sunrise, sunset, stars), clouds, tides coming in and out, and groups of cars or people moving in structured ways, such as on roads or paths.

Aerial time-lapses are not yet common, but the technology is here to make them happen, so I expect to start seeing more of them as users experiment with new perspectives from the air.

Capturing an aerial time-lapse works exactly like it does on land: Capture pictures at set intervals and then process them into a video. If you're shooting using a third-party camera in interval mode, then you are already effectively capturing a time-lapse when you fly. If you're using an integrated camera drone like a DJI Phantom 3, you can use the Timed Shot mode. A time-lapse using a moving camera is also called a *hyper-lapse*, a term that is becoming more popular.

SHOT INTERVALS

The amount of time you choose between shots will determine how smooth your resulting time-lapse is and how much faster than real time it plays. GoPro cameras can shoot successive shots as quickly as 1 every 0.5 seconds, which is 120 shots per minute. When played back at 30 fps, that results in a 15x speedup over real time. So, a 15-minute drone flight will result in 1 minute of time-lapse video. DJI drones currently max out at 1 shot every 5 seconds (in JPEG mode; slower, in DNG+JPEG), but it's likely that DJI will shorten this interval via a firmware update in the future. One shot every 5 seconds is only 12 pictures per minute, or a 150x speedup from real time. Suddenly, a 15-minute drone flight is only 6 seconds of video, which isn't usually long

enough to be interesting on its own. You could play it back at 15 fps, yielding 12 seconds of video, but playback quality might suffer. With limited flight time, a shot interval of a maximum of two to three seconds is recommended for useful time-lapse capture.

Shot intervals vary greatly by subject matter, and you'll have to experiment to find the ideal interval for your particular project.

HDR

HDR stands for high dynamic range, and HDR images are needed when the dynamic range of a particular composition exceeds that which the sensor can capture in a single exposure (**FIGURE 3.25**). Typically, such scenes involve both the sun (or brightly illuminated objects) and shaded areas being in the same frame.

FIGURE 3.25 A normal picture taken with a DJI Phantom 3 Professional (left) compared to a picture taken using the built-in HDR feature (right)
Photo courtesy Julian Cohen.

Many cameras now include some form of HDR mode, including integrated camera drones like the DJI Phantom 3 and Inspire 1 (**FIGURE 3.26**). Typical HDR modes either do automatic exposure bracketing in a quick, multi-image burst, or shoot a raw frame, pull down blown highlights, and boost shadows. Both will process and tone-map the resulting picture in-camera, compressing the dynamic range back into a JPEG.

Many photographers prefer to capture individual, exposure-bracket images and do HDR processing in post. Because some aerial cameras support both AEB

and burst mode, it's fairly simple to capture bracketed images that are shot in quick succession. The three- and five-shot AEB modes available on the DJI Phantom 3 and Inspire 1 make capturing aerial HDR images easy (**FIGURE 3.27**).

Processing HDR in post can be done using programs such as Adobe Photoshop, Lightroom, Photomatix, and others. I won't go into processing technique here because there are so many HDR tutorials available on the Web. For example, try Trey Ratcliff's tutorials, which are available at www.stuckincustoms.com/hdr-tutorial.

FIGURE 3.26
The DJI Phantom 3 supports HDR, which takes multiple pictures in a burst and processes them in-camera

FIGURE 3.27
A DJI Phantom 3 and DJI GO app showing AEB Triple Shot, which will take a burst of three pictures, bracketing by 0.7 EV between shots

Photogrammetry

Photogrammetry is the science of using photography to measure things. In the aerial context, it usually means generating maps from aerial photography. In the past few years, consumer drones have created an entirely new industry around low-altitude mapping, and the results people are getting using low-cost drones have been extremely disruptive.

On the capture side, think of photogrammetry as requiring a series of overlapping panoramas with the subject being an area on the ground. The reconstruction algorithms merely require that the pictures have full coverage of all the points on the ground, and the more overlap, the better. Plentiful overlap is desired because programs can create not only 2D maps but also 3D models of the ground and any structures on it (**FIGURE 3.28**).

FIGURE 3.28 A program called Pix4D shows imported images from a DJI Phantom 3 flight near Bellagio, Italy, overlaid over the 3D model it created from the images. The blue spheres show where each picture's GPS data says it was taken, while the green spheres show the computed GPS coordinates determined by processing the image data itself.

3D models can be created because any given point on the ground is seen by many cameras viewpoints at once. By using the angle between all the cameras and the matched point, programs can determine where it lives in 3D space. Furthermore, because drones have GPS data, each picture knows where it was taken from; this location data is used to create georeferenced orthomosaics, which are photographs that are geometrically corrected so they can be overlaid over maps and can be used for taking measurements (**FIGURE 3.29**).

Aerial mapping by camera drones is being used in a variety of industries including precision agriculture, construction, mining, utility inspection, conservation, search and rescue, humanitarian disaster response, and more. In the creative space, artists are using drones to generate 3D models of structures and importing the resulting point clouds and texture-mapped meshes into programs where they can be manipulated and even printed using 3D printers.

FIGURE 3.29 Pix4D shows the resulting 3D model that was created as a result of the DJI Phantom 3 flight shown in Figure 3.27.

If you're interested in doing some aerial mapping yourself, there are a few apps that can make it easy:

- **Pix4Dmapper**, https://pix4d.com/pix4dmapper-app/: A free mobile app that uses DJI, 3DR, senseFly, and other drones to automatically map any area you choose.

- **DroneDeploy**, https://www.dronedeploy.com/: A (currently) free mobile mapping app that uses your DJI Phantom, Inspire, or 3DR Iris+.

- **Autodesk 123D Catch**, http://www.123dapp.com/catch: A free app that generates 3D scans of any object or location. Upload aerial images captured using Pix4D or DroneDeploy or during manual mapping flights.

Note that even if you do not use an app that automatically flies your drone to do mapping, you can fly manual missions, capturing the overlapping images yourself, and upload and process the mapping data later.

Post-Processing

The applicable techniques used in processing aerial still images in post are identical to those used in processing pictures taken on land. The only potential difference arises if you're using an integrated camera drone instead of a stand-alone camera attached to a drone. This is important only if you want to use a camera and lens profile during editing to correct for distortion and/or vignetting. Luckily, the most popular cameras used in the air, GoPro HERO cameras and DJI integrated cameras, feature profiles included in Adobe Photoshop and Adobe Photoshop Lightroom, as shown in Figure 3.22. If the programs do not automatically detect your camera, try updating to the most recent version.

What's Next?

We've been thrown quickly into a new era of photography in which the vertical dimension has been unlocked by the mainstream availability of camera drones. We're seeing traditional camera features migrating into the feature sets of integrated camera drones, and it's likely that the trend will continue. As integrated camera drones become more functional and easier to use, it will become difficult for drones that use stand-alone cameras to compete with integrated drones for value.

There are also numerous software apps on the horizon that target both vertical industries and horizontal applications, suggesting that the software app economy for drones might be even more important in the future than the drones themselves. This is exactly what happened with smartphones, and we're seeing many similarities in the evolution of the market as drones start to take off.

Third-party photography apps for drones will emerge, and you should expect to see camera app alternatives for the various drone platforms, as well as apps that tap into increased drone autonomy as sensors get better with each generation of drones. Manual piloting is currently a big part of aerial imaging, but as you've seen in the earlier chapters of this book, becoming a competent pilot can require quite a bit of work.

Future drones will most likely be able to navigate safely and beautifully by themselves, removing manual piloting from the equation. At that point, a photographer will be able to intuitively direct a drone into position for photography or even ask the drone to take pictures by itself. Photographers have never before had the ability to ask a robot to move around and take pictures by itself. This sounds like science fiction, but we are essentially already there, and it remains to be seen how such capabilities might change the nature of photography.

CHAPTER 4

Aerial Videography

In Chapter 3, you learned about taking still pictures from the air. Many of the settings and techniques I introduced there are relevant to aerial videography, so it's worth reading even if you aren't interested in still photography.

Aerial videography is the primary reason drones have burst into the mainstream and have been growing exponentially in popularity. At the end of 2012, there were not many drone videos shared on sites such as YouTube, and a search for the word *drone* resulted mostly in videos of military drones. In 2012, camera drones were available only to the few hobbyists who could configure, build, and repair them. Small stabilizing gimbals had not yet made it to the marketplace.

Hollywood, however, had been using scale-model helicopters and multirotor drones for years to carry cameras, although they had been doing it without much publicity, possibly attempting to fly under the radar of the FAA for legal reasons (see Chapter 6 for more about regulations and policy). The camera drones used by Hollywood were designed to carry large cameras, and gimbal technology was still relatively simple when compared to the products that would emerge only a few years later.

I've already talked about the first ready-to-fly camera drones and the ways they affected the industry. But it was likely the sharing of videos captured from the air that amplified growth exponentially. Those of us who fly camera drones know that we are effectively in the drone sales business. If someone sees you flying one, it's likely that they will come over to see what you are doing, and chances are good that they will leave wanting one for themselves. In a given flight, you might influence a couple dozen people at the most, but millions of people might see a shared video gone viral, and some percentage of them will become drone video converts.

Telling Stories

When consumer drones first started to become popular, almost all aerial video from camera drones attracted attention. The low-altitude perspectives and the way drones could move with almost complete freedom were enough to keep a viewer's attention. This kind of special attention happens only during periods of fast and dramatic technological change. During these moments, expectations are violated, and viewers are often as interested in the technology and novelty as they are in being pulled into a story.

One of my first popular videos was a short aerial cut of surfers in Santa Cruz taken with a DJI Phantom and a prototype Rotorpixel brushless gimbal for the GoPro HERO3 (**FIGURE 4.1**). The video went viral and was featured all over the Web and on many news networks around the world. I attempted some rudimentary storytelling in the video, but what made it really interesting was that the footage was incredibly smooth. It was some of the first good, gimbal-stabilized footage from a new kind of camera drone, and viewers were amazed.

FIGURE 4.1 A DJI Phantom with prototype gimbal captures footage of a surfer in Santa Cruz in July 2013 Photo courtesy George Krieger.

When technology is no longer novel, videos need more substance to impel viewers to watch, engage, and share, and we've already reached that point with camera drones. Most people have probably seen footage from a camera drone, and drones are in the media almost every day. These days, it's no longer sufficient to show videos that do not have an interesting subject or tell a compelling story.

When I talk about storytelling, I'm talking about both the kind of stories that involve a plot of some kind and the kind of stories that might be only visual or abstract in nature but have a sense of place and progression. There always needs to be a journey in order for a story to work well.

If you aren't interested in making movies that include people, you can still tell a story that explores space. A particular natural formation like the cliffs over a nice spot on the coast, a lake that reflects light just so in the hours before sunset, or the silhouette of a bunch of cacti in the desert all can be part of an interesting story if the right pieces are captured.

Here are some basic questions to ask while you are collecting footage for your video:

- Does your video have a clear beginning, middle, and end?
- Is there a sense of context? Are the subjects anchored, somehow, in an environment or feeling?
- Is the video satisfying to watch? Is it beautiful, evocative, disturbing, educational, and so forth?
- Do you care about the video? Did you spend time planning, capturing, and editing it?

Videos need to have a reason to be shared. Typically, if you can't think of a reason to share a video or don't care about it, others will also not care when they are watching it (if they watch any of it at all). I'm not saying that you shouldn't capture as much video as you can—you certainly should capture footage for practice, to satisfy curiosity, or simply for fun, but you don't need to share videos just for the sake of sharing them. A meandering video of a boring location is not something most people want to see. Spend time crafting stories, and you'll be rewarded by the feedback you get from viewers who are affected in a positive way by your work.

Image Stabilization: Beating Jello

Modern camera drones are quite good at capturing aerial video, but they are still essentially cameras mounted on platforms that can move around violently during flight. In Chapter 1, we talked about the importance of vibration isolation, which reduces the amount of high-frequency shaking that reaches the camera sensor. Obviously, shaking a camera while recording video is not going to lead to great results, and even vibration that is too subtle for the human eye to see can lead to artifacts called *jello* that will ruin your video (**FIGURE 4.2**). To see examples of jello in aerial drone videos, do a YouTube search for *drone jello*.

Luckily, good camera drones ship with effective vibration dampeners preinstalled and propellers that are pre-balanced from the factory. When flying in calm conditions, you should not see any jello in video, and in most cases,

FIGURE 4.2 An example of "jello" in an image captured from a vibrating camera

jello is caused by damaged propellers or problems resulting from a previous crash. If you see jello, inspect your motors to make sure they are not damaged, swap out or balance propellers, and make sure vibration dampeners are properly installed.

If you continue to see jello in your video even with a perfectly balanced camera drone, the vibration may result from environmental factors like wind. Gimbals and vibration dampeners are designed to withstand a certain amount of wind before they start to vibrate; the strength of a motor is a direct trade-off with weight, and manufacturers always have to strike a balance between stabilization strength and total weight.

In my own anecdotal experience, I've found that camera drones like the DJI Phantom 3 will not exhibit jello at maximum speed if there isn't much wind. However, if the wind is blowing strongly (say, at 25 MPH or higher), a Phantom 3 may exhibit jello in its video if it is flying against the wind, both forward and backward. This is a bit confusing because a Phantom that is stationary against 35 MPH winds should be subjected to the same forces as a Phantom that is flying at 35 MPH in windless conditions. This confusion reflects how complex camera drone systems really are, and jello is just one of the potential issues that can occur if your camera drone is not properly tuned, either by a manufacturer or by a custom builder.

Using Gimbals

In early 2013, getting stabilized aerial video from small consumer drones was almost unheard of. By the end of 2013, two-axis stabilization (roll and pitch) via brushless gimbals had become standard, and these days, three-axis stabilization is required—and, expected—to capture usable aerial video. Luckily, most popular camera drones work well with modern three-axis gimbals, both integrated and stand-alone, and the silky-smooth video that comes from using them is not very difficult to get (**FIGURE 4.3**).

FIGURE 4.3 A 2-axis Zenmuse H3-2D gimbal keeps a GoPro level during a flight with DJI Phantom 2.

Gimbal Modes and Control

Gimbals that are used in the air have a few main operating modes that are useful.

- Follow Mode, in which the gimbal's roll and pitch (tilt up and down) are fixed in orientation, but yaw (pan side to side) is allowed. Follow Mode is the default mode for most gimbals and is the only useful mode found on camera drones with fixed landing struts, such as DJI Phantoms. In Follow Mode, a pilot can fly the drone around and expect the camera to follow as the drone turns. All pitching and rolling of the aircraft due to stabilization or navigation are completely removed, and abrupt yaw motion is smoothed out, allowing only large yaw motions (navigation panning). The vast majority of drone videos are shot using Follow Mode.

- Free Mode, in which all three of the gimbal axes are fixed in orientation. In Free Mode, the gimbal prevents all aircraft movement from reaching the camera platform, regardless of aircraft orientation. Video footage captured in Free Mode from a nonmoving camera drone often looks like it was captured using a tripod. Free Mode is the most common gimbal mode for dual-operator flights, during which piloting and camera operations are separate duties, each controlled by a dedicated operator and remote controller. See http://ech.cc/gimbal-free-mode for an example of how effective a DJI Inspire 1's Free Mode stabilizes its camera during aggressive flight.

- Advanced gimbal modes tied to smart flight modes. One example of a smart flight mode is Point of Interest, or Region of Interest, during which the gimbal is kept oriented toward a fixed point in space (such as a person standing on the ground). Another is Follow Me, during which the camera drone can be asked to keep a moving subject in frame using a combination of drone and gimbal orientation. DJI's FPV Mode is used to simulate fixed-wing flight and to allow a pilot to see the roll orientation of the drone. In FPV Mode, rolling your drone to the side will result in rolling the gimbal (and the horizon will no longer be straight).

NOTE *Follow Mode and Free Mode are the terms used by DJI. Other manufacturers may have different terms for equivalent modes.*

Some camera drones include custom buttons on the remote controller that can be mapped to useful gimbal shortcuts. The 3DR Solo features two custom buttons on the front of the remote controller that are designed to be mapped to flight modes. Its remote also features dedicated gimbal controls. DJI remote controllers feature similar custom buttons that are most typically used by operators to control gimbal features (**FIGURE 4.4**). In dual-operator mode, the pilot and camera operator can each map their own custom functions to the custom buttons.

The DJI Inspire 1 is a common camera drone for dual-operator flights because the landing gear retracts, giving the camera an unrestricted 360° range for panning. The versatility in motion gives the gimbal additional modes of operation, and custom buttons become extremely useful for accessing features that are used often.

FIGURE 4.4
Some camera drone remote controllers feature custom buttons that can be mapped to gimbal modes, flight modes, and other useful settings.

Custom A and B buttons on a 3DR Solo remote controller

A spring-loaded rocker, used to control gimbal pitch and roll

Custom buttons on the back of a DJI Phantom 3 remote controller

I like to configure my Inspire 1 custom buttons so C1 resets gimbal yaw and C2 toggles between Free Mode and Follow Mode (**FIGURE 4.5**). In typical use, I might fly in Follow Mode with the camera pointing forward until I see a subject I want to film. I will yaw the aircraft and pitch the gimbal until my composition is roughly where I want it to be. From here, I'll sometimes press C2 to toggle from Follow Mode to Free Mode, which locks the gimbal orientation in place. This leaves me free to fly the Inspire 1 however I'd like to, and the camera orientation will never change. When I'm done, I can use C1 to reset the gimbal yaw so it's facing forward again and press C2 to get back to Follow Mode.

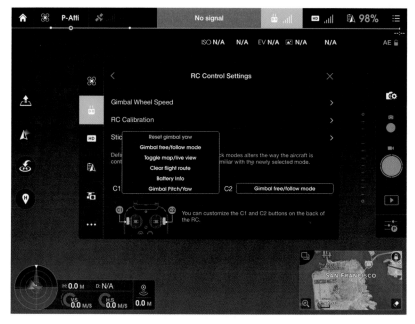

FIGURE 4.5 Mapping remote control custom buttons C1 and C2 for use with a DJI Inspire 1

Another commonly used custom setting is Gimbal Pitch/Yaw, which toggles the gimbal rocker wheel so it controls either pitch or yaw, so you can move the camera up and down or side to side (but not both at the same time).

If you need to control both pitch and yaw at the same time and don't want to pilot the drone to control yaw while using the gimbal wheel for pitch, you can also tap and hold your finger down on the FPV display in the DJI GO app (**FIGURE 4.6**). You'll see a white dot where you initially tapped and a turquoise

circle at your finger's current position. By dragging your finger around on the screen, you can move the gimbal in any direction, with its velocity controlled by the distance between where you originally tapped and your current finger position. This feature also works if you are using a DJI Phantom 3, but only pitch control is supported.

FIGURE 4.6 In the DJI GO app, tapping, holding, and dragging is an effective way to change the orientation of a DJI gimbal.

Camera drones that do not have retractable landing gear have fewer options when it comes to gimbal operation, but software is starting to evolve to compensate for the lack of gimbal freedom in the yaw direction. Some drones abstract the experience to simple camera control; the actual aircraft orientation becomes irrelevant to the pilot, who needs only to think about what camera movements are required. These control schemes are still in their infancy in the consumer camera drone market but are sure to develop quickly as demand escalates for simpler interfaces.

Gimbal Speed

Obviously, the quality of camera movements is extremely important when shooting video. Most movements should be slow, smooth, and considered, with fast movements used only when necessary (for example, in an action scene, when you might want to purposefully create excitement or discomfort). Manual gimbal controls are still fairly simple, with position-sensitive rockers and wheels that allow for variable-speed movements. These have not yet been tuned to the complete satisfaction of serious filmmakers who are accustomed to using dedicated remotes for gimbal control but are a huge step forward when compared to some of the first attempts, which used simpler mechanical controls or buttons on a screen. These older interfaces were impossible to use to create pleasing movements.

Most single operators using DJI products elect to turn down the maximum gimbal speed (**FIGURE 4.7**). This is known as the maximum *rate* in the RC world. This decreases the movement speed of the gimbal across the full range of the control wheel, giving pilots more gimbal control but removing the ability to turn a camera quickly. I like to set mine at somewhere between 30 and 50 (out of 100).

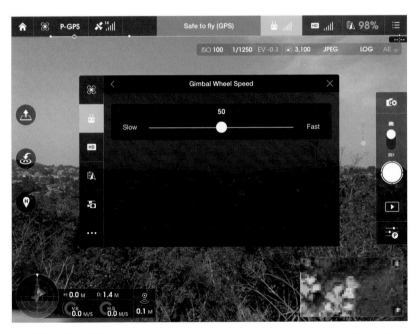

FIGURE 4.7 DJI GO allows pilots to limit the maximum speed a gimbal can move.

Dual-operator setups also support advanced customization of gimbal control, allowing for the control rates of various axes of movement to have curves applied to them (as opposed to a enforcing a linear response). These settings are usually labeled as "EXPO," which is short for exponential curve, and are typically used to increase or decrease stick sensitivity near the center of a stick's range and change responsiveness based on the selected curve when a stick is farther away from the center. Tuning EXPO is beyond the scope of this book, but there is plenty of online material that discusses EXPO and how to use it.

Automatic gimbal controls are starting to appear in smart flight modes and mobile apps released by both manufacturers and third-party app developers. Features designed for aerial videography use smooth, natural gimbal movements, with easing applied at the beginning and end of all movements. These new apps and flight modes will help new drone pilots execute the kinds of camera movements that experienced drone teams achieve through countless hours of practice and experience.

Gimbal Tuning and Calibration

Gimbals are complex systems and are comprised of a gimbal controller, inertial measurement unit (IMU), camera platform, electronic speed controls (ESCs), and brushless motors. Their components are similar to what comprises a drone, only instead of stabilizing an aircraft while flying, a gimbal stabilizes a camera platform. Gimbals work well only when they're tuned to a particular configuration that includes the weight of the stabilized payload. Furthermore, balance is critical, and pushing the center of mass too far off any single axis can cause failure, sometimes resulting in a motor burning out.

Most gimbals currently in use either were designed as part of an integrated camera drone or were made specifically for one camera model (such as a GoPro) or a narrow range of camera types. These gimbals are typically pretuned at the factory and do not need any additional calibration or tuning to work well. However, a gimbal might sometimes need calibration, especially if it was bumped hard in a crash or during transit. Gimbals all ship with calibration tools, which range from being nearly unusable to being really simple to use.

There are two kinds of gimbal calibrations that aerial videographers might need to do in the field.

- Gimbal IMU calibration (usually just called *gimbal calibration*), during which a gimbal's IMU measures acceleration and motion in all directions and declares, "I am now level." This levels the gimbal and also prevents it from drifting. Early gimbals required special mounts to perform IMU calibration because the IMU had to be positioned exactly level, but newer gimbals are able to autocalibrate in a wide range of environments. The latest DJI camera drones can be auto-calibrated with a single tap, using the DJI GO app from a smartphone or tablet.

- Gimbal roll adjustment, during which an operator manually adjusts gimbal roll in order to level the horizon (**FIGURE 4.8**).

FIGURE 4.8 Manually adjusting the gimbal roll position during a DJI Phantom flight via the DJI GO app

Most gimbals that are purchased ready to use can be calibrated by users, but more serious tuning usually requires a trip to the manufacturer for repair. Homemade gimbals can be built using a variety of third-party gimbal controllers like SimpleBGC (**FIGURE 4.9**). These gimbal controllers have entire guides dedicated to tuning, and one can spend many hours to ensure perfect operation of such custom setups.

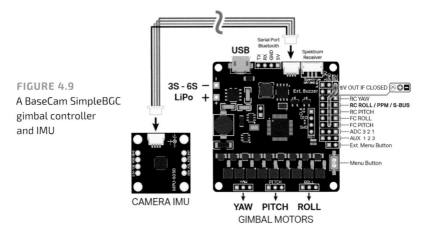

FIGURE 4.9

A BaseCam SimpleBGC gimbal controller and IMU

CAMERA IMU

YAW PITCH ROLL
GIMBAL MOTORS

Gimbals and Filters

As I have mentioned, when using accessories such as lens filters on gimbaled cameras, you need to be careful that you are not upsetting the balance too much. There are a couple ways to help figure out whether a filter or other accessory will work well on a particular gimbal.

- If it's made by the same manufacturer for use on an integrated gimbal, it is probably OK.

- If it's made by a third-party manufacturer specifically for use on a gimbaled camera, it might be OK. Do a web search and read reviews to see whether others have had success.

In general, gimbals are built with a bit of latitude when it comes to payload weights and will support lightweight accessories, especially if they're close to the centers of rotation. Because of mechanical advantage, a lightweight accessory far away from a center of rotation will require a lot more force to move than an accessory close to the center of rotation.

If you're worried about gimbal balance, you can try to compensate by adding weight on the other side of the imbalance. Many hobbyists did this, for example, when adapting gimbals made for the GoPro HERO3 to work with the HERO4. They glued a single penny to the side of the gimbal's pitch motor, which seemed to balance the 14-gram weight difference nearly perfectly. A word of warning: Making these modifications will likely void your warranty, so proceed with caution.

Camera Settings

Camera settings for videography differ from settings a photographer might use when shooting stills, but many of the fundamental issues are the same. If you haven't yet read Chapter 3, I recommend going back and reading it before you continue. Chapter 3 includes a lot of discussion about the current state of integrated camera drones and the cameras used in aerial imaging. Many of the settings and techniques used in stills capture also apply to videography.

General Settings

Traditionally, digital cameras have treated video and stills separately, and pretty much all cameras feature distinct video captures modes with their own saved settings. Videos add time to the capture equation, and camera settings need to be evaluated for effectiveness both in a single frame and across multiple frames over time.

VIDEO SIZE AND FRAME RATE

In consumer cameras, video size is typically described using between two and four variables. Most cameras include the resolution in pixels (horizontal and vertical or just vertical) and the frame rate. Frame rates can range from 24 fps to 240 fps or so, but some options might require changing a camera from NTSC to PAL, or vice versa. These two options seem like they should have gone away long ago but are still specified for output compatibility with video monitors and broadcast equipment in different global regions.

The additional two variables are usually scanning method, specified often by a *p* or *i* appended to the end of a vertical resolution number or frame rate; and less commonly, bit rate, which describes how much video data is stored per second.

Here are some common options for each variable:

- **Resolution:** 4K/UHD (4096x2160 or 3840x2160), FHD 1080p/i (1920x1080), HD 720p (1280x720), 480p (640x480)

- **Frame rate:** 24p, 25p (PAL) 30p (NTSC), 48p, 50p/i (PAL), 60p/i (NTSC), 120p, 240p

- **Scanning method:** Progressive scanning ("p"), interlaced scanning ("i")

- **Bit rate:** A number in megabits per second (Mbps), not to be confused with megabytes per second (MBps). A lowercase *b* specifics bits, and an uppercase *B* specifies bytes. There are 8 bits in 1 byte (and 4 bits in 1 nibble). I'm not making this up.

It might be easier to look at a common camera drone's video size options, as shown in **FIGURE 4.10**.

FIGURE 4.10 The DJI Phantom 3 Professional's Video Size options

The Phantom 3 Pro, which has been set to NTSC mode here, offers various combinations of 4K at 24/30 fps, and 720p/1080p at 24/30/48/60 fps. Frame rates of 25/50 replace 30/60 fps when the camera drone is in PAL mode.

All of this can be pretty confusing for someone who is new to video, so I'll make some recommendations for the various sizes and frame rates I like to capture. These settings are not camera-dependent, although a camera must obviously support the resolution and frame rate in order to select the size. There are some specific settings I like to use when I shoot GoPro cameras, which can be found in the "GoPro" section later in this chapter.

- **4K/30 fps:** This is my default capture resolution and frame rate. It's the highest resolution for video capture, and 30 fps plays back on computers and the Web in a pleasing manner. Capturing 4K video gives you plenty of resolution for exporting frame grabs to be used as still images and provides plenty of resolution latitude for video editing if you are targeting 1080p for output.

- **4K/24 fps:** I shoot 24 fps when I want my footage to match other footage shot at 24p, which many people consider to be more cinematic in look. 24p is what you're used to seeing in the theater, but it isn't good when the camera is moving too quickly and can easily look jerky during such movements. In aerial video, the camera is almost always moving, so I tend to avoid 24p as much as I can. Also, most computers, phones, and tablets use a 60 Hz refresh rate, and if you do the math, 24 doesn't fit into 60 evenly. This means that playing a video back at 24 fps on most devices will result in playback artifacts even if you shot your video perfectly.

- **1080p/60 fps:** I like to shoot at 60 fps because it produces extremely smooth video, especially when played back on a computer, or via YouTube on Chrome, which has supported 60 fps since late 2014. 60 fps is the native frame rate of most playback devices. It's also extremely versatile; it can be converted easily to lower-frame-rate video and can also be played back at a slower frame rate, which results in slow-motion video.

EXPOSURE

Exposing for video is completely different from exposing for still imagery. In still imagery, the goal is usually to capture a frame that is as sharp as possible (unless you're using blur as a creative effect). When you're shooting

video, you actually want some motion blur to avoid a staccato effect in motion during playback. The general rule is to expose at half your frame rate, so if you're shooting at 30 fps, expose each frame for 1/60 second. If you are shooting at 60 fps, target a shutter speed of 1/125 second. Some people call this *twice* the frame rate because the number is doubled, and it's also referred to as a 180° shutter angle for historic reasons relating to how shutters worked when exposing film.

Shooting at half the frame rate gives each frame a bit of motion blur, resulting in cinematic motion, considered to be natural in look. Longer exposures yield more motion blur and can make motion appear to be "smeary." Short exposures will stop motion in each frame, making movement look staccato and strobed.

Most videographers shoot during the day using neutral-density (ND) filters, which block light out to allow for longer exposure times (**FIGURE 4.11**). A camera shooting at ISO 100 with a lens at f/2.8 might typically require a four-stop ND filter (also called an ND16 because 1 stop = 2x the light; 4 stops = 2^4, or 16x the light) to cut out enough light to hit shutter speeds of 1/60 second. If video is your main goal in learning how to use a camera drone, you should invest in a set of gimbal-compatible ND filters that vary between one and four stops. Polarizers also cut some light out and can be used on their own or in conjunction with an ND filter.

FIGURE 4.11 A set of six filters from Polar Pro, including ND, polarizing, and combination filters

At the moment, it's mostly heavy-lift drones that carry land cameras that feature adjustable apertures. Most integrated and small camera drones use cameras with a fixed aperture of f/2.8, which is considered fairly light-sensitive. A camera shooting at f/2.8, ISO 100 will shoot only at 1/60 second without overexposing the scene after the sun has set. Before sunset, shutter speeds need to be much faster for a proper exposure. Getting to 1/60 second (or 1/125 second, if you're targeting 60 fps) can be tricky, especially if you're working with rapidly changing light levels, but you can also use ISO as a variable in exposure. Getting down to 1/30 second at ISO 100 means that you can shoot at 1/60 second at ISO 200, at the cost of a bit more noise in your footage.

Not having aperture as a variable is a temporary problem and is likely to change quickly as more sophisticated cameras begin to make their way into small and medium-sized integrated camera drones. DJI's new Zenmuse X5 Micro Four Thirds camera, for example, features both interchangeable lenses and adjustable aperture (**FIGURE 4.12**), which means that photographers will again be free to use aperture as a variable in exposure and could achieve 1/60 second even on a bright-but-overcast day at around f/11, ISO 100. If pushed, an even smaller aperture could be used, but most videographers don't like to stop down too far because the whole image starts to suffer from diffraction softness when the aperture becomes too small. At f/11 and a sensor resolution of 16 megapixels, a shot taken by a Micro Four Thirds camera is already theoretically beyond its diffraction limit.

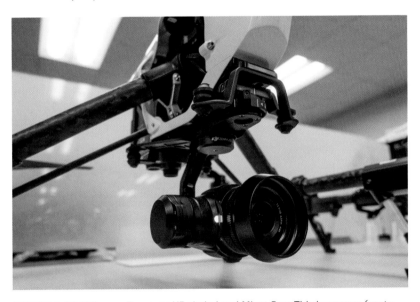

FIGURE 4.12 DJI's new Zenmuse X5 gimbal and Micro Four Thirds camera (prototype, with 15mm lens) brings interchangeable lenses and medium-sized sensors to integrated camera drones.

In the real world, diffraction needs to be balanced with depth of field and potential image degradation from ND filters, so you should do your own tests if you're interested in figuring out how far you can stop down before your image starts to degrade. There is also a lot of web material about diffraction limits—it's worth reading, if this is a topic that interests you.

Regarding exposure, locking it down and shooting manually is usually considered to produce video with a more cinematic feel; one rarely sees exposure

changes during any single clip in a movie. Integrated cameras sometimes support full manual exposure (such as on DJI drones), but action cameras like GoPro HEROs typically support only exposure compensation and not full manual control. If you're shooting a camera that will shoot only in auto exposure, the camera needs to have a good auto-exposure system and be able to transition from one exposure to another smoothly. The Phantom 2 Vision+ was the first integrated camera drone with a brushless gimbal. This offered a lot of convenience, but the camera was unable to move smoothly between exposure levels (it jumped), and as a result, any exposure change during a video essentially ruined its usability.

After all of this talk about manual exposure, ND filters, and 180° shutter angles, it should be noted that the vast majority of hobbyists and mainstream camera owners shoot video using extremely fast shutter speeds, especially during the day, and most shoot in auto exposure. Almost all smartphones use fixed apertures between f/1.8 and f/2.4, so it isn't uncommon to have shutter speeds as 1/1000 second (or faster) in videos taken during the day. I don't hear many people complaining about stroboscopic video; users' tastes may be changing as a result of watching so much video with sharp individual frames.

Video shot from a modern $800 camera drone like the DJI Phantom 3 Standard often looks so good out of the box that it will be more than sufficient for most people's needs, even when run in full auto. All of my most popular videos were shot during the day without using ND filters, and not a single person has complained about anything looking strange aside from the few who have noticed 30p to 24p conversion artifacts stemming from an editor's creative desires.

WHITE BALANCE

Most stills photographers don't think much about white balance when they're out shooting, especially if they're saving to raw formats, which allow white balance (WB) to be changed in post without any loss of quality. But in video, white balance matters a lot. In all but the highest-end systems, video is not saved to raw, and getting it right in camera is important. It isn't necessarily true that white balance can't be changed in post, but it's hard to color-correct when white balance is changing over time.

Most compact cameras used on camera drones do not have sophisticated auto white balance algorithms, and white balance can swing wildly as compositions change within the time and composition of a single clip. Correcting against a moving target is not easy, and it's almost always better to capture using a fixed white balance setting (usually, anything but auto).

I usually set my camera to a "native" WB, if the setting is available like it is on GoPros, for example (**FIGURE 4.13**). Native WB settings are designed to allow the most information to be captured and stored, giving videographers the maximum latitude to color-grade in post. If a native setting isn't available, choosing something close to the current conditions is good enough. Most cameras offer options including "sunny," "cloudy,"

FIGURE 4.13 White balance options on a GoPro HERO4 Black

"incandescent," and custom white balance, which allows you to either point the camera at something that it should consider to be white, such as a white or gray card, or dial in a specific color temperature in degrees Kelvin.

Correct white balance is more critical if the footage you are shooting needs to be used immediately, either via a live broadcast (which I'll discuss later in this chapter) or when timely delivery is critical. In those cases, choose a white balance that looks good out of the camera.

SLOW MOTION

Shooting in slow motion might seem like something reserved for dedicated high-speed cameras, but support is actually built into most recent cameras—even the ones found on relatively inexpensive camera drones. "Slow motion" really just means that footage can be reproduced at slower than real time. Since most video is played back between 24 and 30 fps, any capture at a faster frame rate than that can be played back in slow motion with no loss of quality. For example, video shot at 60 fps played back at 30 fps results in playback at 50 percent of real time, which is convincing as slow-motion footage.

The iPhone 6 and action cameras like the GoPro HERO4 Black can shoot as fast as 240 fps, and Sony's new RX100 IV point-and-shoot camera can capture video at a staggering 960 fps. In these relatively inexpensive cameras, there is typically a compromise between frame rate and video quality. Cameras that were designed to shoot at high speed are expensive and heavy because they have the sensors and imaging pipelines required to capture high-quality, high-speed video.

Although slow motion is most obvious at 60 fps and faster, even shooting at 30p and slowing playback down to 24p (a 20 percent slowdown) can be effective in making movement seem more relaxed or regal.

Video capture at 60 fps+ is no longer a hurdle, but showing the video in slow motion can be difficult if you aren't familiar with editing software. Most editing software, even free and entry-level programs such as iMovie and Windows Movie Maker (or GoPro Studio, for GoPro users), have rudimentary controls for slow-motion playback. iOS and Android apps make it easy to convert high-frame-rate video into slower-playback versions, but they aren't really designed (yet) to work with videos that weren't shot using the host device. For more advanced control of slow motion, I recommend subscribing to Adobe's Creative Cloud and learning Adobe Premiere Pro CC, which has tools sophisticated enough for full film production (**FIGURE 4.14**).

FIGURE 4.14 In Adobe Premiere Pro CC, interpreting a clip as 29.97 fps instead of 59.94 fps results in slow-motion playback at 50 percent real-time.

In terms of camera motion and action, it's usually more effective to fly a drone quickly and to capture motion that is also happening quickly. Attention span is a rare commodity these days, and if your clip doesn't fit into 10 to 15 seconds, you'll likely have lost the majority of your audience by the end.

If you decide you're interested in capturing slow-motion video from the air, shoot at the frame rate that gives you the slowdown you desire, and familiarize yourself with the relevant adjustments in post-production using your chosen video editor. Once a video is slowed down in post and exported at normal frame rates, it will play back in slow motion everywhere, even if you upload it to YouTube or Vimeo for sharing.

Here are two links to sample slow-motion clips:

- Aerial rocks and surge, played back at 50 percent speed (shot with a DJI Inspire 1 at 60 fps and played back at 30 fps): http://ech.cc/droneslomo

- Ocean sparkles (land-based), shot with a $5,495 Edgertronic high-speed camera at 700 fps and played back at 30 fps (23x slower than real time): http://ech.cc/oceansparkles

STORAGE SPEED

Capturing video, especially in 4K, is data-intensive, and some of the small cameras used in consumer camera drones capture video at up to 60 Mbps, which is 7.5 MBps. At that rate, an 8 GB media card will fill up in just under 18 minutes, and obviously, the media card needs to be able to sustain a write speed of at least 7.5 MBps. Some cameras will detect slow media cards and display a warning, but not all do. Most cameras will do just fine with an SD or microSD card that is labeled "UHS-1" or "Class 10," both of which indicate that they can sustain writes of 10 MBps.

If you're using higher-end cameras that capture video at bit rates higher than 60 Mbps, you will need to use even faster media.

PROFESSIONAL CAPTURE MODES

Some consumer and prosumer cameras feature capture settings that are designed to retain the most information possible when shooting video so editors have the latitude to make adjustments in post. These capture formats usually bypass filters that are applied to video to make them look good to humans, resulting in video that is unsaturated, unsharp, and flat in appearance. A good editor can then shape the video into the desired style for the final product.

Both GoPro and DJI have professional capture modes built into their cameras; I'll talk more in detail about these modes later in this chapter.

Integrated Cameras

Chapter 3 contains a great deal of information about the benefits and disadvantages of using integrated camera drones for aerial imaging. For video, one of the obvious benefits is that pilots can both start and stop video at will, capturing only footage that was meant to be saved. Full manual exposure and remote control of deep camera settings are other important benefits, as is integrated FPV.

Another difference is that the lenses currently used on camera drones like the DJI Phantom 3 and Inspire 1 are less wide than those commonly found on action cameras like GoPros. Most action cams use ultra-wide fisheye optics (**FIGURE 4.15**) because the cameras are designed to capture people doing things close to the camera (the cameras are often mounted on the people themselves to capture the user's point of view).

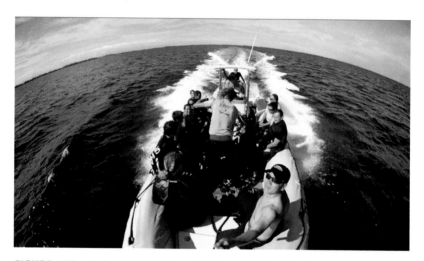

FIGURE 4.15 A GoPro camera doing what it was designed to do: capturing content close to the camera. Wide-angle, fisheye distortion makes the horizon bubble-shaped.

Fisheye optics allow for a large field of view (FOV) using small optics, and the combination of wide-angle optics and small sensors provide a deep depth of field in which almost everything is in focus at the same time. In contrast, the DJI Phantom 3's camera has an FOV of about 94°, which is similar to a 20mm, rectilinear lens on a full-frame camera (as opposed to the 170° lens on the GoPro HERO4). Rectilinear lenses yield straight lines with little to no barrel distortion and look more natural. Most serious aerial GoPro shooters remove distortion during post-processing or shoot in modes that are less wide, sacrificing some resolution in the process.

This lens difference is likely to be temporary; some of the latest action cameras are available with lenses that are less wide with less barrel distortion, and there will probably be many models to choose from in the future. But at this moment, one of the benefits of using integrated cameras is that the lenses yield more natural-looking images out of the camera.

REMOTE CONTROL

I mentioned earlier in this chapter that the remote control of camera settings is an important feature of integrated camera drones. Using a DJI Phantom 3, you can, in a single flight, shoot a bunch of still images and record many videos in multiple resolutions, frame rates, and exposures, all without landing or feeling like you have to jump through hoops to change settings. The user experience in well-designed camera drones should make you feel like you're operating a camera in your hands, and attention to detail makes a big difference.

DJI's LOG Mode

DJI's Inspire 1 and Phantom 3 camera drones feature a capture mode called LOG mode, which can be accessed in the Color settings of the camera via the DJI GO app (**FIGURE 4.16**). Shooting in LOG mode results in the standard log-mode effects: less saturation, less sharpening, and a flat look from a gamma curve that maximizes data in the resulting file.

FIGURE 4.16 Selecting LOG mode in the DJI GO app

Competent editors can grade and sharpen this video to get it to look good, but you can also use DJI's Inspire 1/Phantom 3 transcoding tool to add the punch back into the video, saving an intermediate file as high-bitrate Apple ProRes 422LT. Note that this makes for absolutely gigantic files—about 60 MBps for 4K footage, or 3.6 GB/minute. The transcoding tool is available from the download pages at dji.com.

Feedback from users suggests that learning to color grade in an editor like Adobe Premiere Pro yields equivalent results and a more convenient workflow than using the DJI transcoding tool to create an intermediate working file.

GoPro

Both integrated and third-party cameras have been used successfully to capture beautiful aerial video, and both kinds of cameras have benefits and disadvantages. With the ever-popular GoPro models, as with any camera, it's important to make sure your settings match what is required to accomplish your aerial storytelling goals.

PROTUNE

GoPro's ProTune is a professional setting that enables higher-bitrate capture (up to 65 Mbps for 4K video) and settings to control white balance, color, ISO, sharpness, and exposure compensation (**FIGURE 4.17**).

I always shoot in ProTune unless I need to deliver small files to someone immediately after a shoot. These days, computers are fast and hard drives are cheap, so there is almost no reason to skimp on capture quality.

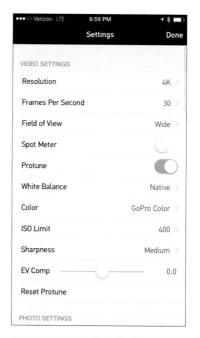

FIGURE 4.17 GoPro's ProTune settings for video on a HERO4 Black

VIDEO SIZE AND FOV

GoPro HERO cameras have a wide variety of video size variables that can be mixed and matched in different combinations. In the "Video Size and Frame Rate" section earlier in this chapter, I wrote about some of my favorite settings to use when shooting video from the air. GoPro cameras have another variable to consider: field of view, which can be set to wide, medium, or narrow. The various combinations of resolution and FOV settings result in a wide range of captured image quality and actual FOV. My favorite settings to use when shooting a GoPro HERO3+ Black or HERO4 Black in the air are the following:

- **4K (2.7K on HERO3+ Black), 30 fps, Wide FOV, Protune on, Native White Balance, GoPro Color, ISO Limit 400, Sharpness Low, EV Comp as needed:** This is my default setting because it is the highest resolution for capture in the highest capture quality, with the exception of using GoPro Color instead of Flat. I find GoPro Color to be close to what I want my end product to look like, so I choose to allow the camera to make the video pop instead of forcing me to do it in post.

- **2.7K, 30 fps, Medium FOV, Protune on, Native White Balance, GoPro Color, ISO Limit 400, Sharpness Low, EV Comp as needed (HERO4 Black only):** The 2.7K Medium setting on the HERO4 Black is a 1:1 crop from the center of the sensor and looks great. You might ask why you would shoot at 2.7K instead of 4K if the crop uses 1:1 subsampling (which would be similar to just cropping from the 4K image in post). The answer is that the available data rate is used for the 2.7K video frame, which means that video shot at 2.7K Medium is better than cropped video shot at 4K Wide.

- **1080p, 60 fps, Wide FOV, Protune on, Native White Balance, GoPro Color, ISO Limit 400, Sharpness Low, EV Comp as needed.**

I have focused on the GoPro HERO3+ Black and HERO4 Black here, but you can use similar decision-making principles when determining what size, FOV, and other settings to choose on other cameras. If you do happen to be using a HERO4 Black, I highly recommend reading Cinema5D's article "How to get best quality from GoPro HERO4 Black," at www.ech.cc/gopro4best.

ISN'T THE EARTH FLAT?

The fisheye barrel distortion that I mentioned earlier can easily be seen in the picture of Stanford University, which was taken with a GoPro HERO3+ Black on a DJI Phantom 2 and Zenmuse gimbal (**FIGURE 4.18**).

This kind of distortion is more pronounced the further from the center of the image you look. Near the top and bottom of each frame, horizontal lines bow outward aggressively, and near the left and right sides of the frame, vertical lines distort. In a still image, some folks might actually prefer this look, or at least not be bothered too much by it, and in close-up action videos in which the subject is close to the frame doing something crazy, one might not even notice. But in aerial video, the distortion is obvious, especially if a camera is pitched up or down at any point.

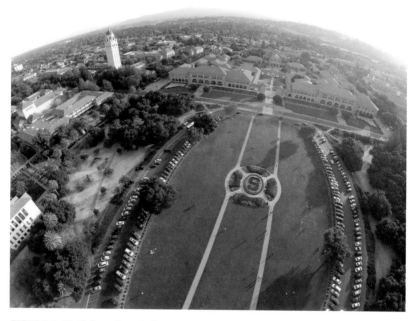

FIGURE 4.18 Fisheye barrel distortion from a GoPro

GoPro provides a Remove Fisheye option in its GoPro Studio desktop app, which is the most convenient way to correct for the distortion found in all videos captured by a GoPro. However, the fisheye removal process also transcodes the video, which can take a long time on slow computers and results in large intermediate files (**FIGURE 4.19**).

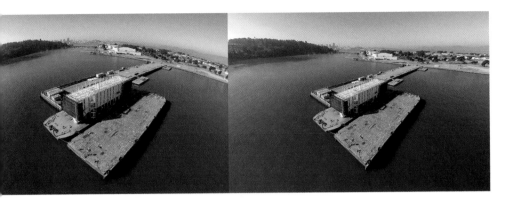

FIGURE 4.19 An aerial image of Google's secret barge in Alameda, California, before and after fisheye distortion removal

Adobe Premiere Pro CC users can take advantage of built-in lens distortion removal presets for GoPro HERO2, HERO3 Black, and HERO3+ Black.

▶ **GOPRO WIRELESS AND DRONES**

As a reminder, be careful with a GoPro's built-in wireless connection when using your GoPro on a drone. If your drone communicates in the unlicensed 2.4 GHz frequency band (it probably does), you should disable the GoPro's wireless connection before flying.

Aerial Video Techniques

Aerial videography is exciting because it removes many of the limitations you face while tethered to the ground. Not only can cameras now be sent higher than the tallest of cranes, but they can pass through openings and between objects, all while shooting silky-smooth, gimbal-stabilized video.

Almost all the stills photography techniques and tips in Chapter 3 apply to aerial videography, and I recommend reading that section before continuing. These guidelines and tips are suited only to aerial video, mostly because they involve movement over time.

Tilt Up/Down

Tilt up/down (**FIGURE 4.20**) is one of the simplest maneuvers you can do using a camera drone, but it's actually quite difficult to do in a way that looks natural. Using your drone's gimbal pitch control, tilt your camera up or down. Remember that videography is all about storytelling. What can you accomplish by tilting the camera? You could be following a subject as it moves by you, tilting up to reveal an establishing shot, or tilting down from an establishing shot to focus on a specific area.

One technical issue that makes tilt up/down difficult is that single-operator gimbal controls are simple and don't always offer an easy way to ease in and out of a camera movement. Some camera drones only have a virtual button on a touchscreen for moving a gimbal, and these kinds of movements feel extremely robotic. A dual-operator setup with a dedicated remote controller for a camera operator usually provides the right tools to achieve eased camera movements, but these setups cost more money and are more complicated to deploy.

FIGURE 4.20 Tilting up from an aerial view of an abandoned warehouse shows its context in downtown San Francisco.

WATCH THE VIDEO
THE AERIAL VIDEOGRAPHER'S CINEMATIC TOOLKIT

Download Chapter04_Toolkit.mov to
see a video example of a tracking shot
(at timecode 01:25 to 01:41), along with
other aerial moves in the cinematic tool-
kit. Please see this book's Introduction
for information on how you can access
and download the video files designed
to accompany this book.

Tracking Shot

In a *tracking shot*, the camera drone follows a subject, moving with it as it
moves. If your subject is moving in a straight line and there are no obstacles
for the drone to avoid (like trees), this shot is pretty straightforward to
accomplish. However, tracking shots can also be difficult to pull off, especially
in environments with many obstacles or when the tracking shot includes
other elements such as camera angle and distance changes during the shot.

Accomplished pilots can execute a tracking shot without thinking and can
even follow subjects whose movements are not planned, but this takes a lot
of practice. If you can fly a figure eight (see Chapter 2), you should be able to
track pretty much anything.

Dronie

In April 2014, Photojojo founder Amit Gupta showed Vimeo cofounder Zach
Klein and *New York Times* writer Nick Bilton (and their three dogs) how to
take a drone selfie on Bernal Hill in San Francisco. Bilton wrote about it in the
New York Times' Bits blog, and the rest was history. It wasn't the first drone
selfie ever shot, but the video went viral, and the word *dronie* was coined, short
for "drone selfie." You can see the original video at www.ech.cc/dronieorigin.

To take a dronie, fly your camera drone in front of you and turn it around so
the camera is facing you. Making sure that you have plenty of space behind
and above the drone, fly backward quickly while ascending. You might also
have to slowly tilt the gimbal down as the drone ascends.

Crane Up/Down

In *crane up/down* (**FIGURE 4.21**), the camera drone moves straight up and down. This technique can be used to transition from a subject on the ground to a shot that shows the surrounding environment. It can also be used to start from a wide establishing shot up high, ending near the ground right in front of a subject. Crane up/down can also be combined with other techniques, such as tilt up/down. An effective combo technique is to crane up while tilting down. The subject stays in frame the entire time, but the camera moves up and ends in an overhead view.

Orbit

An *orbit*, also called an *arc* or *point of interest* (POI), is a maneuver in which a drone flies in a circle around a subject, keeping the camera pointed inward the whole time. Orbit is one of the practice exercises in Chapter 2 and is considered an advanced piloting technique. Orbits are

FIGURE 4.21 A combination crane up/ tilt down keeps the subject in frame as the drone ascends straight up in the air.

used in big films all the time because they are effective for showing a subject in a big environment in a dynamic and dramatic way.

Drones are effective in orbits because they are versatile. A drone can get close to a subject during the start of an orbit and pull out as it circles away, revealing the subject, the environment, and the relationship between the two.

These are just a few aerial video techniques I like to keep in my drone cinema "toolkit." The real lesson is that camera drones are really just cameras that have freedom of motion in all directions. With enough practice, you'll learn to pilot a drone and operate its camera without thinking, and like in all art forms that require both technology and technique, creativity really starts once the technology fades away from active thinking.

WATCH THE VIDEO DRONIE

To see a dronie in San Francisco taken with a DJI Phantom 2 Vision+, visit www.ech.cc/sfdronie.

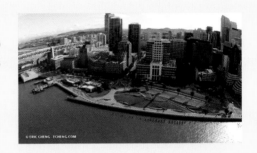

WATCH THE VIDEO ARC/POI DEMONSTRATION

Download Chapter04_Orbit.mov to see a video example of an Arc/POI maneuver, along with other aerial moves in the cinematic toolkit. Please see this book's Introduction for information on how you can access and download the video files designed to accompany this book.

Advanced: Live Aerial Video Streaming

Live streaming video from drones has only recently become a possibility, and media outlets everywhere dream about the day they can have drones overhead to capture video of timely news. The regulatory policy here in the United States makes this complicated (see Chapter 6), but there is nothing currently stopping hobbyists from putting a drone up into the air and streaming video from it.

Using Video Out/HDMI

Live streaming is not new, but for some reason, live streaming from a drone is still novel. Services like Ustream, Google's Hangouts On Air, and YouTube Live all enable just about anyone to push a video feed to the Web in real time (more or less). Streaming live from a drone just involves getting the video signal over to one of those services.

My first attempt to stream video from a drone was in May 2014, and it was not easy. I used a DJI Phantom 2 Vision+ camera drone, pulled an HDMI video feed out of my iPhone using an adapter, and fed it into Google's Hangouts On Air using a specific USB HDMI capture dongle sourced from Taiwan. In the end, I managed to do a live drone broadcast using about $2,000 worth of equipment.

Not long after, I started doing live aerial streaming tests using DJI Lightbridge, which provided a local HDMI output with clean video. Using Lightbridge, I now had a generic video source like what any camera might output, except that my camera could be flown more than a mile away while still streaming video at HD 720p. I took this setup to Burning Man that summer to stream aerial drone footage to the Burning Man Ustream channel (**FIGURE 4.22**).

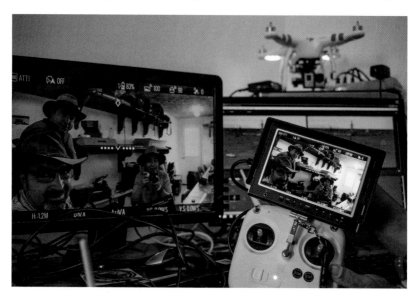

FIGURE 4.22 A Lightbridge ground unit in the Burning Man media container received wireless HD footage any time I put my Phantom 2 in the air. This is a picture of our first successful test, showing me, George Krieger, and Gerard Mattimoe with HDMI from the drone reaching the preview monitor.

In November 2014, DJI released the Inspire 1 camera drone, which included integrated Lightbridge. The remote controller had HDMI output, which now meant that every Inspire 1 owner could output HDMI to live streaming infrastructure.

In February 2015, I went to Iceland with ABC's *Good Morning America* and put two DJI Inspire 1 camera drones on top of the Holuhraun volcano eruption, broadcasting live to six million people (**FIGURE 4.23**). As far as we know, this was the first large-scale live broadcast from a nonmilitary drone. The broadcast was a huge success for us and the network and even yielded the still image that we used for the cover of this book.

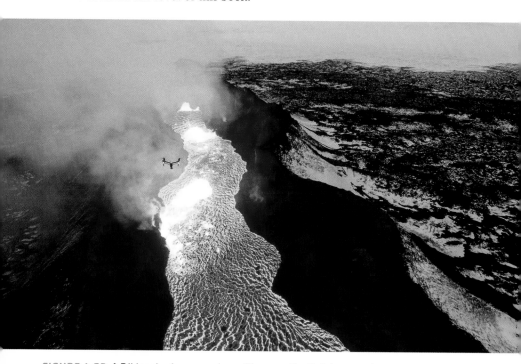

FIGURE 4.23 A DJI Inspire 1 camera drone flies over the Holuhraun volcano eruption in Iceland as part of a live broadcast event with ABC's Good Morning America. See the behind-the-scenes video at http://ech.cc/btsvolcano.
Photo courtesy Eric Cheng/DJI and Ferdinand Wolf/Skynamic.

Now, there are a few camera drones that provide HDMI outputs from their remote controllers, including the DJI Inspire 1, DJI Phantom 3 (optional accessory), and 3DR Solo (**FIGURE 4.24**). In addition, stand-alone wireless digital transmissions systems for drones are available from Paralinx and Connex (**FIGURE 4.25**).

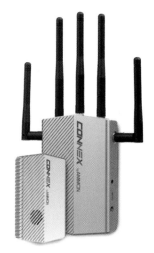

FIGURE 4.24 The DJI Inspire 1's remote controller includes HDMI out.

FIGURE 4.25 The Animon Connex is a zero-latency full-HD video transmission system designed for drones.

▶ DJI LIGHTBRIDGE AND BROADCASTING

DJI Lightbridge outputs video locally via HDMI on its receiver or integrated remote controller at HD 720/60p. The video signal is 1280 x 720 pixels at 60 fps, which is important because it is *not* 59.94p, the broadcast standard. During the Iceland live broadcast event, we spent three days trying to get 720/60p to work with ABC's gear. We did equipment swaps at the volcano (extremely remote, in Icelandic winter), at the satellite receiver bridge in London, and at the final destination in New York. Finally, through some miracle, the 60p signal stabilized, and we were able to go through with the broadcast as planned.

If you plan to use Lightbridge to conduct a live broadcast, you should absolutely test the setup with plenty of time to spare! In theory, DJI's new Lightbridge 2, announced in September 2015, should solve some of these broadcast incompatibilities.

Periscope and Other Apps

Periscope (**FIGURE 4.26**) is Twitter's live streaming app for iOS and Android devices and is probably the easiest way to stream live video from phone. A week after Periscope launched (in March 2015), people attached smartphones to their drones in an attempt to be the first to live stream using Periscope from a drone. The video they captured is probably some of the worst video ever captured by a drone, but they do get to claim it as a first.

Another common live broadcasting service is Shou.TV, which provides both Android and iOS apps that can live broadcast what the phone or tablet screen is showing. Android devices must be rooted to run Shou, and iOS requires a jailbreak for best performance.

Note that live streaming from a smart device that is connected to a drone over Wi-Fi is difficult unless one uses a video output (such as an HDMI adapter) because the Wi-Fi connection takes precedence over the LTE or 3G cell modem. When a Wi-Fi signal is active, the cell modem is not allowed to talk to the Internet. This

FIGURE 4.26 Screenshot of the April 3, 2015, live Periscope dronie, by Air-vid.com

will likely be fixed by a future version of iOS or Android, but in the meantime, it gives the advantage to drones that talk to smart devices using USB, like the DJI Phantom 3 and Inspire 1. Smart devices used with these drones can talk to the Internet over both Wi-Fi and LTE/3G while simultaneously communicating with the drone.

YouTube Live

The easiest way to broadcast live video footage from a drone is to use a camera drone with YouTube Live integration. The DJI Inspire 1 and Phantom 3 were the first camera drones to integrate YouTube Live (**FIGURE 4.27**), a feature that was announced at the Phantom 3 unveiling in April 2015.

The current DJI GO app allows live streaming to YouTube Live with about 20 seconds of latency, during which time YouTube transcodes the video to many different formats and makes the stream available globally. Before you can stream live, DJI GO walks you through the steps required to enable YouTube

Live in your YouTube account. This is, unfortunately, still a fairly rough process, but it's sure to improve as YouTube puts more resources into consumer live streaming. Once YouTube Live is properly set up, you can initiate a live stream with just a few taps, with audio recorded from your mobile device.

Aerial live streaming has the potential to fundamentally change how news about noteworthy events is captured and delivered. YouTube already has countless videos of public events, natural disasters, protests, and many other situations in which live streaming could be beneficial for the general public. Citizen journalists' efforts will most likely start to incorporate drone footage as they realize that live streaming from drones is as easy as it's recently become.

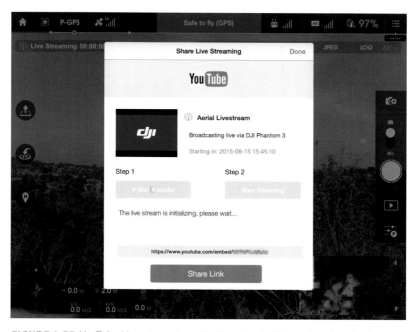

FIGURE 4.27 YouTube Live streaming a DJI Phantom 3 flight using the DJI GO app

FLYING OVER NATURAL DISASTERS

Check local laws and coordinate with emergency responders if you would like to fly a drone over a natural disaster. Natural disasters often are accompanied by temporary flight restrictions (TFRs), and flying in the area could hamper efforts by emergency responders who need to use helicopters and other manned aircraft to provide assistance. If you fly a drone in such conditions, you could be arrested and prosecuted.

Post-processing and Sharing

Once you have transferred your aerial video files to a computer or smart device, they are now just videos, and post-processing works the same way it would for any project and associated video sources. Most modern integrated camera drones provide a way to copy pictures and videos directly to a smart device via a wireless signal, but it's almost always faster to remove the memory card and transfer the media directly.

There are, however, some interesting efforts going on to help edit and share aerial videos quickly. DJI is particularly interested in this space, and the DJI GO app includes a built-in video editor that allows for quick selection and clipping of desired footage, followed by timeline layout and music selection based on templates (**FIGURE 4.28**). GoPro has also announced an interest in cloud-based video editing and sharing.

FIGURE 4.28 The DJI GO app includes a built-in video editor that can share directly to Skypixel, DJI's hosted aerial imaging community, or save to the Camera Roll.

The DJI GO video editor does require that media be transferred to the app, which happens via Lightbridge when the drone and remote control are both powered on. Early efforts such as this are heartening because video editing and sharing are currently such painful and time-consuming processes. Most aerial videographers want to cut and share a quick edit of their flight, even if they plan to do a more considered, high-quality cut later. DJI GO's editor bypasses the computer altogether and provides a quick path to share to Skypixel, DJI's sharing platform, or to save to the Camera Roll for uploading to social sharing platforms via other methods.

The Future of Aerial Videography

The future of aerial videography is bright. Camera drones are in their infancy, and we don't yet know how they will evolve in the future. Certainly, we'll see hardware advances in every functional area of a drone: flight controller, sensors, batteries, propulsion systems, cameras, gimbals, wireless systems, and so on. In the short term, we can expect improvements in camera quality, system redundancy, flight time, and more.

It's likely that a functioning sense-and-avoid system will appear sometime before the end of 2016 as sensors are embedded in drones to help them do real-time reconstruction of their environments. At the moment, drones are essentially flying blind, with little knowledge of their surroundings, which is why early efforts at automatic flight algorithms like Follow Me are so rough.

Speaking of automatic flight, we're already seeing an evolution in ground station software; instead of relying on dumb waypoints that users put down on a 2D map, cinematic toolkits currently in development allow planning and previsualization of flight paths in 3D environments. When a drone operator is happy with the plan, she can simply put a drone on the ground and hit Play to execute the mission. Because the software is designed for cinematography, the appropriate timing and easing controls are integrated, allowing flexibility to account for timing variation between takes and smoothing all motion so everything looks natural.

Advanced autonomy in flight is certainly going to be part of how we capture aerial footage in the future, especially in cases that don't require explicit path planning by a human. The ultimate Follow Me camera drone will appear at some point in the future, and it will be able to navigate in diverse environments without hitting anything.

Finally, we can expect camera drones to get smaller and smaller. There are already small and light drones that carry HD cameras, but the poor quality of both cameras and flight controllers prevents them from truly being useful. Once decent cameras shrink down in size and weight, we'll see usable camera drones that weigh just a few ounces and can navigate by themselves.

Most of the challenges we'll face in this industry are regulatory and cultural. We can already see technological progress accelerating exponentially, as it always does when something new becomes popular. Technology will not be an issue. However, people are not used to drones flying around, and much remains unclear about how regulatory and cultural issues will shape the direction of camera drone usage. I'll talk about these issues in detail in Chapter 6.

CHAPTER 5

Getting the Shot: Real-World Stories

Photography is about storytelling, but each picture really represents two different storylines: the story that a picture tells visually or inspires in a viewer and the story behind the shot. I love both kinds of stories, and this chapter presents aerial images captured by camera drones, along with their behind-the-scenes stories. I've also invited three guest artists to contribute stories to the mix. Their biographies are listed next, along with links to where you can find more of their work.

Photo: Ragnar Sigurdsson

Guest Artists

Julian Cohen was incredibly fortunate to be able to retire early in life from a professional career in the foreign-exchange markets and pursue his first love, underwater photography. When I showed him the first DJI Phantom a couple of years ago, his interests started to migrate vertically from the water to the air. He now travels extensively, still shooting underwater as well as aerial images, which has added considerably to his excess baggage charges.

Website: www.juliancohen.com/

Born and raised in Switzerland, **Romeo Durscher** moved to San Jose, California, to work on a NASA space mission. After almost 13 years of working on NASA's Solar Dynamics Observatory, doing project management, education, and public outreach, as well as social media, Romeo has joined DJI as Director of Education. He advises and educates organizations, industries, government, and individuals on beneficial use and safe integration of unmanned aerial systems.

Twitter: @RomeoCH
Website: http://visual-aerials.com/

Renee Lusano is a designer from Los Angeles who loves to travel the world with colorful hair and with her drone, taking photos and dronie videos that she features on Instagram and her blog.

Instagram: @wrenees
Website: www.wrenee.com/

All the images shown in this chapter are mine (Eric Cheng) except where

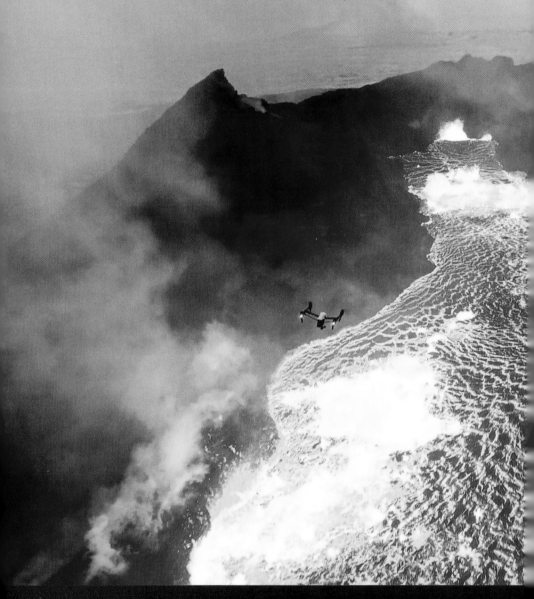

Holuhraun Volcano (2015)

In January 2015, I helped ABC's *Good Morning America* to broadcast live from the Holuhraun volcano eruption in Iceland. Ace pilot Ferdinand Wolf and I flew two DJI Inspire 1 units from about a mile away to stream live HD footage of the erupting lava lake to more than 6 million viewers.

These flights were extremely challenging to accomplish. We had to deal with freezing temperatures, strong winds, and snow, all in a remote location with no facilities. Luckily, the Inspire 1 units handled the harsh environment with relative ease, although all the drones we used were melted to some degree. See the video at www.ech.cc/btsvolcano.

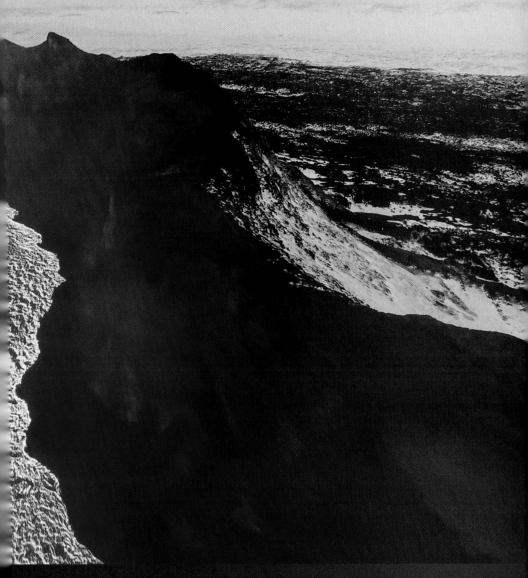

LOCATION
Holuhraun volcano eruption;
Bárðarbunga volcanic system, Iceland

ARTIST
Eric Cheng/DJI and Ferdinand Wolf/
Skynamic

EQUIPMENT
DJI Inspire 1

SHOT DETAILS
Screenshot from 4K video footage

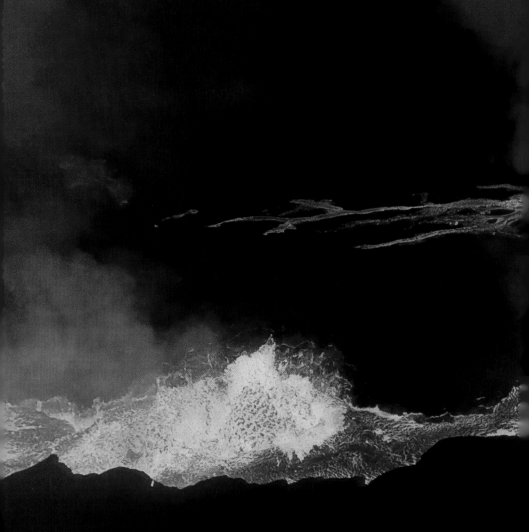

Holuhraun Volcano (2014)

In September 2014, I went to Iceland with a Phantom 2 and a small crew. Holuhraun volcano had begun to erupt just a month earlier. We obtained the necessary permits and were allowed to get close enough for our small camera drone to fly over the exploding lava lake. This was very different than the January 2015 trip—just four of us in two vehicles, testing the limits of what might be possible with camera drones. During the last flight, my drone's GoPro melted and stopped working (and I lost FPV). I asked the drone to return home, and a few minutes later, it actually came back! The footage survived. See the video at www.ocb.cc/dronevolcanohts

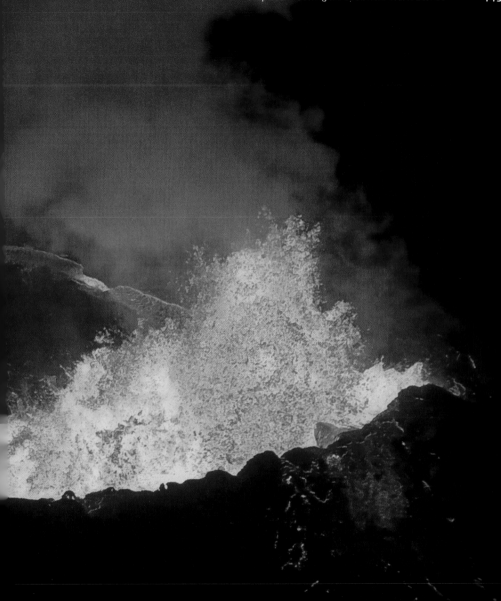

LOCATION
Holuhraun volcano eruption;
Bárðarbunga volcanic system, Iceland

EQUIPMENT
DJI Phantom 2, Zenmuse H3-3D
gimbal, GoPro HERO3+ Black, DJI
Lightbridge, Atomos Ninja Blade field
monitor/recorder

SHOT DETAILS
Screenshot from GoPro video shot at
2.7K, 30 fps, Medium FOV, EV -1.7

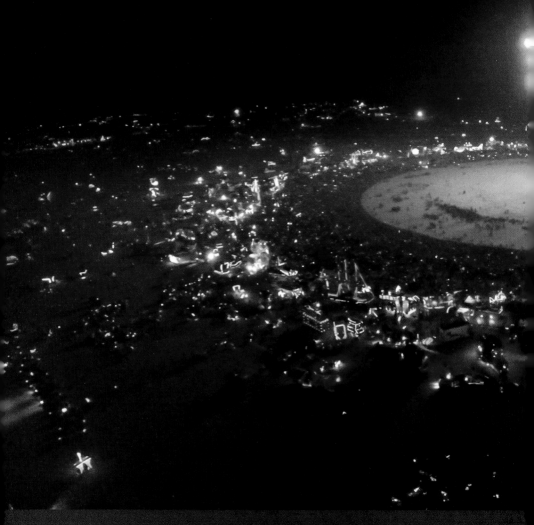

Man Burn

In 2014, I was part of the Burning Man media team, flying drones around the event and streaming the aerial footage live to Burning Man's Ustream channel. The low-altitude aerial perspective was really effective at showing the scale of the event. See the video at www.ech.cc/bmdrone2014.

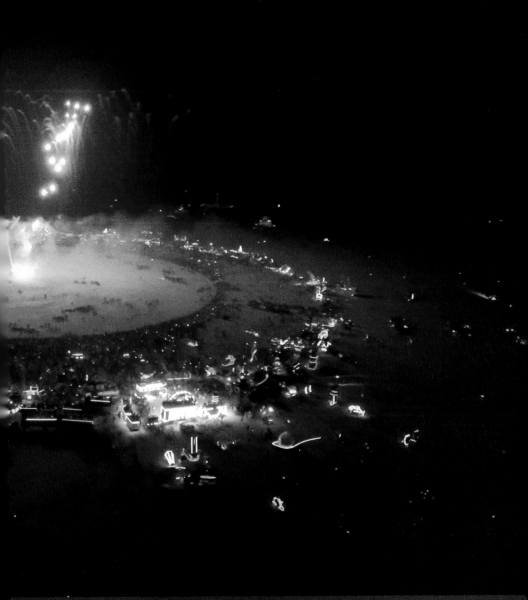

LOCATION
Black Rock City, Nevada

EQUIPMENT
DJI Phantom 2, Zenmuse H3-3D
gimbal, GoPro HERO3+ Black, DJI
Lightbridge, Lilliput HD field monitor

SHOT DETAILS
Screenshot from GoPro video shot at
2.7K, 30 fps, Medium FOV, EV -1.7

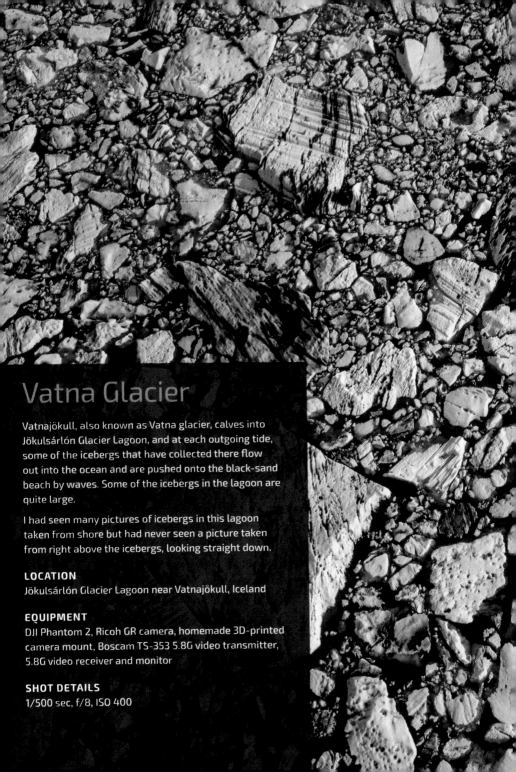

Vatna Glacier

Vatnajökull, also known as Vatna glacier, calves into Jökulsárlón Glacier Lagoon, and at each outgoing tide, some of the icebergs that have collected there flow out into the ocean and are pushed onto the black-sand beach by waves. Some of the icebergs in the lagoon are quite large.

I had seen many pictures of icebergs in this lagoon taken from shore but had never seen a picture taken from right above the icebergs, looking straight down.

LOCATION
Jökulsárlón Glacier Lagoon near Vatnajökull, Iceland

EQUIPMENT
DJI Phantom 2, Ricoh GR camera, homemade 3D-printed camera mount, Boscam TS-353 5.8G video transmitter, 5.8G video receiver and monitor

SHOT DETAILS
1/500 sec, f/8, ISO 400

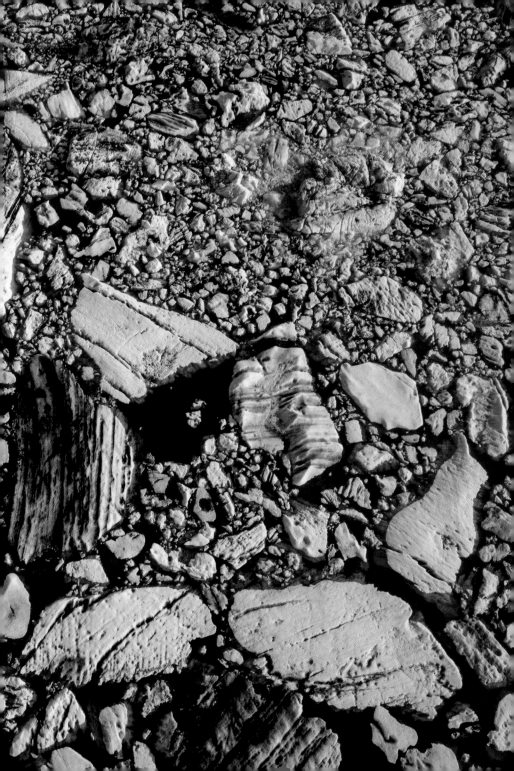

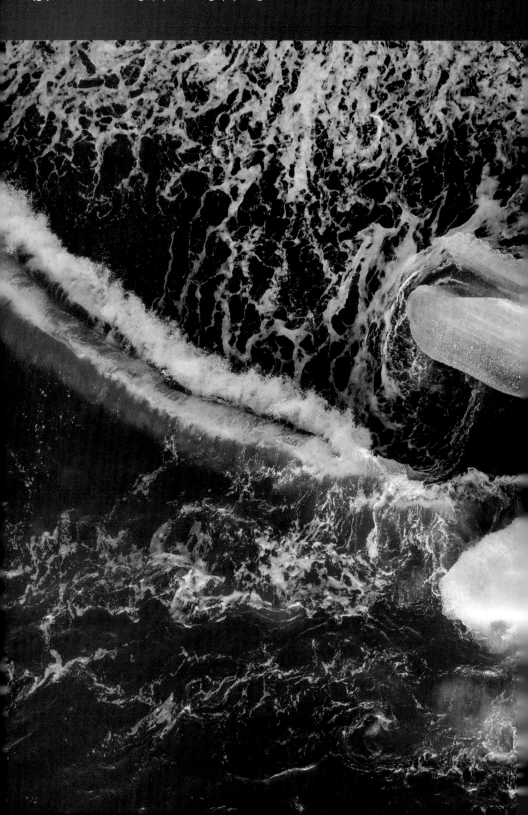

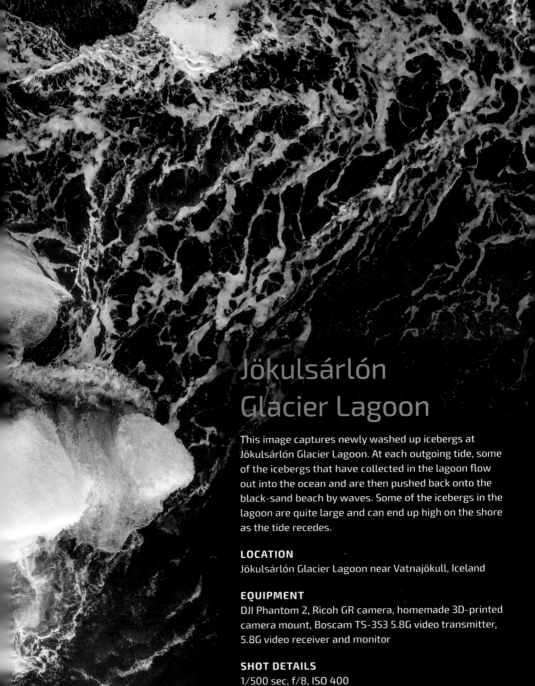

Jökulsárlón Glacier Lagoon

This image captures newly washed up icebergs at Jökulsárlón Glacier Lagoon. At each outgoing tide, some of the icebergs that have collected in the lagoon flow out into the ocean and are then pushed back onto the black-sand beach by waves. Some of the icebergs in the lagoon are quite large and can end up high on the shore as the tide recedes.

LOCATION
Jökulsárlón Glacier Lagoon near Vatnajökull, Iceland

EQUIPMENT
DJI Phantom 2, Ricoh GR camera, homemade 3D-printed camera mount, Boscam TS-353 5.8G video transmitter, 5.8G video receiver and monitor

SHOT DETAILS
1/500 sec, f/8, ISO 400

Lake Mývatn

My wife and I were staying at a small hotel across the street from Lake Mývatn during a vacation to Iceland, and when she went out for a run one morning, I sent the camera drone up to follow her. Quickly I discovered that these pseudocraters were a more interesting photographic subject, so I veered off to investigate. (I don't think my wife noticed—she ignores my hobbies!) Pseudocraters (rootless cones) are formed by steam explosions originating from running lava flowing over wet surfaces.

LOCATION
Lake Mývatn, Iceland

EQUIPMENT
DJI Phantom 2, Ricoh GR camera, homemade 3D-printed camera mount, Boscam TS-353 5.8G video transmitter, 5.8G video receiver and monitor

SHOT DETAILS
1/400 sec, f/6.3, ISO 400

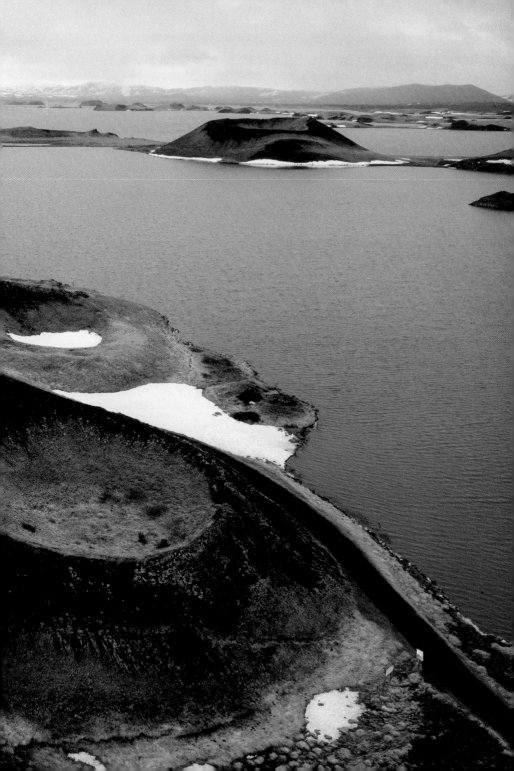

DC-3 Plane Crash

A U.S. Navy DC-3 plane crashed on the black-sand
beach near Sólheimasandur, Iceland. The plane, which
went down in 1973 because of engine freeze-up (the
whole crew survived), is unmarked and must be found
by using GPS (pull off the road at 63.491338, -19.363403
and drive SSE to 63.459523, -19.364618). I shared this
aerial picture (and a video) online. Half a year later,
I received an e-mail from Mike, a retired USAF officer,
who told me about his roommate, "Rummy," and the
full story behind the crash. What an amazing e-mail to
receive! See the e-mail at www.ech.cc/icelanddc3.

LOCATION
Sólheimasandur, Iceland

EQUIPMENT
DJI Phantom 2, Ricoh GR camera, homemade 3D-printed
camera mount, Boscam TS-353 5.8G video transmitter,
5.8G video receiver and monitor

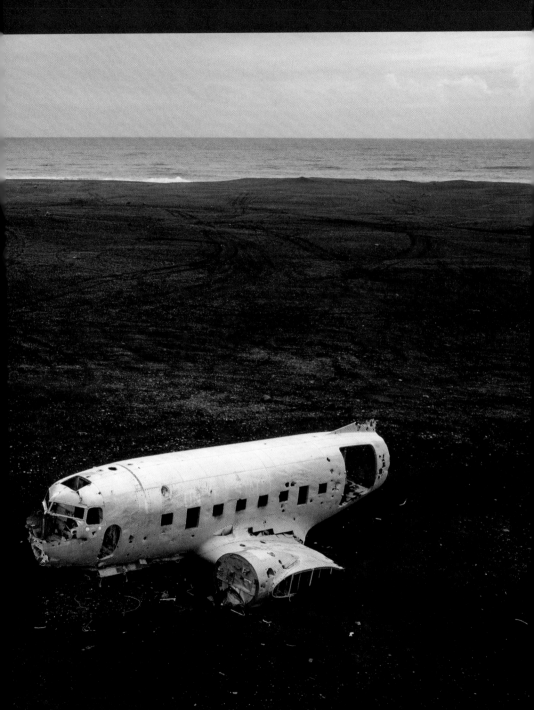

Bahamas
Shipwrecks

Shipwrecks like the Ray of Hope and Big Crab dot
the coast off the island of New Providence.
Many of the shipwrecks are popular scuba
diving destinations, and it isn't by accident.
Cooperation between the Bahamian government
and private companies like Stuart Cove's
Dive Bahamas result in old, abandoned ships
being processed and sunk to provide artificial
reefs for marine life and new backgrounds for
underwater photos.

LOCATION
New Providence, Bahamas

EQUIPMENT
DJI Phantom 2 Vision+

SHOT DETAILS
1/750 sec, f/2.8, ISO 100

Glass Window Bridge

The Glass Window Bridge is located on an extremely narrow strip of Harbour Island and features the incredible contrast of dark blue water on one side and bright turquoise water on the other. The difference in color comes from a difference in depth: The deep side is exposed to the Atlantic Ocean, while the protected side is shallow and covered by sand. Tourists like to pose on or near the bridge, which can be dangerous because large waves can hit the island from the Atlantic side, which doesn't have a protective barrier reef.

LOCATION
Harbour Island, Eleuthera, Bahamas

EQUIPMENT
DJI Phantom 2 Vision+

SHOT DETAILS
1/6400 sec, f/2.8, ISO 100

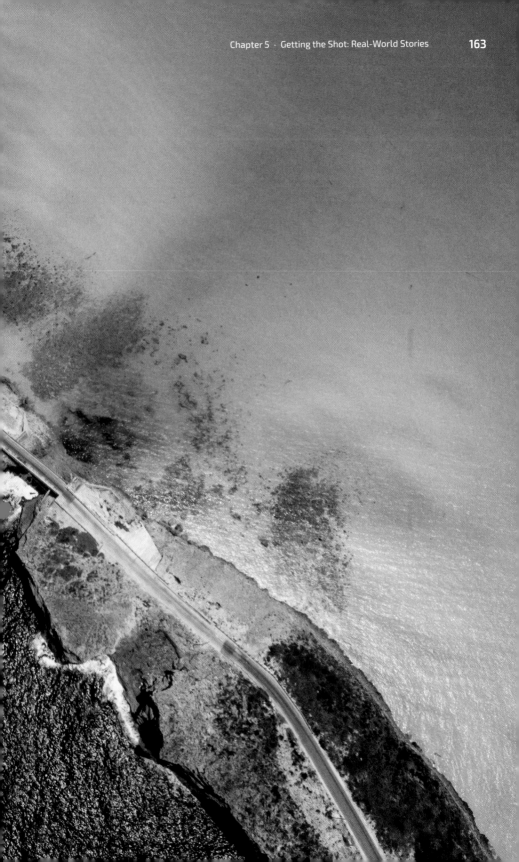

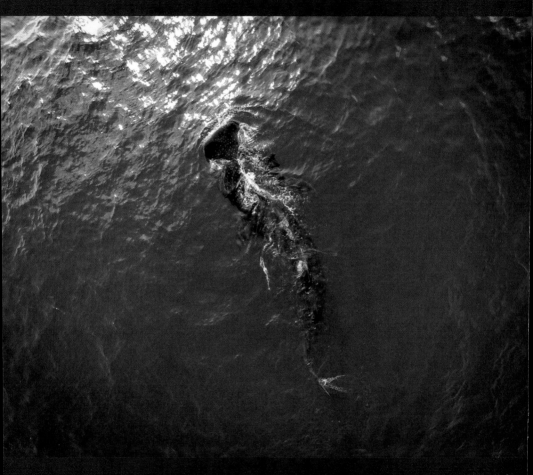

Whale Sharks

Each summer hundreds of whale sharks aggregate in the Gulf of Mexico near Isla Mujeres to feed on huge clouds of fish eggs generated by the massive spawning events of little tunny. The whale sharks, which are the world's biggest fish, swim along the surface of the water with their mouths open, filtering out large amounts of fish eggs for food. It's common to see hundreds of whale sharks on the surface at once.

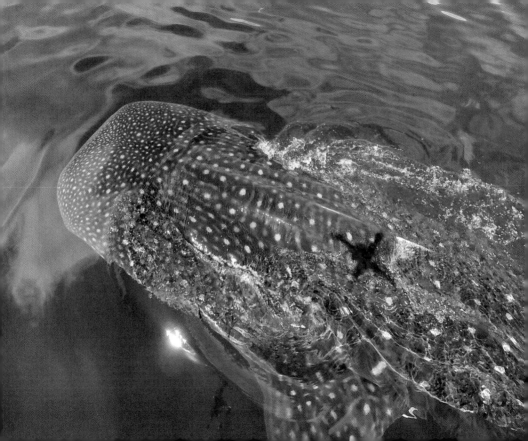

Cannibal Rock

During an underwater photography trip to Komodo, we
spent a full week at Cannibal Rock, one of the area's most
famous SCUBA diving sites known for incredible marine
life, including a diverse collection of tiny little critters to
schools of large dogtooth tuna cruising. I put a camera
drone into the air and captured this shot of divers getting
ready to drop in above the site. The local guides were
fascinated—they had never seen the site they dove day
after day from this perspective.

LOCATION
Horseshoe Bay, Komodo National Park, Indonesia

EQUIPMENT
DJI Phantom 2, Ricoh GR camera, homemade 3D-printed
camera mount, Boscam TS-353 5.8G video transmitter,
5.8G video receiver and monitor

SHOT DETAILS
1/180 sec, f/7.1, ISO 800

Tonga

Tonga is an extremely remote archipelago in the South Pacific comprised of 177 islands. During a trip there to photograph humpback whales, which are there to calf and mate in the late summer, I grew obsessed with aerial imagery of some of the small islands, which are completely undeveloped.

LOCATION
Vakaeitu, Vava'u, Tonga

EQUIPMENT
DJI Phantom 2, Zenmuse H3-2D gimbal, GoPro HERO3 Black, Boscam TS-353 5.8G video transmitter, 5.8G video receiver and monitor

SHOT DETAILS
1/950 sec, f/2.8, ISO 177

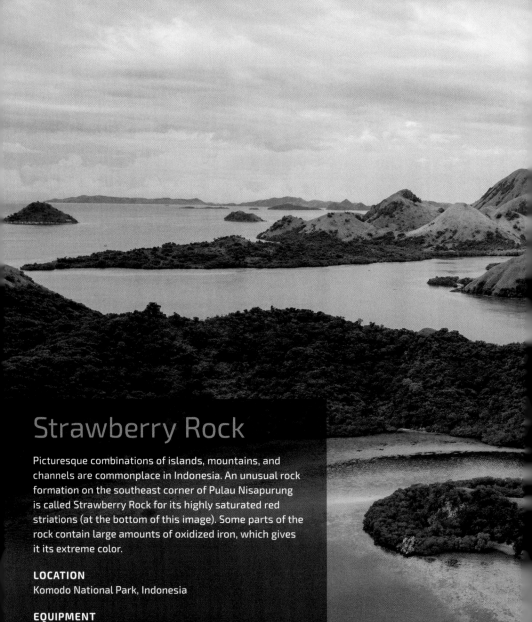

Strawberry Rock

Picturesque combinations of islands, mountains, and
channels are commonplace in Indonesia. An unusual rock
formation on the southeast corner of Pulau Nisapurung
is called Strawberry Rock for its highly saturated red
striations (at the bottom of this image). Some parts of the
rock contain large amounts of oxidized iron, which gives
it its extreme color.

LOCATION
Komodo National Park, Indonesia

EQUIPMENT
DJI Phantom 2, Ricoh GR camera, homemade 3D-printed
camera mount, Boscam TS-353 5.8G video transmitter,
5.8G video receiver and monitor

SHOT DETAILS
1/1250 sec, f/7.1, ISO 400

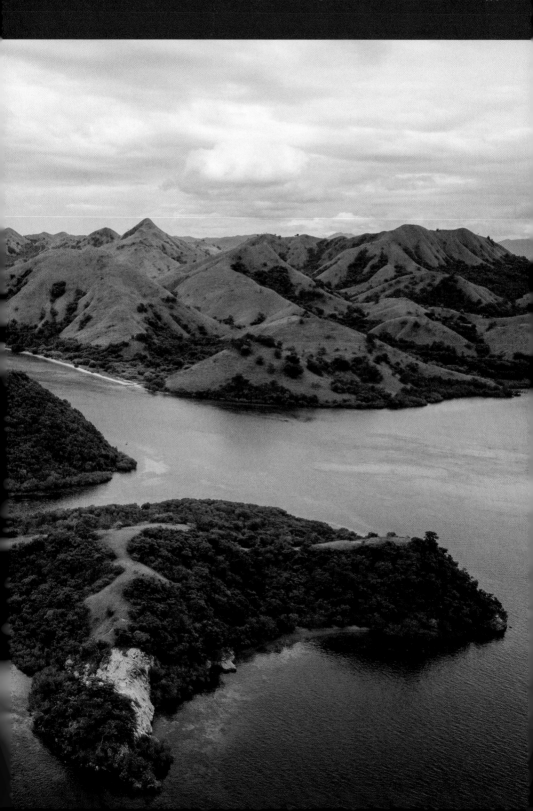

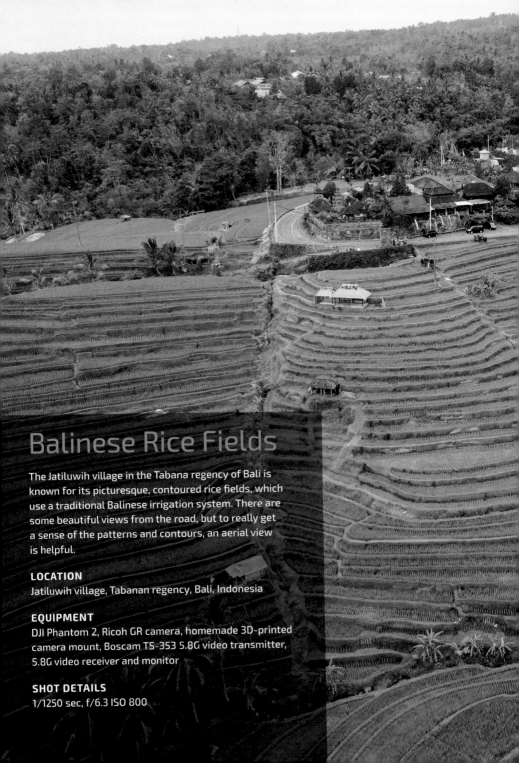

Balinese Rice Fields

The Jatiluwih village in the Tabana regency of Bali is
known for its picturesque, contoured rice fields, which
use a traditional Balinese irrigation system. There are
some beautiful views from the road, but to really get
a sense of the patterns and contours, an aerial view
is helpful.

LOCATION
Jatiluwih village, Tabanan regency, Bali, Indonesia

EQUIPMENT
DJI Phantom 2, Ricoh GR camera, homemade 3D-printed
camera mount, Boscam TS-353 5.8G video transmitter,
5.8G video receiver and monitor

SHOT DETAILS
1/1250 sec, f/6.3 ISO 800

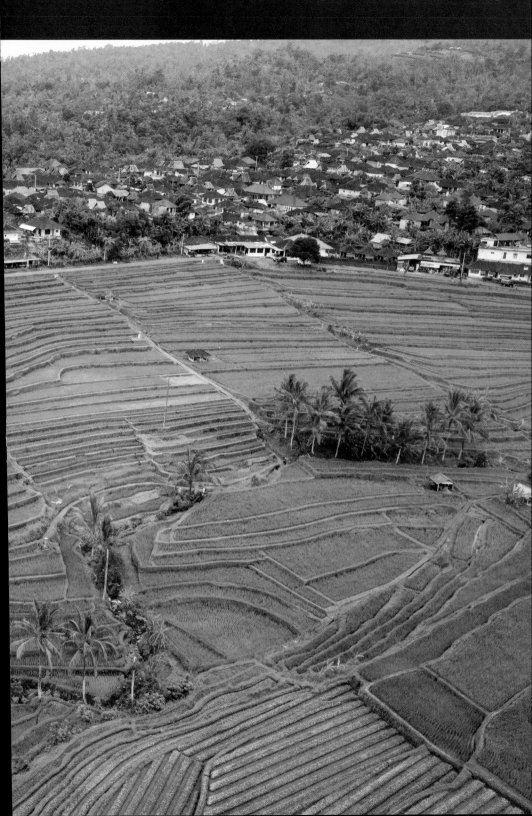

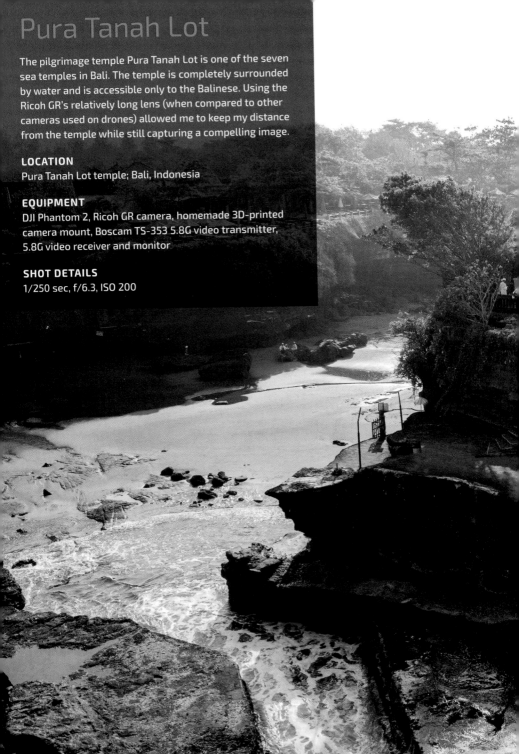

Pura Tanah Lot

The pilgrimage temple Pura Tanah Lot is one of the seven sea temples in Bali. The temple is completely surrounded by water and is accessible only to the Balinese. Using the Ricoh GR's relatively long lens (when compared to other cameras used on drones) allowed me to keep my distance from the temple while still capturing a compelling image.

LOCATION
Pura Tanah Lot temple; Bali, Indonesia

EQUIPMENT
DJI Phantom 2, Ricoh GR camera, homemade 3D-printed camera mount, Boscam TS-353 5.8G video transmitter, 5.8G video receiver and monitor

SHOT DETAILS
1/250 sec, f/6.3, ISO 200

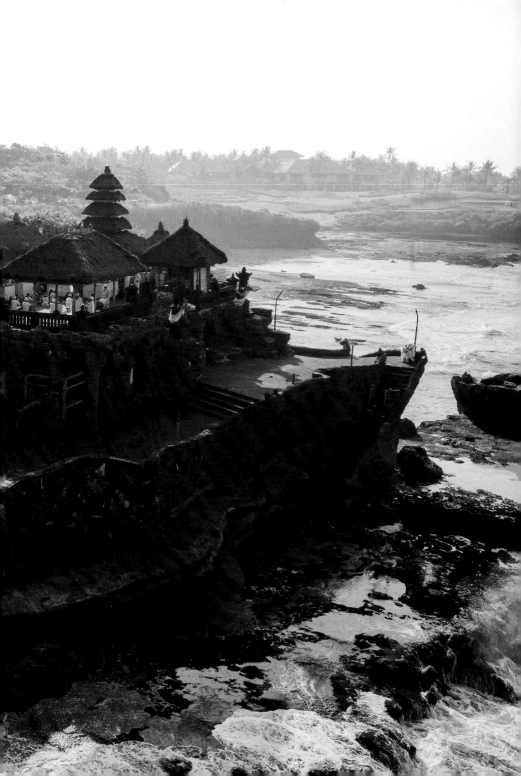

Son Doong Cave

In May 2015, I joined ABC's *Good Morning America* to do a live broadcast in the world's largest cave, deep inside the jungle in central Vietnam. Flying inside a cave this size was challenging because there is no GPS signal and depth perception is difficult. This picture is of a doline, a big opening in the cave about 1,000 feet above, which cast a beam of light into the cave onto ABC's chief meteorologist, Ginger Zee.—*Romeo Durscher*

LOCATION
Son Doong Cave, Vietnam

ARTIST
Romeo Durscher

EQUIPMENT
DJI Phantom 3 Professional

SHOT DETAILS
1/13 sec, f/2.8, ISO 710

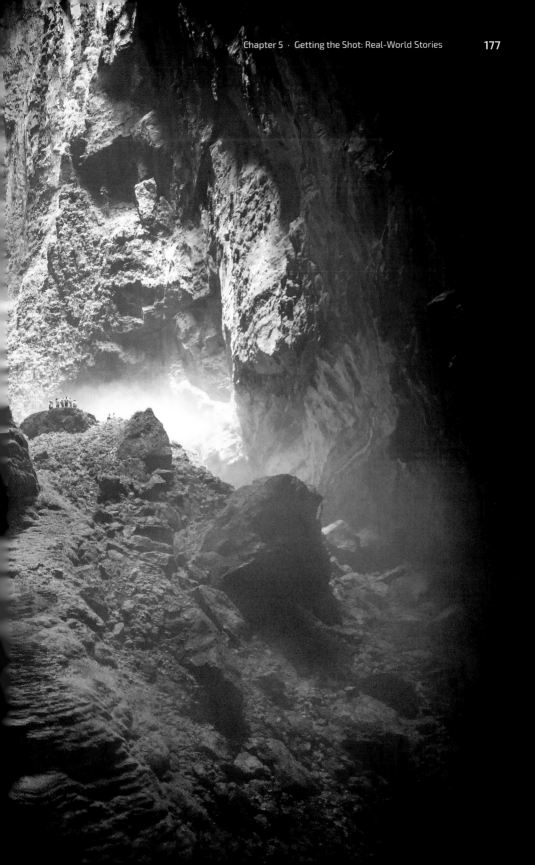

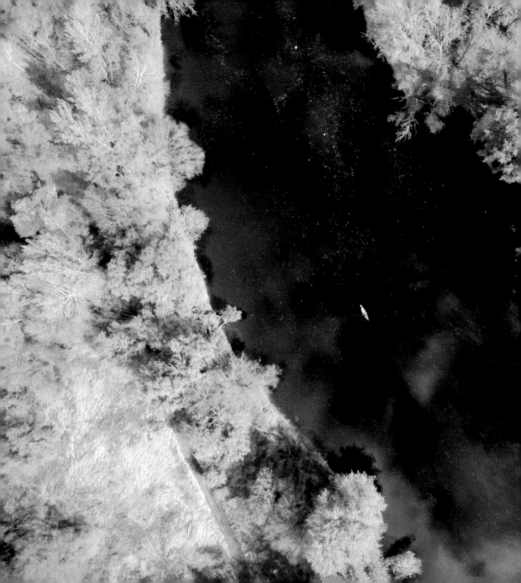

Backyard River Dronie

Since shooting dronies has become my thing, I see the opportunity to shoot them everywhere. My friend's parents' house has a river in their backyard and they own a canoe. I knew this would be a beautiful shot, but what I didn't realize was how calm and glassy the water would be and how perfectly the clouds would reflect on the water. The reflection of the clouds on the water made this one of my favorite Instagram dronie videos.—*Renee Lusano*

LOCATION
Milwaukee, Wisconsin

ARTIST
Renee Lusano

EQUIPMENT
DJI Phantom 2, GoPro HERO3+, 5.8 GHz FPV transmitter, receiver and monitor

SHOT DETAILS
Screenshot from GoPro video, color processed in Adobe Photoshop Lightroom

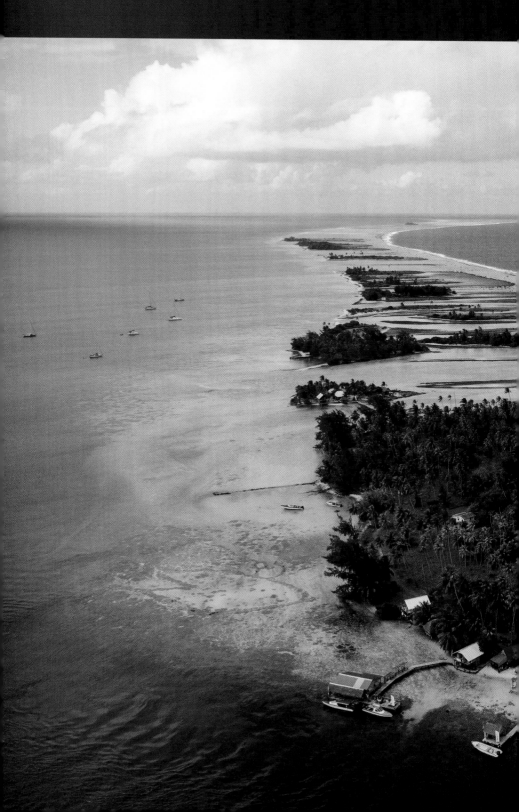

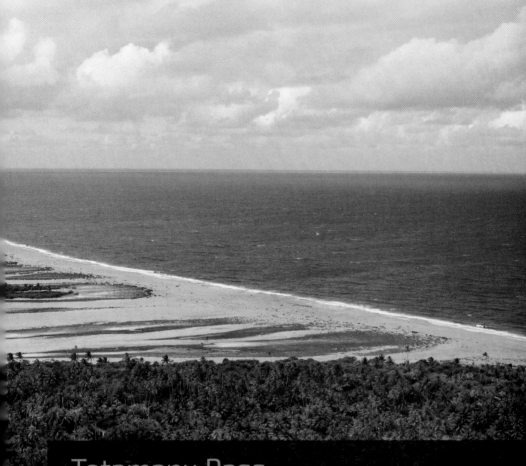

Tetamanu Pass

Tetamanu Pass, which is located at the southern end of Fakarava atoll in French Polynesia, is home to what is likely the best shark dive in the world. Upward of 700 gray reef sharks hang out in the pass during the day, attracting adventurous SCUBA divers who make the long trek to the pass. I was there to photograph both the sharks and an annual spawning event of marbled groupers, which assemble in the pass in huge numbers.

LOCATION
Tetamanu Pass, Fakarava, Archipelago Tuamotu, French Polynesia

EQUIPMENT
DJI Phantom 2, Ricoh GR camera, homemade 3D-printed camera mount, Boscam TS-353 5.8G video transmitter, 5.8G video receiver and monitor

SHOT DETAILS
1/500 sec, f/10, ISO 400

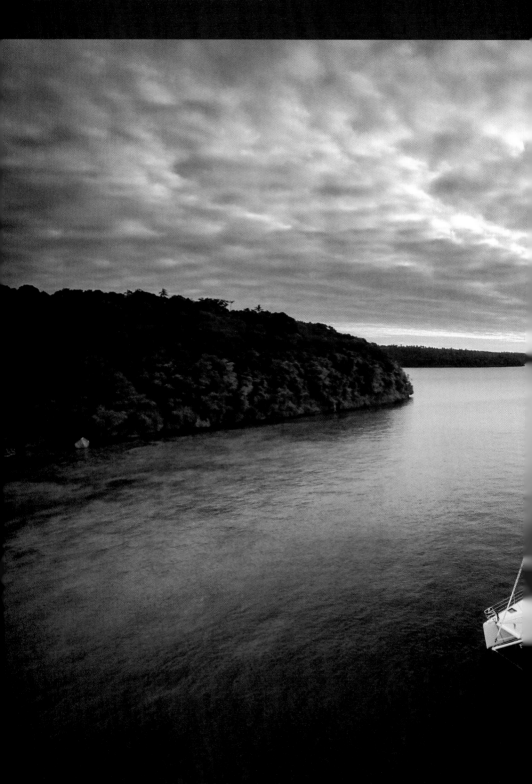

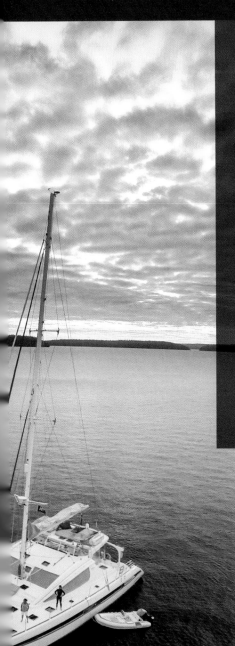

Tonga Via Catamaran

Earlier in this chapter, I showed a straight-down aerial shot of one of the beautiful undeveloped islands of Tonga. The islands are amazing but really require boats to get to. I spent a couple of weeks aboard the S/Y Bella Principessa, a comfortable catamaran owned by my friend and guest artist Julian Cohen that we used as a snorkeling and drone launch platform.

LOCATION
Port Maurelle, Vava'u, Tonga

EQUIPMENT
DJI Phantom 2, Zenmuse H3-2D gimbal, GoPro HERO3 Black, Boscam TS-353 5.8G video transmitter, 5.8G video receiver and monitor

SHOT DETAILS
1/480 sec, f/2.8, ISO 110

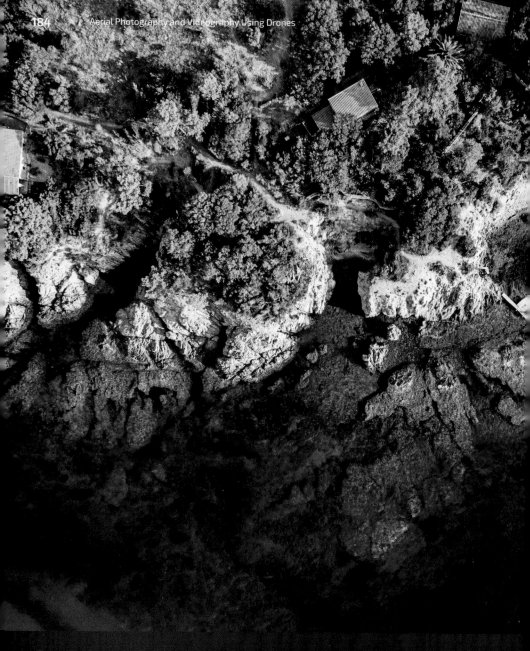

Corsica Panorama

The east coast of Corsica is dotted with many beautiful bays and in the summer is a favorite haunt for tourists. They rent small RIBs, inflatable boats with a speedy outboard engine, and spend the days zooming around the calm sea or relaxing close to a beach somewhere. I have a particular penchant for aerial images that look straight down, below the craft, because that view is something that really can be captured only with a drone or maybe by lying at the edge of a cliff. The polarizing filter really helps to bring out the details of rocks under the water, and the

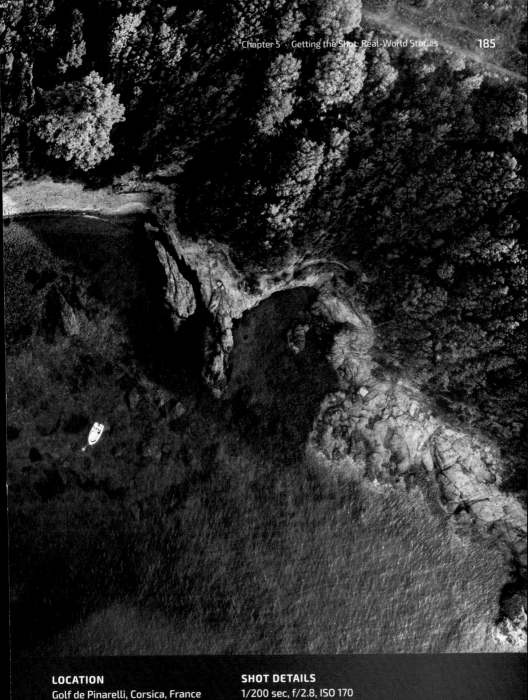

LOCATION
Golf de Pinarelli, Corsica, France

SHOT DETAILS
1/200 sec, f/2.8, ISO 170

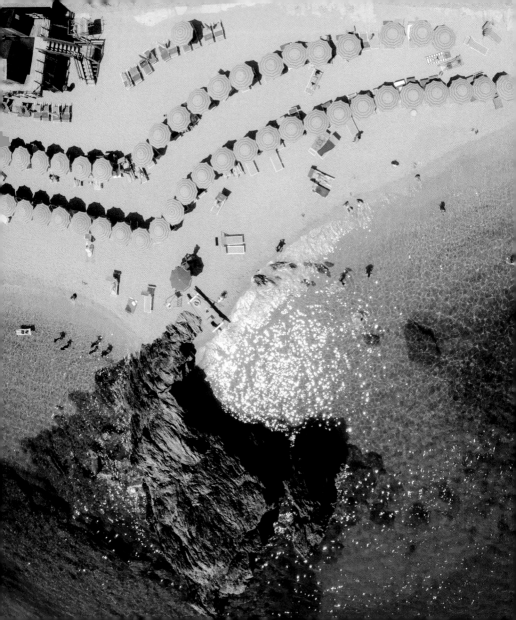

Cinque Terre

I traveled to Italy's Cinque Terre in June 2015 and shot video and photos in several of the towns I visited. All views of Cinque Terre are breathtaking from the land and sky, but I especially liked this view of the umbrellas lining the beach in Monterosso al Mare.—*Renee Lusano*

LOCATION
Monterosso al Mare, Italy

ARTIST
Renee Lusano

EQUIPMENT
DJI Phantom 2, GoPro HERO4, 5.8 GHz FPV transmitter, receiver and monitor

SHOT DETAILS
1/1900 sec, f/2.8, ISO 100
Lens distortion removed, color processed in Adobe Photoshop Lightroom

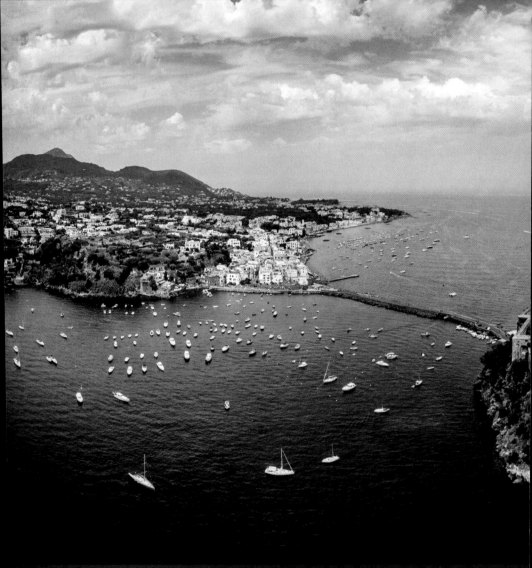

Castello Aragonese

There has been some form of fortification on the spot of Castello Aragonese since 400 BCE. The present castle was built around 1700 to protect the town against pirates. Nowadays, it's a popular tourist destination, and when I saw it, I knew I had to shoot it from the air. Unfortunately, I wasn't able to do it at sunrise or sunset, so I had to settle for the middle of the day, but luckily there were clouds around to help break up the skyline and add a little something to the image.
—*Julian Cohen*

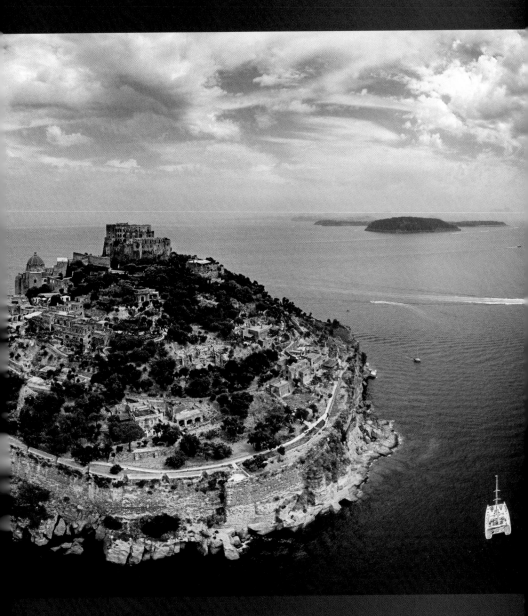

LOCATION
Castello Aragonese;
Gulf of Naples, Italy

ARTIST
Julian Cohen

EQUIPMENT
DJI Phantom 3 Professional,
PolarPro Polarizer Filter

SHOT DETAILS
1/800 sec, f/2.8, ISO 100
Five-shot panorama created in
Photoshop CC

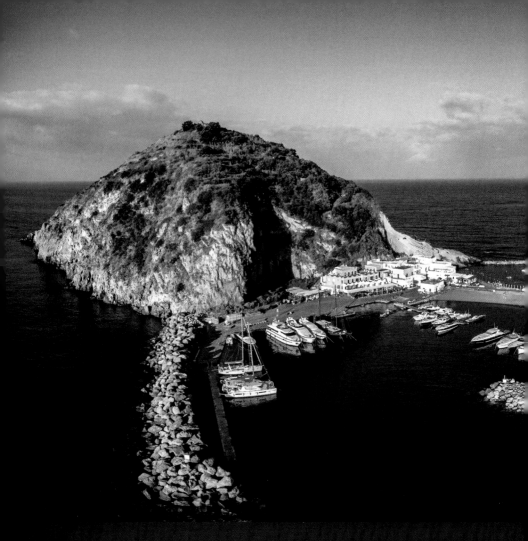

St. Angelo

St. Angelo is a tiny little town on the Island of Ischia, which is just at the north of the Bay of Naples. Mainly a resort frequented by local Italian tourists, it sits perched on the end of a rocky outcrop, and first thing in the morning there is not a person in sight. Sunrise and sunset are my favorite times of day to shoot aerial images; the quality of the light is just wonderful. This image was taken as the sun started to light up the town, bathing it in golden light. —*Julian Cohen*

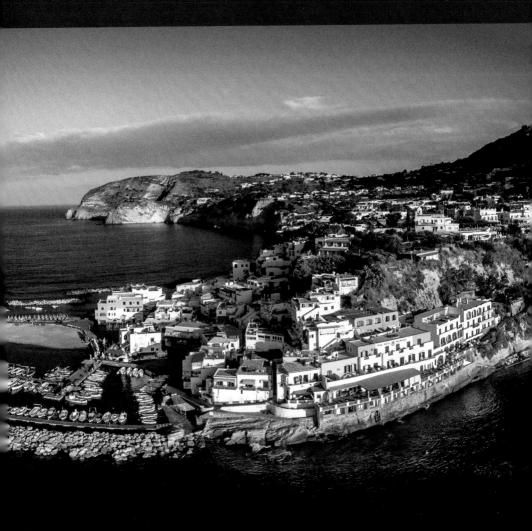

LOCATION
St. Angelo, Ischia, Italy

ARTIST
Julian Cohen

EQUIPMENT
DJI Phantom 3 Professional,
PolarPro Polarizer Filter

SHOT DETAILS
1/2100 sec, f/2.8, ISO 100
Five-shot panorama created in
Photoshop CC

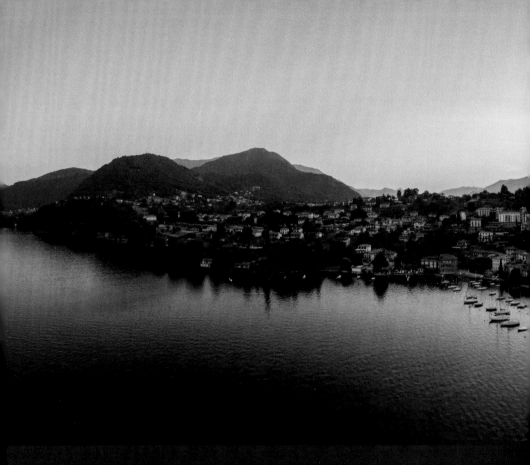

Lake Como Panorama

Lake Como is a beautiful, narrow lake in Italy near the Swiss border. I was invited to the Rockefeller Foundation's Bellagio Center as part of a working group to come up with an initial draft of guidelines for the humanitarian use of drones. During the session, I put my DJI Phantom 3 into the sky and took this seven-shot panorama at dusk from 170 feet up.

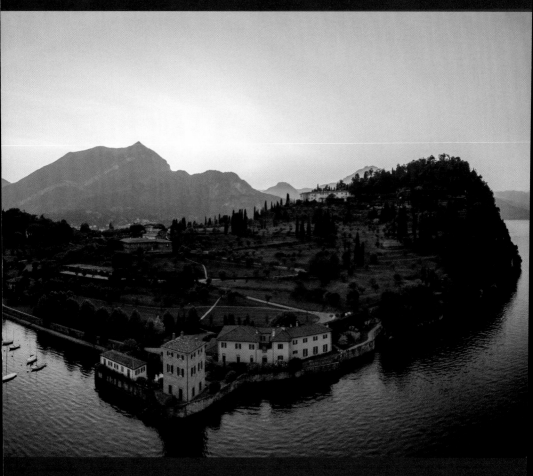

LOCATION
Bellagio, Lake Como, Italy

SHOT DETAILS
1/200 sec, f/2.8, ISO 200

EQUIPMENT
DJI Phantom 3 Professional
Seven-shot panorama created in
Adobe Photoshop Lightroom CC

Shark Aggregation

While wandering around Cape Point, I put my Phantom 2 in the air to see whether I could get some interesting footage of the coastline. After seeing some dark spots in the shallow surf, I descended to investigate and discovered an aggregation of spotted gully sharks (sharptooth houndsharks)! The sharks were literally in the breaking surf, and as a bonus, a Cape fur seal came by, chased some of them around, and then surfed a wave.

LOCATION
Cape Point, Cape Town, South Africa

EQUIPMENT
DJI Phantom 2, Zenmuse H3-3D gimbal, GoPro HERO3+ Black, Boscam TS-353 5.8G video transmitter, 5.8G video receiver and monitor

SHOT DETAILS
1/2800 sec, f/2.8, ISO 100

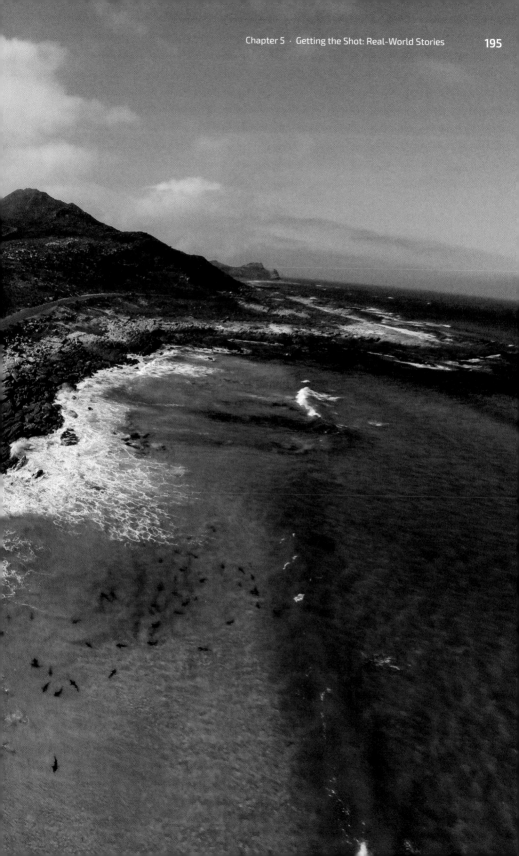

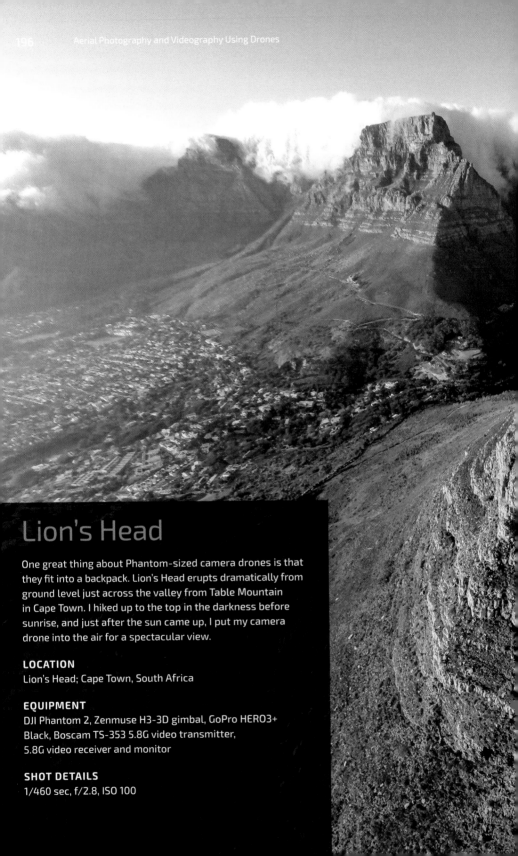

Lion's Head

One great thing about Phantom-sized camera drones is that they fit into a backpack. Lion's Head erupts dramatically from ground level just across the valley from Table Mountain in Cape Town. I hiked up to the top in the darkness before sunrise, and just after the sun came up, I put my camera drone into the air for a spectacular view.

LOCATION
Lion's Head; Cape Town, South Africa

EQUIPMENT
DJI Phantom 2, Zenmuse H3-3D gimbal, GoPro HERO3+ Black, Boscam TS-353 5.8G video transmitter, 5.8G video receiver and monitor

SHOT DETAILS
1/460 sec, f/2.8, ISO 100

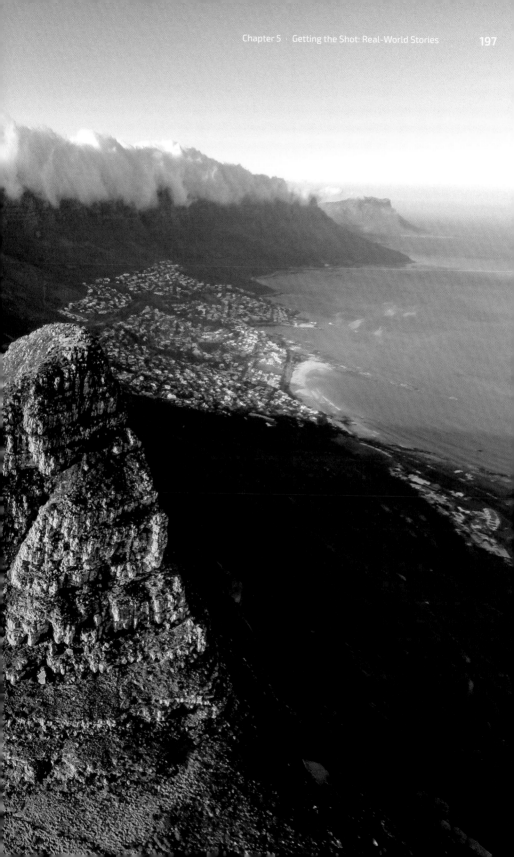

Poaching at Duiker Island

A secluded inlet near Duiker Island outside of Hout Bay Harbour houses three poacher rowboats sitting on a bed of thousands of illegally harvested abalone shells. Aerial perspectives like this show the power that low-cost drones can give to conservation organizations. Unfortunately, there is not much enforcement of such marine poaching in Cape Town, but with more exposure, maybe things will change.

LOCATION
Outside of Hout Bay Harbour, Cape Town, South Africa

EQUIPMENT
DJI Phantom 2, Zenmuse H3-3D gimbal, GoPro HERO3+ Black, Boscam TS-353 5.8G video transmitter, 5.8G video receiver and monitor

SHOT DETAILS
1/730 sec, f/2.8, ISO 100

Monwabisi Beach

A community group called Waves for Change uses youth leaders in the large township of Khayelitsha to teach kids how to surf using donated surfboards and wetsuits. Surfing is used as a form of therapy in Khayelitsha, which experiences high levels of violence and poverty. Support Waves for Change at www.waves-for-change.org.

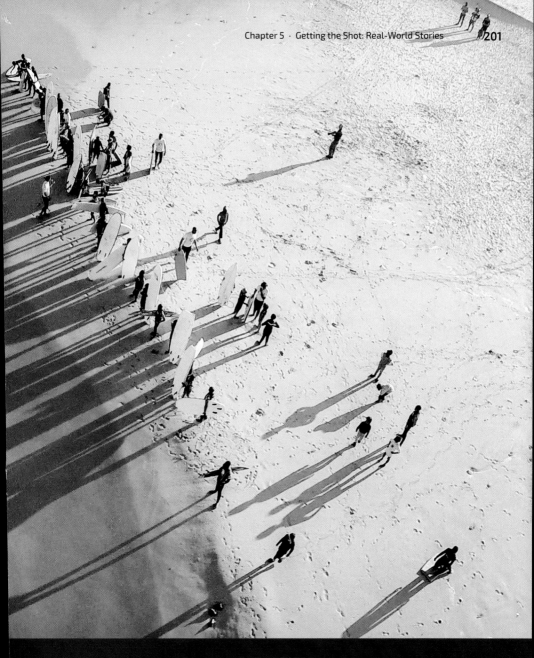

LOCATION
Monwabisi Beach, Khayelitsha,
Western Cape, South Africa

EQUIPMENT
DJI Phantom 2, Zenmuse H3-3D
gimbal, GoPro HERO3+ Black, Boscam
TS-353 5.8G video transmitter,
5.8G video receiver and monitor

SHOT DETAILS
Screenshot from GoPro HERO3+ Black,
2.7K/24p Medium

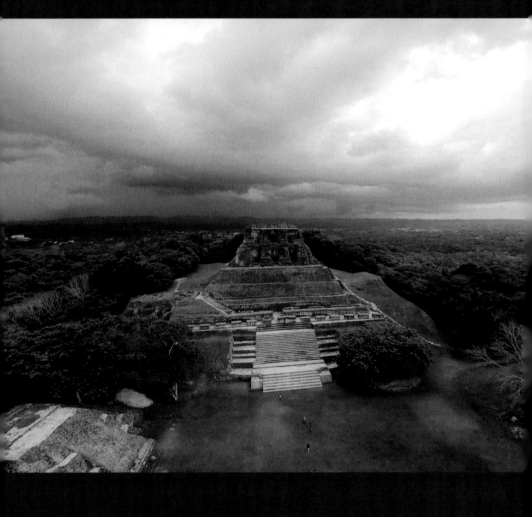

Xunantunich Ruins Dronie

This video is what started my dronie career (May 2014). I had upgraded to a Phantom 2 for a trip to Belize—I wanted a better drone to fly from a dive boat over the Great Blue Hole. I did not yet have FPV, so my shots were all just trial and error. I convinced a guard by paying $100 to be allowed to fly at this location.
—*Renee Lusano*

LOCATION
Xunantunich Ruins, Belize

ARTIST
Renee Lusano

EQUIPMENT
DJI Phantom 2, GoPro HERO3+

SHOT DETAILS
Still from GoPro video, lens distortion removed, color processed in Adobe Photoshop Lightroom

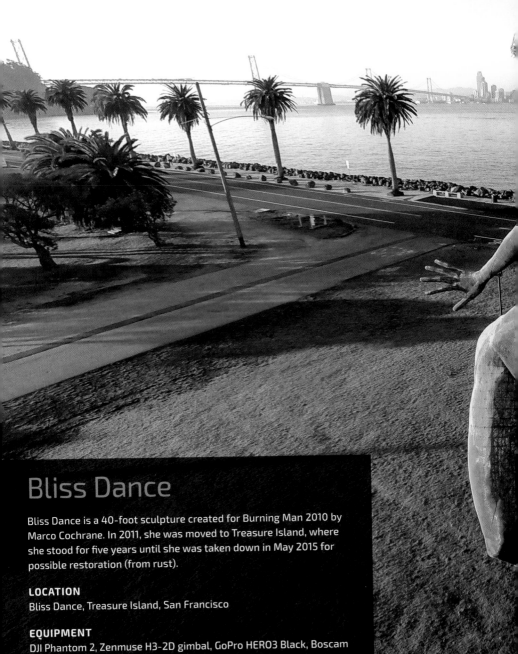

Bliss Dance

Bliss Dance is a 40-foot sculpture created for Burning Man 2010 by
Marco Cochrane. In 2011, she was moved to Treasure Island, where
she stood for five years until she was taken down in May 2015 for
possible restoration (from rust).

LOCATION
Bliss Dance, Treasure Island, San Francisco

EQUIPMENT
DJI Phantom 2, Zenmuse H3-2D gimbal, GoPro HERO3 Black, Boscam
TS-353 5.8G video transmitter, 5.8G video receiver and monitor

SHOT DETAILS
1/340 sec, f/2.8, ISO 100

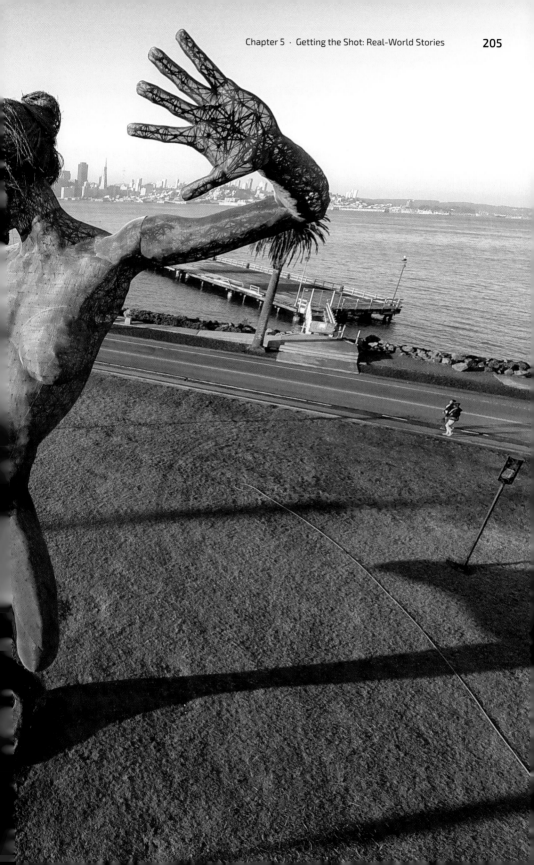

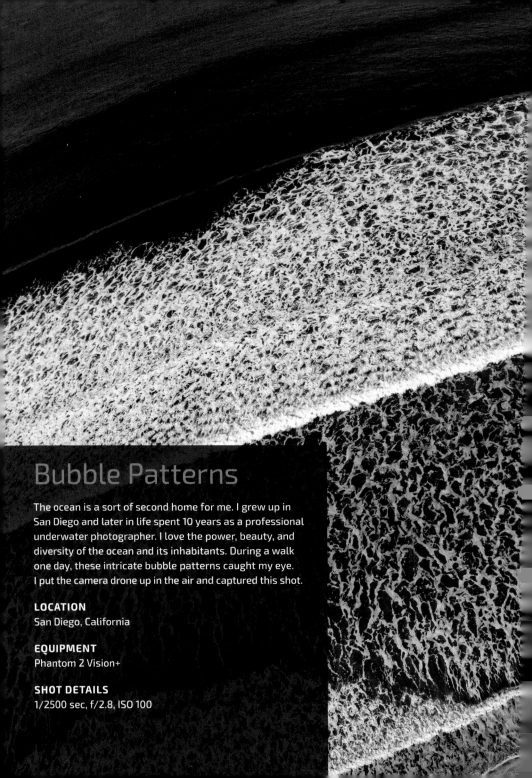

Bubble Patterns

The ocean is a sort of second home for me. I grew up in San Diego and later in life spent 10 years as a professional underwater photographer. I love the power, beauty, and diversity of the ocean and its inhabitants. During a walk one day, these intricate bubble patterns caught my eye. I put the camera drone up in the air and captured this shot.

LOCATION
San Diego, California

EQUIPMENT
Phantom 2 Vision+

SHOT DETAILS
1/2500 sec, f/2.8, ISO 100

Tennis

In 2013, my father was diagnosed with terminal lung cancer. This was a devastating event for our family, but during the next two years until his passing, we spent a lot of time together reevaluating the things that are important in life. Long after his diagnosis, he was still able to beat all of us in a game of tennis.

LOCATION
San Diego, California

EQUIPMENT
DJI Phantom 2, Ricoh GR camera, homemade 3D-printed camera mount, Boscam TS-353 5.8G video transmitter, 5.8G video receiver and monitor

SHOT DETAILS
1/800 sec, f/9, ISO 800

Wigman Motel Dronie

Sometimes I go to a place because I know that a cool aerial image will come from the landscape or architecture of that location. I visited the Wigwam Motel knowing that it would look awesome from the sky, but I didn't realize just how perfectly geometric the grounds of the motel were until I flew my Phantom and shot straight down.—*Renee Lusano*

LOCATION
Wigwam Motel; San Bernardino, California

ARTIST
Renee Lusano

EQUIPMENT
DJI Phantom 2 v2, GoPro HERO4, 5.8 GHz FPV transmitter, receiver, and monitor

SHOT DETAILS
Screenshot from GoPro video, lens distortion removed

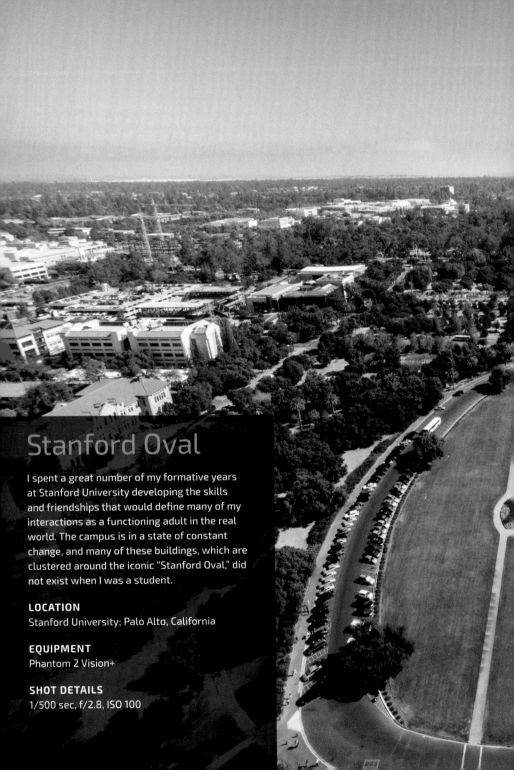

Stanford Oval

I spent a great number of my formative years at Stanford University developing the skills and friendships that would define many of my interactions as a functioning adult in the real world. The campus is in a state of constant change, and many of these buildings, which are clustered around the iconic "Stanford Oval," did not exist when I was a student.

LOCATION
Stanford University; Palo Alto, California

EQUIPMENT
Phantom 2 Vision+

SHOT DETAILS
1/500 sec, f/2.8, ISO 100

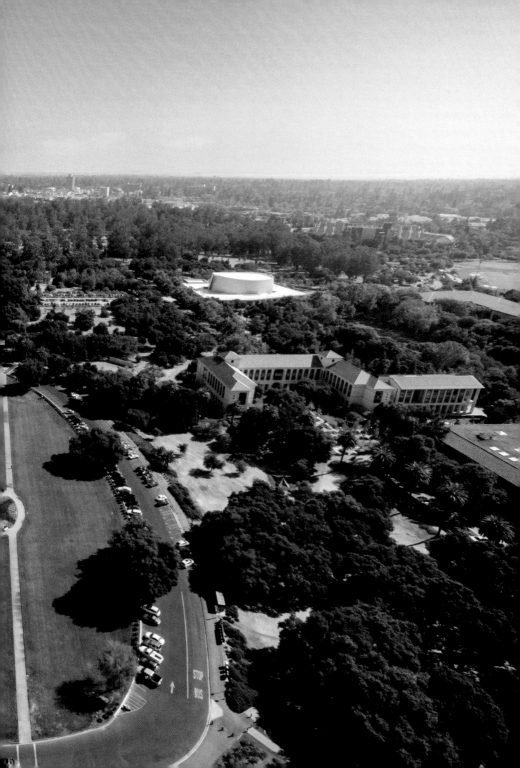

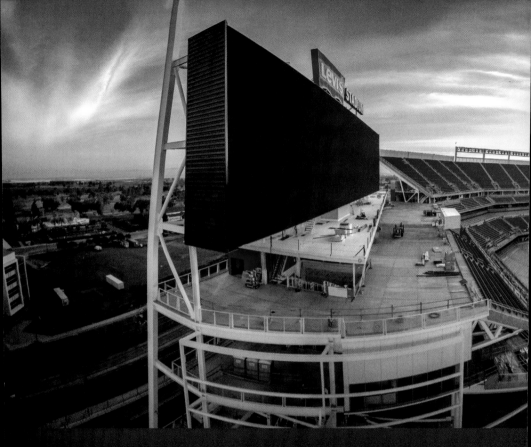

49'ers Stadium Panorama

Just a few miles from my home, a massive stadium was being built. I went out there several times capturing the progress of the stadium from the air, and one Sunday morning, the sunrise was particularly nice, allowing me to capture a beautiful panorama of this majestic structure.
—*Romeo Durscher*

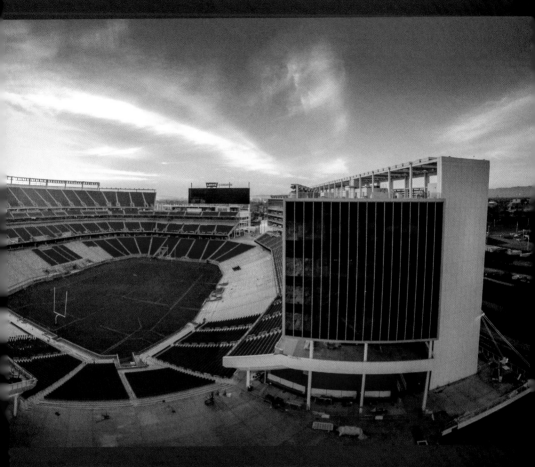

LOCATION
Santa Clara, California

ARTIST
Romeo Durscher

EQUIPMENT
DJI Phantom 2 Vision+

SHOT DETAILS
1/500 sec, f/2.8, ISO 100
Multishot panorama created in
Adobe Photoshop

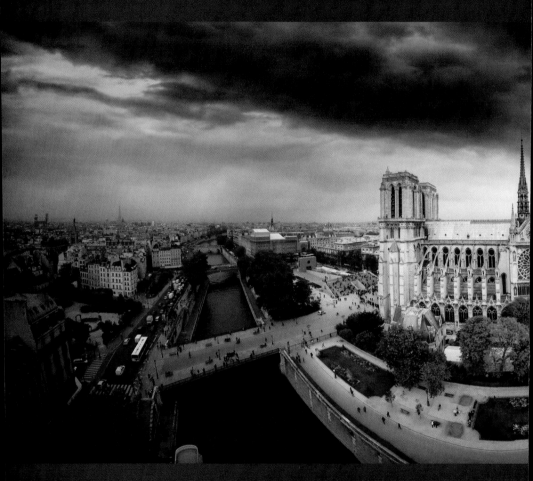

Notre Dame Cathedral

In fall 2013 my best friend Mark Johnson and I spent five weeks in Europe with our first-generation Phantom camera drones. We had decided that we would really test this new technology and see whether it had the potential to change travel and vacation photography as we knew it. We took a trip to Paris on a dark, cloudy day (which I had hoped for), and I captured a dark band of clouds over this amazing cathedral.—*Romeo Durscher*

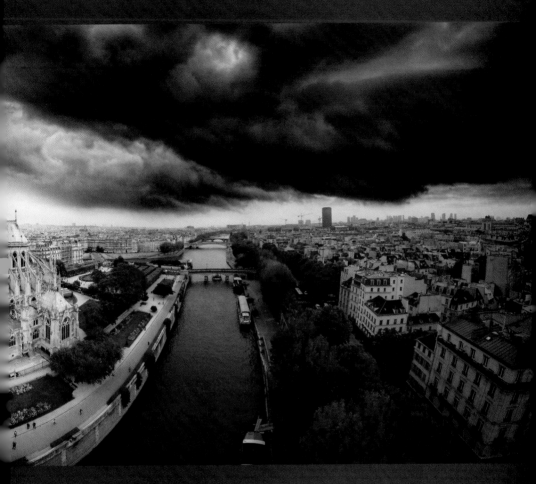

LOCATION
Notre Dame de Paris; Paris, France

ARTIST
Romeo Durscher

EQUIPMENT
DJI Phantom, GoPro HERO3 Black

SHOT DETAILS
1/950 sec, f/2.8, ISO 100
Multishot panorama created in
Adobe Photoshop

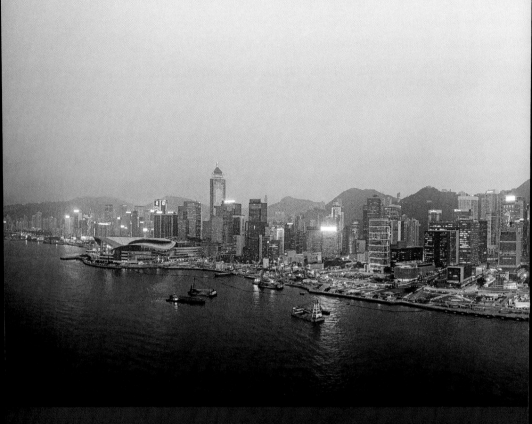

Hong Kong Skyline Panorama

This six-image panorama shot at dawn shows the amazing light show provided by Hong Kong's dramatic, urban skyline. I was absolutely fascinated with this city, and I wish I could spend time exploring the maze from the air.—*Romeo Durscher*

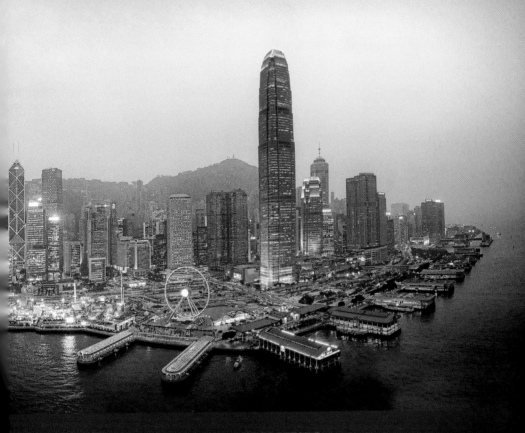

LOCATION
Hong Kong

ARTIST
Romeo Durscher

EQUIPMENT
DJI Inspire 1

SHOT DETAILS
1/13 sec, f/2.8, ISO 698
Six-shot panorama created in
Adobe Photoshop

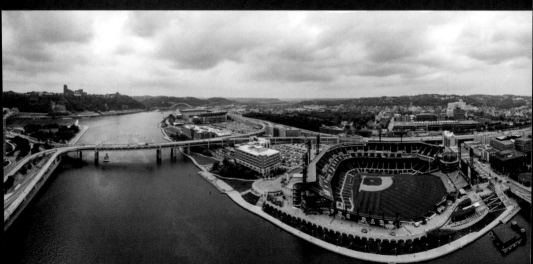

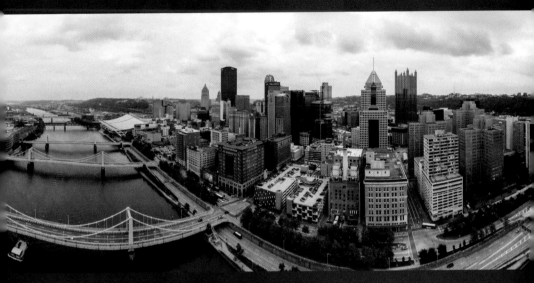

LOCATION
Pittsburgh, Pennsylvania

EQUIPMENT
DJI Phantom 2 Vision+

SHOT DETAILS
1/2000 sec, f/2.8, ISO 100
11-shot panorama created in
Adobe Photoshop CC

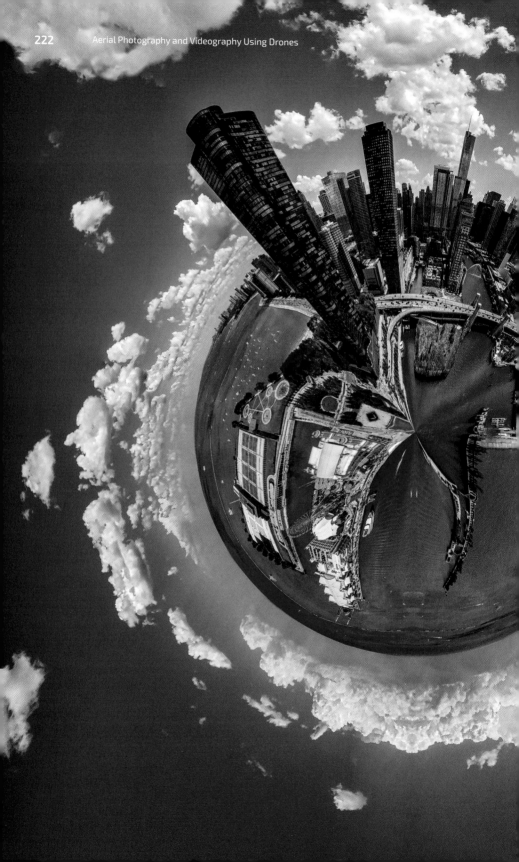

Chicago Waterfront Panorama

On the way back from a wedding, I had a few minutes to stop at the waterfront in Chicago for a quick flight. It was a hot summer day, and the clouds were spectacular. I captured some great aerial images and was working on panoramas when I had the idea of turning one of them into a tiny planet. The buildings around me were higher than my Phantom was, which helped the image to be dramatic.
—*Romeo Durscher*

LOCATION
Chicago, Illinois

ARTIST
Romeo Durscher

EQUIPMENT
DJI Phantom 2 Vision+

SHOT DETAILS
1/3400 sec, f/2.8, ISO 100
Six-shot panorama created in
Adobe Photoshop

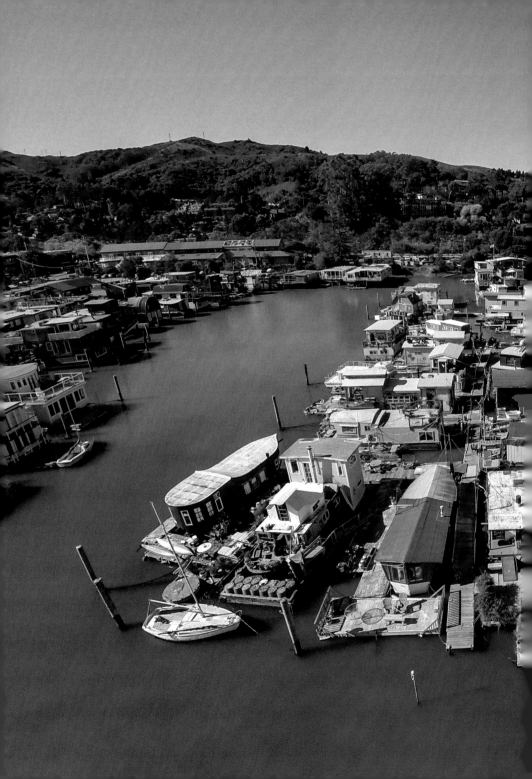

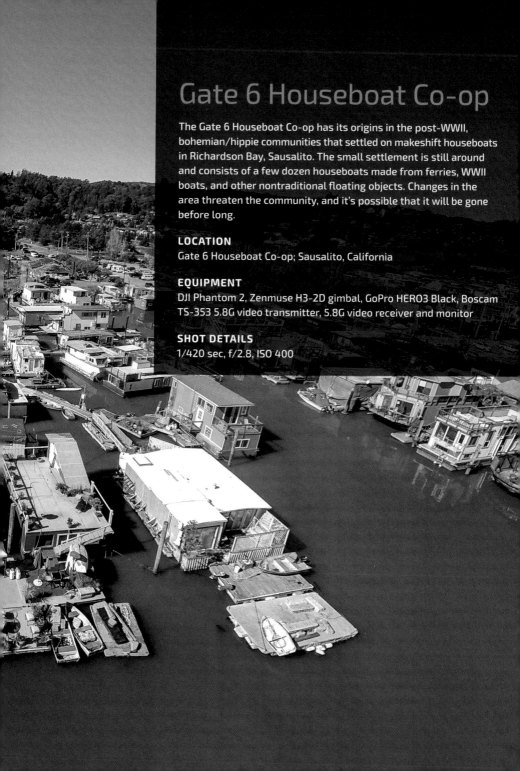

Gate 6 Houseboat Co-op

The Gate 6 Houseboat Co-op has its origins in the post-WWII, bohemian/hippie communities that settled on makeshift houseboats in Richardson Bay, Sausalito. The small settlement is still around and consists of a few dozen houseboats made from ferries, WWII boats, and other nontraditional floating objects. Changes in the area threaten the community, and it's possible that it will be gone before long.

LOCATION
Gate 6 Houseboat Co-op; Sausalito, California

EQUIPMENT
DJI Phantom 2, Zenmuse H3-2D gimbal, GoPro HERO3 Black, Boscam TS-353 5.8G video transmitter, 5.8G video receiver and monitor

SHOT DETAILS
1/420 sec, f/2.8, ISO 400

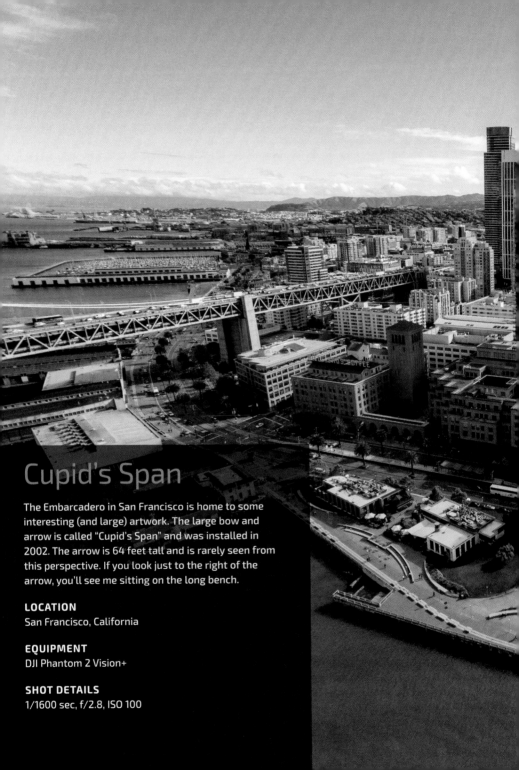

Cupid's Span

The Embarcadero in San Francisco is home to some interesting (and large) artwork. The large bow and arrow is called "Cupid's Span" and was installed in 2002. The arrow is 64 feet tall and is rarely seen from this perspective. If you look just to the right of the arrow, you'll see me sitting on the long bench.

LOCATION
San Francisco, California

EQUIPMENT
DJI Phantom 2 Vision+

SHOT DETAILS
1/1600 sec, f/2.8, ISO 100

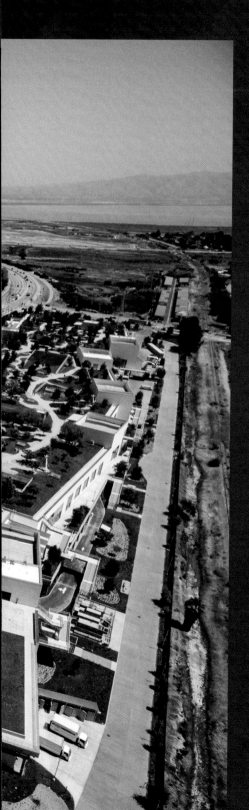

Facebook HQ

Facebook's new building in Menlo Park was designed by renowned architect Frank Gehry and features a 9-acre living roof complete with trees, a lawn, and walking paths. Inside, the building is one large space and can house up to 2,800 employees.

LOCATION
Facebook HQ Building 20; Menlo Park, California

EQUIPMENT
DJI Phantom 3 Professional

SHOT DETAILS
1/500 sec, f/2.8, ISO 100

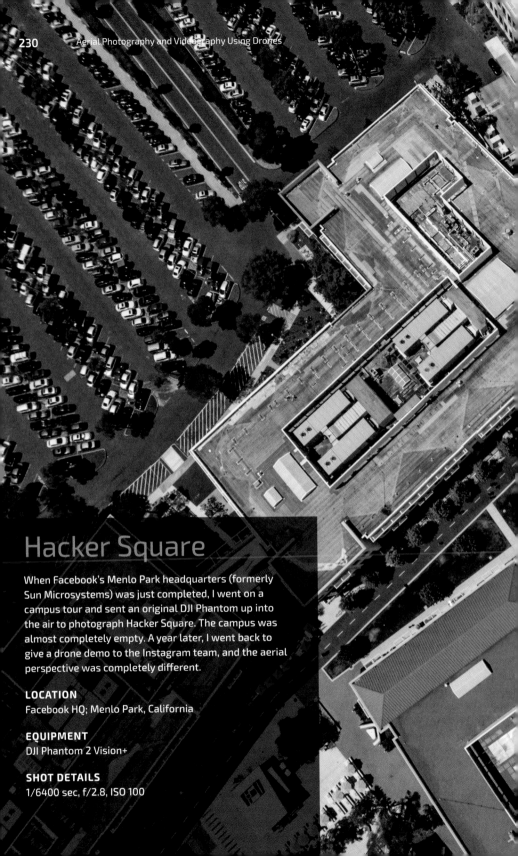

Hacker Square

When Facebook's Menlo Park headquarters (formerly Sun Microsystems) was just completed, I went on a campus tour and sent an original DJI Phantom up into the air to photograph Hacker Square. The campus was almost completely empty. A year later, I went back to give a drone demo to the Instagram team, and the aerial perspective was completely different.

LOCATION
Facebook HQ; Menlo Park, California

EQUIPMENT
DJI Phantom 2 Vision+

SHOT DETAILS
1/6400 sec, f/2.8, ISO 100

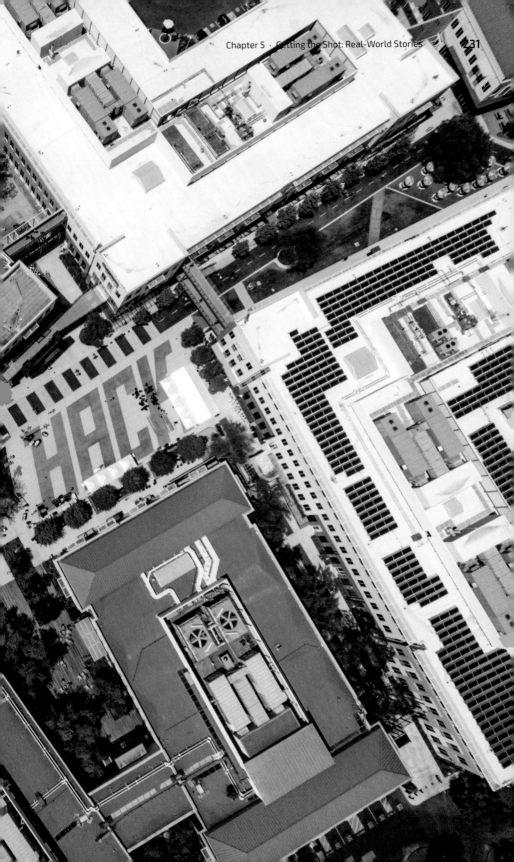

L.A. Rooftop

I travel often, and packing is such an essential part of every trip, especially since I travel with several cameras and my drone. I thought it would be fun to shoot an overhead photo of the contents of my luggage like many people do before a trip, but with my Phantom I was able to get the shot from a distance and include myself and all of my clothing and luggage unfolded.—*Renee Lusano*

LOCATION
My downtown Los Angeles rooftop

ARTIST
Renee Lusano

EQUIPMENT
DJI Phantom 2, GoPro HERO4, 5.8 GHz FPV transmitter, receiver, and monitor

SHOT DETAILS
(unknown); Lens distortion removed, color processed in Adobe Photoshop Lightroom

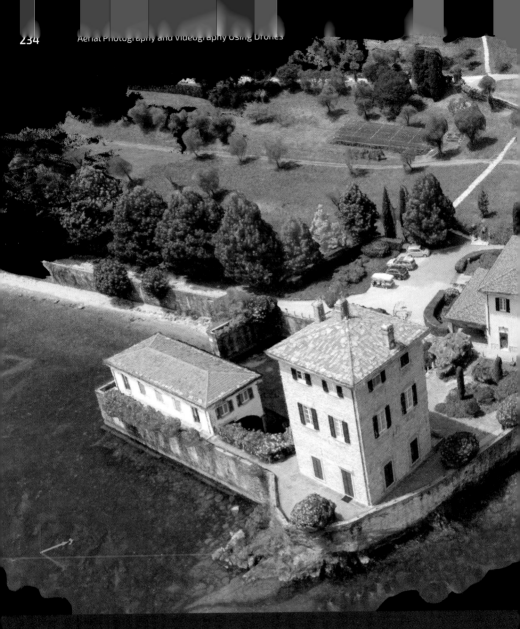

Rockefeller 3D

At the Rockefeller Foundation's Bellagio Center on the shores of Lake Como, Italy, I flew a manual sawtooth pattern of 96 overlapping aerial images. Later, I pointed Pix4DMapper at those images to create a georectified 2D orthomosaic and a 3D model. This is a rendering showing both densified point cloud and texture-mapped mesh.

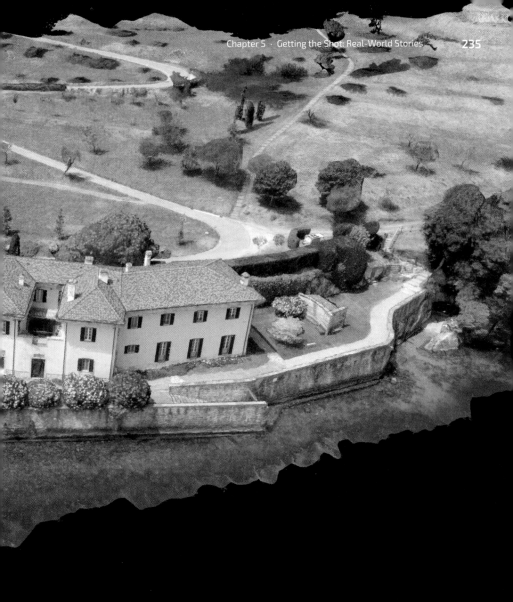

LOCATION
Bellagio, Lake Como, Italy

EQUIPMENT
DJI Phantom 3 Professional 96-shot
aerial 3D map created using
Pix4DMapper

SHOT DETAILS
1/640 sec, f/2.8, ISO 100

CHAPTER 6

Flight, Policy, and Travel

The exponential rise in the popularity of drones has been accompanied by a similar increase in the number of news articles about them. Every once in a while, there is a heartening article about how a drone found someone during a search-and-rescue mission or about how drones could revolutionize certain industries, but most stories seem to be theoretical accounts of near misses with (manned) airplanes or speculative articles about potential threats arising from the democratization of drones.

So, where and when can you fly a camera drone? Are you allowed to go into your backyard and fly? What if you cross over into your neighbor's yard? Can you fly at the local park? What if someone gives you $1 for the flight you just did?

The Federal Aviation Administration (FAA) is in the middle of proposed rule-making around commercial drone use, and regional governments are trying to pass reactive policy that most often addresses drones specifically instead of the underlying, technology-neutral issues. The answers to the previous questions are not straightforward and exist in a changing landscape. Most pro-drone groups advocate for a risk-based approach that uses kinetic energy potential (how much damage a drone can do upon impact), but a final rule has yet to be written.

It is simply not possible to write a definitive guide at this time that will be 100 percent accurate when you are reading this book. This chapter is not meant to be an exhaustive primer on Unmanned Aircraft Systems (UAS) policy in the United States, but it will highlight some of the issues at play and guide you to resources that can be used to conduct further research. Note also that nothing in this chapter constitutes legal advice, and you should always check with local laws if you need more information.

Flying Recreationally

"Drones" are regulated federally in America by the FAA rulemaking around UAS. Recreational (noncommercial) use of UAS by hobbyists was governed for over 31 years by a set of voluntary guidelines issued in 1981 as Advisory Circular (AC) 91-57 (**FIGURE 6.1**), which explicitly addresses model aircraft safety standards.

FIGURE 6.1
FAA Advisory Circular 91-57

AC 91-57 specifies the following safety standards (verbatim):

- Select an operating site that is of sufficient distance from populated areas. The selected site should be away from noise sensitive areas such as parks, schools, hospitals, churches, etc.

- Do not operate model aircraft in the presence of spectators until the aircraft is successfully flight tested and proven airworthy.

- Do not fly model aircraft higher than 400 feet above the surface. When flying aircraft within 3 miles of an airport, notify the airport operator, or when an air traffic facility is located at the airport, notify the control tower, or flight service station.

- Give right of way to, and avoid flying in the proximity of, full-scale aircraft. Use observers to help if possible.

- Do not hesitate to ask for assistance from any airport traffic control tower or flight service station concerning compliance with these standards.

For decades, model aircraft hobbyists operated safely and responsibly under AC 91-57. But in the past few years, flying things have exploded in complexity, feature set, and popularity. The entire model aircraft category has been complicated by the fact that the term *model aircraft* is no longer sufficiently descriptive enough to cover all classes of accessible flying objects. Is a 1-ounce toy quadcopter a model aircraft? If so, is it governed these rules?

Today, a *model aircraft* is a continuous spectrum of product between something like the 0.4-ounce Cheerson CX-10 toy quadcopter, which I wrote about in Chapter 1, to homemade scale jets that weigh 100 pounds or more (I'll refer to them as *drones* going forward). This makes it difficult to come up with meaningful and reasonable rules to govern the legal use of such a wide variety of drones.

In 2012, President Obama signed into law the FAA Modernization and Reform Act of 2012 (FMRA), which included in Section 336 a special rule for model aircraft. Specifically, Section 336 prohibits the FAA from promulgating "any rule or regulation regarding a model aircraft, or an aircraft being developed as a model aircraft" as long as the following requirements are met (again, verbatim):

1. The aircraft is flown strictly for hobby or recreational use;

2. The aircraft is operated in accordance with a community-based set of safety guidelines and within the programming of a nationwide community-based organization;

3. The aircraft is limited to not more than 55 pounds unless otherwise certified through a design, construction, inspection, flight test, and operational safety program administered by a community-based organization;

4. The aircraft is operated in a manner that does not interfere with and gives way to any manned aircraft; and

5. When flown within 5 miles of an airport, the operator of the aircraft provides the airport operator and the airport air traffic control tower (when an air traffic facility is located at the airport) with prior notice of the operation (model aircraft operators flying from a permanent location within 5 miles of an airport should establish a mutually-agreed upon operating procedure with the airport operator and the airport air traffic control tower (when an air traffic facility is located at the airport)).

A *model aircraft* is defined in the same section as an unmanned aircraft that is:

1. capable of sustained flight in the atmosphere;

2. flown within visual line of sight of the person operating the aircraft; and

3. flown for hobby or recreational purposes.

Essentially, Congress mandated that the FAA cannot make rules specifically targeting model aircraft, when model aircraft are defined as unmanned aircraft less than 55 pounds in weight and flown noncommercially, within visual line of sight, not within 5 miles of an airport (with caveats), not interfering with manned aircraft, and operated in accordance with safety guidelines set by a community-based organization (CBO).

Historically, model aircraft operators have banded together in CBOs like the Academy of Model Aeronautics (AMA), which charters roughly 2,400 clubs nationwide and provides education and places to fly for model aircraft enthusiasts. But the emergence of consumer drones as ready-to-fly (RTF) products suddenly resulted in the majority of model aircraft operators being outside of such traditions and outside any formalized process of education.

This lack of education and usage outside of the traditional aeromodeling hobby has led to some pilots flying drones near airports and in areas involving large crowds of people. As a result, the FAA issued an interpretation to the Section 336 special rules for model aircraft in June 2014, specifically

reinforcing the requirements for exemption for future FAA rulemaking regarding model aircraft and explicitly defining phrases like "visual line of sight," "hobby and recreational use," and other potentially ambiguous terms and language.

The FMRA and the 2014 special interpretation formalizes into rulemaking how Americans can legally operate model aircraft (including consumer drones), effectively ending the time of operating only by voluntary guidelines. The FAA has also stated that it may take enforcement action against operators who endanger the safety of the national airspace system (NAS).

On September 2, 2015, the FAA canceled AC 91-57 and promulgated its replacement, AC 91-57A (**FIGURE 6.2**), which formalized many of the definitions and rules outlined by Section 336 of the FRMA and made them required instead of voluntary.

General Flight Restrictions

In Chapter 2, I wrote about finding good places to fly. Most of that discussion was about good places to fly for practice, but if you're reading this book, it's likely that your goals are to capture beautiful aerial imagery of interesting subjects. If you're out in remote areas, it's likely that you won't have any problems when you fly a camera drone. But when you dig a bit deeper, it can actually be quite complicated to know where and when you can and can't fly. Pilots of manned aircraft go through training and know where to find information about how to navigate through airspace, but camera drone pilots are currently not required to undergo any special training, and information

FIGURE 6.2 FAA Advisory Circular 91-57A

about flight restrictions (including the recreational limits discussed in the previous section) can be hard to find.

Given all the negative media coverage about uninformed drone operators flying in inappropriate locations, you might be tempted to drive off into the remote wilderness to take pictures from the air. However, this too might pose a problem. Currently, it's illegal to fly drones in national parks. In coastal areas, National Oceanic and Atmospheric Administration (NOAA) rules say that you can't fly lower than 1,000 feet in marine preserves, and since you can't fly higher than 400 feet as a hobbyist, no drone flights are possible. Depending on your location, it may also be illegal to fly in state and county parks. To make things even more complicated, most rangers and law enforcement personnel are also confused about where you can and can't fly and might stop you even if you're operating your drone in an area where it is legal to fly.

This sort of confusion also happens with cameras and isn't new to most photographers. Are you shooting with your iPhone or with a point-and-shoot camera? That's fine. Oh, you're using a single-lens reflex (SLR)? That's a "professional" camera—you can't use that here! Being stubborn or rude when approached by law enforcement, even if you're right, can be risky, and you should think carefully before making a stand about doing something an officer thinks is not legal.

In addition to blanket bans on drones in various classifications of land, it's also illegal to fly when there is a temporary flight restriction (TFR) in place. TFRs are classified in the following categories:

- **Presidential:** Restricts flying in areas in proximity to the president. Presidential TFRs can be huge in area, covering entire counties.

- **Air shows/sporting events:** Protects air shows and major sporting events.

- **Stadiums:** Restricts flights less than 3,000 feet above ground level (AGL) within 3 nautical miles (nm) of a stadium that seats more than 30,000.

- **Disaster/hazard areas:** Protects fire-fighting aircraft, disaster relief aircraft, and areas with a high degree of public interest (from congestion).

- **Space flight:** Protects areas around space flight operations.

- **Other circumstances:** The FAA reserves the right to issue TFRs when appropriate, but historically, the organization has not done so.

Source: www.faasafety.gov

There are also special flight restricted zones (FRZs) such as the Washington, D.C., FRZ, and the Washington, D.C., special flight rules area (SFRA), which prevent flights of any kind in an area approximately 13 nm in radius centered at Reagan National Airport in Virginia. This FRZ is so restrictive that tethered balloons cannot even be used.

In the media, stories about camera drones flying over wildfires, which violate the TFRs that protect fire-fighting aircraft, and flying over stadiums during games, have been popular. These actions are already illegal given current law, but regional regulators have been proposing and enacting legislation explicitly targeted at drones because there has been so much publicity and fearmongering about such events by mass media. A proposed bill in California states that first responders could lawfully "damage or disable" drones that are preventing them from doing their jobs, and another proposed bill sets fines and possible jail time for interfering with fire departments.

Reactionary proposed regulations might not make much sense because they almost never attempt to address the root problems (interfering with fire-fighting and emergency-response operations, in this case), but these reactions are not surprising, given the sudden and drastic increase in such reported incidents (whether they actually happened or not).

Until recently, it was difficult for drone operators to find good resources for information regarding TFRs, FRZs, SFRAs, and other seemingly random acronyms. Manned aviation resources include a lot of information drone operators might need to know but are typically not in forms that are easily accessible or digestible to a layperson. Luckily, the FAA and private companies are starting to release mobile apps that target drone operators, seeking to educate the entire community. These are two such tools (shown in **FIGURE 6.3**):

- **AirMap** (www.airmap.io), which provides real-time airspace information for drone operators
- **B4UFLY** (www.faa.gov/uas/b4ufly), an FAA app for mobile devices that shows flight restrictions (and incorporates AirMap data)

Both AirMap and B4UFLY require that a drone pilot first know about the resource's existence and then run the app during planning or in the field to determine whether she should fly. It's likely that many people will not know about such resources, and I doubt that such apps will reach the majority of drone pilots unless their usage is mandated in future required certification or training. However, companies like AirMap are being smart about their products and are in discussions with drone manufacturers to include flight restriction information in the point-of-flight apps used to fly (like the apps

used by 3DR and DJI pilots). Camera drone operators are almost guaranteed to be using an app of some kind for FPV and camera control, and reaching operators through the actual operating apps has the highest likelihood of being effective.

The best thing you can do as a camera drone owner is to operate responsibly, with the future of our industry in mind. Both recreational and commercial safety guidelines state that operators should not operate directly over unprotected people or crowded areas. If something you're doing seems risky or has the potential to cause a negative media story (even if you are operating legally), pack up your drone and call it a day.

FIGURE 6.3 AirMap (left) and the FAA's beta B4UFLY mobile app (right)

Manufacturer Responsibility

Some manufacturers have put safeguards into their consumer drone products to help prevent operators from doing bad things with their drones, and some lawmakers are calling for such safeguards, such as no-fly zones (NFZs) and altitude limits, to be required by law. Long before any call for such requirements, DJI's NFZs have prevented operators from flying near airports and in the Washington, D.C., FRZ, and limits flights to 400 feet AGL (from launch altitude) (**FIGURE 6.4**).

Adding NFZs and altitude limits to drone firmware and software prevents naïve and unskilled operators from flying irresponsibly by accident. For example, new drone owners often throttle up and see how high their drones can fly. DJI products will stop at 400 feet AGL and notify the operator that

the altitude limit has been reached. It's likely that we'll see similar NFZs and altitude restrictions being implemented by other drone manufacturers in the near future.

Laws that require restrictions that cannot be overridden are naïve in themselves because many operators actually do have permission to fly near airports and over standard altitude limits. For example, many AMA airfields are actually located at airports, and most airline manufacturers are trying to figure out how to use drones to do aircraft inspection, again, at airports, where manned aircraft are located. Also, such restrictions, even if required, will never prevent bad actors from doing malicious things because drone technology is so ubiquitous in the open source and open hardware world. Such restrictions are based in a naïve belief that drones always navigate by GPS, and it's obvious that GPS is only one sensor of many that drones will use to see the world and navigate in the near future.

Another risk of requiring that drones incorporate built-in NFZs is that technology-based restrictions can result in a false sense of security to operators, who might start to rely on software to determine where they can and can't fly. It should always be an operator's responsibility to fly safely and responsibly.

No such requirements have made it into law yet, but the fact that they're being proposed at all indicates confusion and lack of education in the space. Historically, operators have almost always been held liable for their actions. Car manufacturers are not required to make their cars stay on roads, and people can purchase and freely use all sorts of useful products that could be dangerous if used incorrectly or maliciously. As an example, the act of taking a selfie with a mobile phone killed 12 people in the first 9 months of 2015, according to a study by Mashable, yet mobile phones are still legal to use. Consumer drones killed 0 people in the same period of time, and are just another useful product.

FIGURE 6.4 DJI GO shows no fly zones in the Washington, D.C., FRZ and surrounding airports.

Flying Commercially

Commercial operation of camera drones is widespread globally, and we see drone footage almost everywhere. Hollywood movies have used camera drones commercially for decades, and these days, drones are used commercially and outside of recreation in industries including real estate, mapping, precision agriculture, construction monitoring, mining, stockpile analysis, infrastructure inspection, search-and-rescue, security, conservation, humanitarian response, and much more. Almost every industry can imagine reasons to put a camera, sensor, or other payload into the air, and the drone industry is exploding as a result.

However, legal, commercial operation of a drone in the United States is currently complicated. Virtually every other first-world country has figured out how to enable drones to be used commercially; unfortunately, the United States now lags several years behind other developed nations in commercial drone policy.

Commercial operations were explicitly excluded from operating under the hobbyist-specific AC 91-57 by a 2007 FAA policy clarification (Docket No. FAA-2006-25714), which stated, "AC 91-57 applies only to modelers, and thus specifically excludes its use by persons or companies for business purposes."

The FMRA specifically refers to exemption from future FAA rulemaking for model aircraft only for hobby or recreational use, and the 2014 special interpretation goes further in excluding commercial operators, specifically stating, "Clearly, commercial operations would not be hobby or recreation flights. Likewise, flights that are in furtherance of a business, or incidental to a person's business, would not be a hobby or recreation flight."

In early 2015, the FAA finally released the Small UAS Notice of Proposed Rulemaking (NPRM), which is a proposal for how UAS under 55 pounds would be governed in the national airspace system. The comment period closed in April, and it is unknown how long the FAA will take to complete the rule and what exact form it will take. The NPRM looks similar to Section 336 of the FMRA but is much more exhaustive in defining operating requirements and parameters.

2472223

The summary, released by the FAA, is shown in **FIGURE 6.5**.

It's not worth going into too many specifics about the NPRM because it hasn't been finalized and the comment period is over. If you're interested in reading the entire NPRM and the 4,568 comments received by the FAA, go to www.faa.gov/uas/nprm/.

It's possible that by the time you are reading this, the NPRM will have been finalized into a rule, which means that the first steps toward allowing mass commercial operations of drones in the USA will have been taken. At the time of writing, the only legal way to fly commercially in the United States is to apply for and be granted a Section 333 Exemption.

Section 333 Exemptions

Section 333 of the FMRA allows the Secretary of Transportation to determine whether certain UAS can operate safely in the NAS. A Section 333 Exemption allows the holder to operate UAS based on a set of requirements for safe operation but cannot exempt the operator from certain requirements, such as flying within line of sight, requiring a valid driver's license, or having at least a sport pilot license (yes, operating a camera drone commercially requires that you are certified to fly an airplane!).

When the FAA first opened up a process to petition for exemption, the process for being granted a Section 333 Exemption was arduous, and it was not uncommon for the expected 120-day waiting period to pass without any action being taken by the FAA. Receiving an exemption still meant that operators had to apply for a certificate of waiver or authorization (COA) to actually operate a drone.

In mid-2015, the FAA suddenly started approving exemptions at a rapid rate and also started including blanket 200-feet (AGL) nationwide COAs (with the standard restrictions around airports, restricted airspace, and densely

FIGURE 6.5 Overview of Small UAS Notice of Proposed Rulemaking, released by the FAA

populated areas) along with Section 333 Exemptions, which greatly increased the utility of an exemption.

As of the end of September 2015, the FAA had granted more than 1,700 petitions. Section 333 Exemptions provide a legal way to conduct commercial drone operations before the rules are finalized, but specified restrictions are generally considered to be too restrictive and, in some cases, ridiculous. For example, my friend Peter Sachs, a prominent drone lawyer, received an exemption for a remote-controlled paper airplane in August 2015 but is actually unable to pilot the paper airplane for commercial use because his helicopter pilot's license has lapsed. This reads like deep satire, but sadly, it is not.

Applying for a Section 333 Exemption is straightforward, but the details are outside the scope of this book. I recommend doing a web search for *how to get Section 333 Exemption*, which will lead you to both online guides that take you through the whole process and consulting companies and legal firms that charge a fee to guide you through the process or file a petition on your behalf.

Micro UAS

The current language in the FMRA and NPRM refers to UAS as being "not more than 55 pounds" (unless otherwise certified). However, the NPRM says that the FAA is "considering including a micro UAS classification" (the so-called micro rule). The micro rule would apply to small UAS up to 4.4 pounds (2 kilograms) made of frangible materials that break up upon impact. Micro-class UAS operators would be prohibited from flying their aircraft autonomously, with FPV, over 30 knots in speed, over 1 mile away, or within 5 miles of an airport (under any circumstances). However, operators could fly their micro-class UAS over people and would require only self-certification instead of being certified via an official knowledge test.

I'm a huge proponent of a micro rule for commercial drone use, and I think that implementing a final rule without such a classification would be short-sighted. It is highly likely that drones that are useful for commercial purposes will be less than 2 pounds within a year or two. In three to five years, the smallest commercially viable drones will weigh much less than a pound (think of something like a current small toy quadcopter, only with sophisticated sensors, cameras, flight controllers, and batteries). If a micro rule is not included, it's likely that owners will continue to fly such "toys" at will, even commercially, without voluntarily opting into a set of regulations that make no sense.

Global Landscape

As mentioned earlier, almost every developed country in the world except for the United States has passed legislation covering the commercial use of small UAS, making it legal to conduct commercial operations given a set of requirements. Many countries have no existing rules about drone use, but that does not mean that flying a drone in such a country is legal.

Canada's UAV regulation (its rules refer to unmanned air vehicles—UAVs) is considered to be a good model for what our final rule could look like. The Canadian legislation is risk-based, and it includes a progressive micro rule for UAVs that weigh 2 kilograms or less (no permission needed to fly commercially, but defined safety conditions must be met). Other countries, such as Australia, go one step further. Their micro UAV category is defined as remotely piloted aircraft (RPA) under 100 grams (0.22 pounds), which are effectively completely unregulated. A 2014 proposal in Australia also opens UAVs under 2 kilograms up for use without direct aviation authority approval. Europe's drone regulations are likely to open up significantly as well. For a summary of what to expect in Europe, read Gregory McNeal's *Forbes Magazine* article, "European Drone Regulations Are About to Get Smarter and More Permissive," at bit.ly/eurodrone.

If you're planning to travel to another country with your drone (covered later in this chapter), it is your responsibility to do the appropriate research before you travel to determine whether you can legally operate your drone there. Again, because of the changing global landscape, it's best to use web searches right before you travel to figure out where you can and can't fly.

Regional Rules

In addition to the complicated federal process that is underway to regulate commercial drone use, states, counties, and cities are passing laws that make it illegal to conduct certain operations with drones. In some jurisdictions, model aircraft ordinances have existed for decades, often specifically banning operation in city parks. It's likely that these regulations were originally created to ban loud, heavy, gas-powered RC aircraft, and because of the regulations' age and lack of recent relevance, they can be difficult to find. Some of these old laws are being resurrected to prevent the flying of consumer drones in parks.

Many states have extended anti-surveillance laws to prevent law enforcement from using drones to surveil inhabitants, but some states, such as Texas, North Carolina, and Florida, actually prevent the use of drones to take pictures of private property, effectively making camera drones tricky to use. In California, a bill called SB 142 was proposed that would have prohibited flying a drone under 350 feet over private property to avoid nuisance and violation of privacy (whether the flight was commercial or recreational). This sort of reactive lawmaking either does not address the underlying problem or serves the interests of private constituents who have a lot of lobbying power. For example, in the case of California's proposed SB 142, hobbyists could have legally hovered a drone at 10 feet just outside of someone's private properly line, but crossing over 1 inch and hovering at any altitude under 350 feet would not have been allowed. Nuisance and privacy repercussions in both of those flight locations would be the same, and the specifics of such a bill were born out of lack of education in the space by all parties involved. Luckily, California Governor Brown vetoed SB 142 at the last minute after an all-out lobbying effort by pro-drone groups. In some states (and countries), environmentalists and conservationists speculate that large companies are lobbying to prevent the photography of private property to prevent illegal operations from being documented from the air.

Our delays in establishing a federal drone policy combined with an increasing number of negative, reactive regional rules have the potential to stifle American innovation in the drone space and drive technology development (and job growth) to other countries. In 2015, many advanced technologies for drones are being developed in the United States, but all of the largest nonmilitary drone manufacturers are headquartered in other countries (such as China and France).

Have Drone, Will Travel

As image makers, most of us are used to hauling camera equipment around to take pictures and capture video. When I travel as an underwater photographer, I frequently have about 200 pounds of camera gear, dive equipment, and computers. These days, I also bring a camera drone or two, which makes getting to my destinations more challenging, but the new perspectives have been well worth the hassles.

Backpacks and Cases

When I first started traveling with camera drones, I packed them in large plastic containers for local travel by car and in normal suitcases stuffed with clothing and other padding for air travel. But as I started using them more and more, I began to use custom cases designed specifically to hold drones. These days, manufacturers like 3DR and DJI make customized backpacks for their smaller drones (**FIGURE 6.6**), and many third-party manufacturers make cases of all kinds for transporting camera drones.

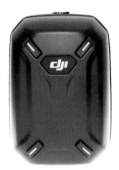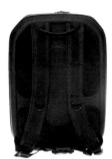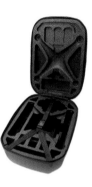

FIGURE 6.6 DJI's OEM Hardshell Backpack for Phantom 3, which retails for about $150

Which backpacks and cases will work best for you will depend largely on what you're carrying and your own preferred way of traveling. Having done dozens of trips carrying drones, I use a customized backpack by Think Tank Photo (**FIGURE 6.7**), which fits under the seat on most airplanes, and hard cases by GPC, which are sturdy enough to be checked as luggage.

FIGURE 6.7 Real-world images of the Think Tank Airport Acceleration backpack, which fits under most airline seats

The Think Tank backpack I use is the Airport Acceleration, which is essentially one large compartment that can be subdivided by the use of sturdy padded dividers. Mine is many years old and has been with me all over the world, mostly carrying underwater camera housings, a computer, and accessories. The backpack is no longer being sold, but the current version, called the Airport Accelerator, is similar ($295). Think Tank also sells the Airport Accelerator DJI Phantom 2 Divider Kit ($35), a set of ten dividers that can be used to configure the backpack similar to the way I've configured mine (I just used the stock dividers). Interestingly, Think Tank also sells the Airport Helipak, which seemingly combines the backpack and divider set for $240, which is significantly less expensive (**FIGURE 6.8**).

The reason I like open backpacks like the Airport Helipak is that they hold a ton of gear and can be easily customized to suit the needs of a specific photographer or trip. I can fit a Phantom, its remote controller, four to five batteries, iPad, extra propellers, a mirrorless camera, a 15-inch laptop, and many accessories into my backpack.

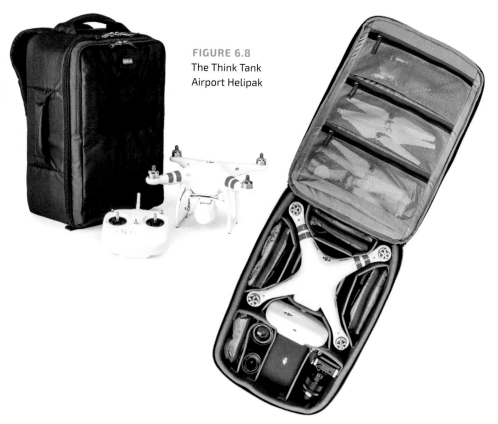

FIGURE 6.8
The Think Tank
Airport Helipak

I also use GPC hard cases to carry larger drones and when I need more protection for smaller drones like Phantoms (**FIGURE 6.9**). GPC cases are well known in the drone hobby, although there are now a few competing brands. I like GPC because they specialize in drones, and their cases are battle tested. During my trip to Iceland with *Good Morning America*, I packed three DJI Inspire 1s into GPC cases, which worked perfectly to protect the drones during travel and in the harsh conditions in the field (**FIGURE 6.10**).

FIGURE 6.9
DJI Inspire 1 camera drones packed up for a trip to Iceland

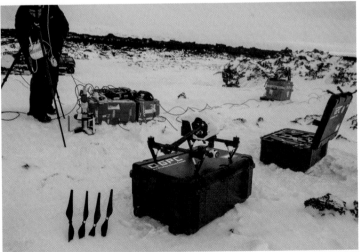

FIGURE 6.10
Getting ready for a flight in the field during Icelandic winter

Air Travel

A few years ago, getting onto an airplane with a camera drone in your bag was sure to draw attention. I remember having my bags inspected virtually every time I went through security. I went through San Francisco International Airport so many times carrying a drone that one of the agents there once referred to me as "that drone guy" as my bags went through the X-ray machine.

Aside from regulatory restrictions at your destination, traveling with a drone these days is relatively straightforward; usually, they're classified as consumer electronics, which is only a bit complicated because they use lithium batteries (like almost all electronics these days). Most X-ray techs won't even look twice as a DJI Phantom goes by, although if you pack enough batteries, you might attract attention, especially in Europe.

Lithium Batteries

Lithium batteries are treated specially during transport because they can burn if they aren't treated properly, and lithium fires burn hot and are hard to extinguish. The rules established by the U.S. Department of Transportation (US DOT) for air travel with electronics that use lithium batteries are as follows:

- If the battery is installed in the device, it can be carried onboard or checked in luggage.

- If the battery is not installed in the device, it must be carried onboard and stored properly (terminals cannot touch metal). There is no limit to the number you can carry (with airline approval).

- If the battery's capacity exceeds 100 watt hours (Wh) but is less than 160 Wh, you can carry no more than two, and you must bring them onboard (with airline approval).

- If the battery's capacity exceeds 160 Wh, you cannot bring it onto an airplane.

The DJI Phantom 3 uses 68 Wh batteries, and the DJI Inspire 1's standard batteries are 99.9 Wh. Larger camera drones use batteries that can easily exceed 100 Wh, and transporting multiple large batteries can be challenging.

If you can't remember how to convert Li-Po battery voltage and current ratings into watt hours, see the "1S, 2S, 3S, Watt?" sidebar in Chapter 1.

Note that Transport Security Administration (TSA), individual airlines, or international air travel might have rules that are more or less restrictive

than the US DOT regulations. Some of my friends have had 68 Wh Phantom batteries confiscated while traveling by air in Europe, even though each battery's capacity is well under 100 Wh, and all batteries were in carry-on luggage.

Customs

Traveling internationally with drones is the same as traveling with any valuable goods, and some destinations might try to charge you duty when you enter with a drone, especially in less developed countries. If you're traveling to a country that honors Carnets, it's a good idea to register your drones and other valuable equipment to make things easy. In general, I've found that if you travel with even one hard case that looks like it is carrying something valuable, you are much more likely to be stopped and questioned by customs on the way into a country.

I registered a Carnet during a trip to Iceland because I had four drones with me in cases that marked me as bringing in a lot of fragile equipment. Unfortunately, one of the drones melted in the volcano, which was an interesting event to try to explain to the customs agent! Luckily, bureaucracy works well in Iceland, and my story checked out.

During all of my travels, I have been illegally asked to pay duty on "importing" a drone only once, and it was upon arrival to the Bahamas as a guest of the Bahamas Ministry of Tourism for a magazine story. I was asked to pay 45 percent of the value of the product. After much haggling I managed to get the illegal customs fee down to $315 (the agent gave me what he called a "discount"). I was unhappy but had no options and was forced to pay. Luckily, I paid by credit card and reversed the charge as soon as I left the country.

Putting identifying information on your drone is a good idea, and many operators label their drones with a name and phone number. I have heard of cases in which people have had lost drones returned because their phone numbers were written on them.

Responsibility and Change

The biggest challenges faced by the emerging drone industry are cultural and regulatory. We are at the beginning of an upward exponential curve when it comes to the development of drone technology, and it's unlikely that technical roadblocks will prevent the mass adoption of useful drones. Cultural and

regulatory change, however, can take a long time, and history has shown that we fear change. We've seen pushback to many technological advances in the past, but in the end, the public has proven again and again that convenience and utility trump privacy protection, so it's likely that we will adapt.

We Fear Change

In the case of drones, privacy issues have so far been overblown. Often, what starts out as an alleged privacy violation is later proven to be an overreaction. But even in cases that are proven to be valid, violations of privacy and property are already covered by tort laws, and violating such laws is not legal regardless of whether a perpetrator is ground-based or in the air. The fact that reactive legislation is being enacted specifically targeting drones suggests that people are afraid and/or mistrustful of drones and that the full story about what drones can and can't do isn't standard knowledge.

Going forward, we need education and enforcement to help keep the drone industry healthy and responsible. Drone pilots should always know what they should and shouldn't be doing when they fly, and we can only hope that future regulations will be reasonable so the incredible utility of drones can continue to be harnessed by hobbyists and commercial users alike.

Drones Are Good

The best thing you can do as a camera drone operator is to fly responsibly. In addition to following regulatory guidelines, using common sense can help you to avoid being the cause of a bad situation.

It might take only a few public examples of bad actors doing irresponsible things with consumer drones for reactive legislation to clamp down catastrophi-cally on consumer drone use. Ultimately, drone operators are responsible for their own actions, and it is our collective responsibility to demonstrate that drones can have a large, positive impact on society.

As you go out and create amazing work with your camera drones, share it with the world. The future of aerial imaging is full of new stories just waiting to be captured. I look forward to seeing what you do!

APPENDIX A

Resources

Camera Drone Manufacturers

- **3DR:** www.3drobotics.com
- **DJI:** www.dji.com
- **Horizon Hobby:** www.horizonhobby.com
- **Parrot:** www.parrot.com/usa/
- **Walkera:** www.walkera.com
- **Yuneec:** www.yuneec.com

Online Communities

- **DIY Drones:** www.diydrones.com (open source DIY drones community; 3DR-focused)
- **DJI Forum:** http://forum.dji.com (DJI products community)
- **Phantom Pilots:** www.phantompilots.com (community for DJI Phantom users)
- **RCGroups:** www.rcgroups.com (the most comprehensive general RC hobby forum)
- **SkyPixel:** www.skypixel.com (DJI aerial imaging community)

Clubs and Associations

- **Academy of Model Aeronautics (AMA):** www.modelaircraft.org
- **United States Association of Unmanned Aerial Videographers (UAVUS):** www.uavus.org

Commercial Drone Insurance

- **Aerial Pak:** www.aerialpak.com
- **Global Aerospace, Inc.:** www.global-aero.com
- **Transport Risk Management:** www.transportrisk.com
- **Google:** Search the Web for *UAV insurance* for more options

Other Resources

- **AirMap airspace information:** www.airmap.io
- **RCGroups.com's Flying Field Directory:** www.rcgroups.com/places/3-rc-flying-fields
- **FAA B4UFLY Smartphone App:** www.faa.gov/uas/b4ufly/
- **DroneCoalition drone news:** www.dronecoalition.net

APPENDIX B

Reference Material

PREFLIGHT

Environment Safety Check:

☐ Area clear of buildings and people; no airports or sensitive areas nearby

Physical Inspection

☐ No cracks

☐ No loose or damaged screws or fasteners

☐ No loose connections or damaged wiring

☐ Propellers tight and/or secured, and not damaged

Control Inspection and Calibration

☐ All batteries charged and securely attached

☐ Remote controller switches and controls in correct positions

☐ Power on remote controller

☐ Power on drone and camera/all components

☐ Calibrate compass, if necessary

☐ Wait for GPS lock

☐ Check LEDs and/or integrated apps for warning indicators

Takeoff

☐ Put drone on a level, safe platform away from people

☐ Start recording, if you are using a stand-alone camera

Landing

☐ Clear the landing area of people

☐ Trigger auto-land or land manually

Post-Flight

☐ Stop recording video before powering off drone

☐ Power off drone, then turn off remote controller

☐ Log your flight

FLIGHT LOG

Date:

Flight Number:

Drone ID:

Location:

Time:

Duration:

Distance Flown:

Weather:

Notes / Incidents:

Index